SEEING THROUGH RACE

THE W. E. B. DU BOIS LECTURES

SEEING THROUGH RACE

W. J. T. Mitchell

HARVARD UNIVERSITY PRESS
CAMBRIDGE, MASSACHUSETTS
LONDON, ENGLAND
2012

Library of Congress Cataloging-in-Publication Data

Mitchell, W. J. T. (William John Thomas), 1942–
Seeing through race / W. J. T. Mitchell.
p. cm.
Includes bibliographical references and index.
ISBN 978-0-674-05981-8 (alk. paper)
1. Race. 2. Race—Religious aspects. 3. Racism.
4. Idolatry. I. Title.
HT1521.M57 2012
305.8—dc23 2011043474

For my Main Man
Henry Louis Gates Jr.

CONTENTS

ILLUSTRATIONS

PREFACE

We are led to believe a lie
When we see with, not through, the eye.

—*William Blake, "Auguries of Innocence"*

The Negro is a sort of seventh son, born with a veil and gifted with
second sight in this American world.

—*W. E. B. Du Bois,* The Souls of Black Folk

One would have to suffer from a very deep form of blindness to ignore the continuing presence of racism in the world today. Islamophobia, anti-Semitism, and Negrophobia, to name the most prominent forms, are clearly alive and well. And yet there is a widespread belief among intellectuals who study this question that race itself is an obsolete concept. We have "seen through race" and exposed it as an illusion, according to the prevailing wisdom. We are, or should be, "color blind" and ignore all the visible signs of racial difference. Or we have "seen race through" to its logical conclusion and rejected it as an outmoded relic of nineteenth-century science. Like the police officer who admonishes us to "move along, nothing to see here," theorists of race have declared that we are living in a "post-racial era," a time of the "declining significance of race" that has concluded with an abandonment of the very idea of race.[1] The idea that racial identity corresponds to some real substance in the physical world is generally understood to be a fallacy. And yet racism persists. Why?

Some have argued that seeing through the illusion of race is a good thing, that it serves as a prelude to the disappearance of racism. If we can just stop talking about race and stop seeing it everywhere then maybe racism will disappear. That is why so many anti-racist arguments start by insisting that races do not exist in nature, and therefore racism is completely irrational. How can anyone be a racist when there are no races? The assumption seems to be that if one just convinces people that race is an irrelevant, incoherent concept, then racism will go away.

We have had over thirty years of the post-racial era to test out this hypothesis, and it has been proven wrong. Perhaps the most dramatic evidence of this was the election of Barack Obama in 2008, declared by some as proof that race was no longer an issue in American politics. At the same time, it was fairly difficult to ignore the fact that Obama was subjected to an unprecedented assault of racist caricatures that revived "Sambo" stereotypes some thought were obsolete: the White House watermelon patch, Michelle Obama as a Black Power radical sporting an Afro, and the *New York Post*'s linking of the economic stimulus package to a slaughtered chimpanzee are the first examples that come to mind. Obama was routinely accused of being a secret Muslim and an illegal immigrant, and to this day his political opponents have treated his moderate, compromising nature with undisguised contempt.

It is time to see through race in a different way and to see the concept of race through to a new formulation, beyond the cul-de-sac of the post-racial era. My proposal is that we see race as a *medium*, an intervening substance, to take the most literal definition. Race, in other words, is something we *see through*, like a frame, a window, a screen, or a lens, rather than something we *look at*. It is a repertoire of cognitive and conceptual filters through which forms of human otherness are mediated. It is also a costume, a mask, or a masquerade that can be put on,

played upon, and disavowed. As such it is, of course, not exclusively a *visual* medium, but engages all the senses and signs that make human cognition, and especially *re*cognition, possible. The title of this book, *Seeing Through Race*, could just as easily have been *Thinking Through Race*, but the dominance of visual images and metaphors in racial discourse made the emphasis on seeing plausible. Seeing has a long history as a synonym for understanding and knowing, if you see what I mean.

The idea of race as a medium has been hiding in plain sight for a very long time, at least since W. E. B. Du Bois taught us to see race as a *veil* that mediates the perception of others while making possible a "second sight" into racism and the experience of racial difference. The following pages provide a second look, a double take on the concept of race in contemporary culture and politics, especially in those critical episodes that Barack Obama has called "teachable moments," when the need to make race thinkable in a new way becomes obvious. It seems clear that we still have a lot to learn about race and how to put it to work in the struggle against racism.

SEEING THROUGH RACE

TEACHABLE MOMENTS

Seeing Through Race consists of three lectures delivered under the title "Teachable Moments in Race, Media, and Visual Culture" at Harvard University as the W. E. B. Du Bois Lectures, April 20–22, 2010. They are accompanied by a supplementary quartet of essays, here entitled "Teachable Objects," that were written at approximately the same time and which I hope will serve to deepen the themes explored in the lectures, especially insofar as the question of race engages issues of images, media, and the arts—including the art of teaching—in the struggle against racism.

As its title suggests, "Teachable Moments" was based in Barack Obama's invocation of this phrase to identify events and episodes that offer themselves up for teaching and learning. Obama used it for the first time in connection with the controversy following the arrest of the W. E. B. Du Bois Professor of African American Studies at Harvard University by a Cambridge police officer in the summer of 2009. But Obama used the phrase explicitly or implicitly on a number of other occasions, usually moments of conflict in which he was "summoned" (as he likes to put it) by events to speak out on matters of broad public concern, especially those concerning race.

My notion in these lectures was to extend the range of Obama's remarks (which have an interesting place in scenes of

elementary education in the United States) to the more general question of race as a global issue in our time—our "moment," as it were. But what is our moment? Is it the Obama era itself, a time when progressive promises of hope and change were dramatically raised, only to be compromised by political realities? Is it the decade of the post-9/11 era when the world was plunged into the "Global War on Terror" that revived racial and religious conflicts which have deep roots in the relation of "the West" to the rest of the world, particularly the world of Islam and the Arab nations? Is it the longer *durée* of what is sometimes called the "post-racial" era, when the very idea of race has been called into question? Or is it, more narrowly, the "post-Black" era in the United States, after the period of Jim Crow and the Civil Rights Movement, when the racial divisions of America were supposed to have been healed, de jure if not de facto?

There is, of course, an even deeper question to be answered about the nature of a "moment" in the first place. What is a moment? The word oscillates between a sense of the trivial and ephemeral on the one hand, and a claim to the "momentous" on the other. Ranging between the expansiveness of an epoch, a period, or an era, and the singular, decisive character of an event, the moment is arguably the most elastic term in the lexicons of time and history. The science of physics hints at its usefulness in the concept of "moments of force," the "tendency of a force to twist or rotate an object," to apply what engineers call "torque" by bringing a set of vectors to bear on a common target. In this sense, the moment is what might be called a "turning point," but one that can range from the subtle and unnoticed to the game-changing event, the feeling that a change of momentum has occurred, that something has come to an end and something new has appeared. In recent history, the clearest symptom of the moment of torque has been the frequent invocation of "post-" as prefix, as in the postmodern, the

postcolonial, the posthuman, and of course, the post-racial. All of these terms name a sense that history has turned a corner but that the new era still remains to some extent unnameable. And this momentous turn can be (and often is) a shift in perception, the "dawning of an aspect" (as Wittgenstein put it) as much as any external event. That is why the idea of the moment engages so naturally with the practice of teaching, and with a pedagogy that does not necessarily know all the answers beforehand but is compelled to improvise with the contingent and the unforeseen.

I have tried to keep all these concepts of the moment in play in these lectures, but to center them around *our* moment, the recent past, when the racial characters of Blacks, Arabs, Jews, and Whites converged in a new constellation around the election of Barack Hussein Obama as president of the United States. Obama's name was immediately associated by his political antagonists not only with generalized racial groups but also with the proper names of Saddam Hussein and Osama bin Laden, the archenemies of the West, of Christian Europe, of the Jewish state of Israel, and (arguably) of "White Folks." Even more interestingly, Obama's election seemed to constitute a paradoxical moment, torquing between opposite vectors: on the one hand, it seemed to vindicate the claim that we are in a "post-Black" and possibly even a "post-racial" era; on the other hand, it seemed like a time in which the issue of race—the prospective topic of a long-awaited "honest conversation"—and racism itself was stronger than ever. The outpouring of racist imagery during and after Obama's election was striking in its vehemence and incoherence: Obama was routinely portrayed as a terrorist, an illegal immigrant, a usurping tyrant comparable to Stalin and Hitler, and a chimpanzee who would turn the south lawn of the White House into a watermelon patch. Obama responded to this by accepting the role of sovereign pedagogue, the master teacher who identifies the "teachable moment"—in this case,

events involving race and racism. This role was thrust upon him, and his best speech, the Philadelphia address on race during the 2008 campaign, was the one he did not want to give.[1]

At the level of theory, I want to torque the concept of race itself as the product of contrary vectors, treating it neither as an objective reality nor as a subjective illusion, regarding it instead as a *medium* constituted by the encounter of fantasy and reality. Instead of regarding race merely as a *content*, then, whether real or imaginary, that is mediated by forms of representation, I want to treat race as itself a medium in the most straightforward sense of the word—that is, as an "intervening substance" that both enables and obstructs social relationships. I also want to examine the way that the torquing of race transforms it from a merely abstract notion into what I call an "iconic concept," the merging of an ideational complex with individual and collective passions, congealed in forms of totemism, fetishism, and idolatry. This may strike some readers as a strange way to think about race, and perhaps also as an unusual way to think about media. Scholars who have tracked the long history of theorizing about race may, by contrast, regard the idea of race-as-medium as strangely familiar, even obvious. I hope that readers will exercise some patience and allow both the strangeness and familiarity of the concept to unfold itself over the pages that follow.

The other major argument that is developed in what follows is an effort to reconceive the relation of race and racism, and to develop a critique of what is sometimes called the "post-racial" moment. Although this book is firmly aligned with antiracist arguments and ethical/political commitments, it is in a certain sense pro-racial or pre-racial in its attempt to recover the usefulness of this concept as what Du Bois himself called "an instrument of progress." The reader, therefore, will not find the word "race" bracketed in scare quotes throughout, nor will there be much emphasis on declaring for the thousandth time that race

is "merely" a social construct, or "simply" an obsolete concept that has outlived its usefulness, or "nothing but" a myth that ought to dissolve under critical scrutiny. Instead, one should anticipate an argument that firmly erases the "merely" and "simply" and "nothing but" in favor of a patient attempt to analyze the way in which race mediates sociopolitical relations, and further, provides a unique and necessary conceptual mediation for a striking range of nature-culture dialectics, including the dividing lines between species, classes, genders, and nations.

Although race and racism will be discussed as universal phenomena, both translocal and transhistorical in some sense, the focus here will be on three specific forms of racism: Negrophobia, Islamophobia, and anti-Semitism. To put it another way, this book concerns three "peoples" that have sometimes been defined as races: Whites, Blacks, and "Semites" (i.e., Jews and Arabs). Hence the three-part structure of the lectures, starting with (1) "The Moment of Theory" (which could also be called the time of "White Mythology" and post-racial theorizing) followed by (2) "The Moment of Blackness" centered on the simultaneous decline and resurgence of Black racialization, and concluding with (3) "The Semitic Moment," focused on the half-century impasse known as Israel-Palestine. The emphasis in Part 2 will then shift from the *moment* and questions of historical temporality to *objects* and the spatial construction of racial difference, comprising four papers on images, media, and the imaginary-real borders of races and nations: (1) "Gilo's Wall and Christo's Gates"; (2) "Binational Allegory"; (3) "Migration, Law, and the Image"; (4) "Idolatry: Nietzsche, Blake, Poussin."

I have not attempted to disguise the oral character of the lectures by renaming them as chapters or erasing the sense of their immediate occasion in the spring of 2010, only a little more than a year after the inauguration of Barack Obama as president of the United States. There is something about that moment

that, to my way of thinking, deserves preservation as a time—a moment—that may itself be worthy of reflection, teachable beyond the pedagogical. Shortly after the historic passage of the first successful attempt to provide publicly financed health care for the people of the United States, it stands as a time replete with high hopes and deep disappointments, a "teachable moment" that we will be learning from in the years to come.

It also stands to me personally as a time when I was able to engage with some of the leading scholars of media, visual imagery, and the history and theory of race: Henry Louis Gates Jr., Homi Bhabha, William Julius Wilson, Stanley Cavell, Orlando Patterson, Caroline Jones, Werner Sollors, and many others honored me with their presence and their comments. I have also benefitted from the careful reading of numerous friends and colleagues, including Elizabeth Abel, Larry Abramson, Gil Anidjar, Lauren Berlant, Jonathan Bordo, Darby English, Ellen Esrock, Tanya Fernando, Robert Gooding-Williams, Stephen Korns, Lital Levy, Janice Misurell-Mitchell, Patrick Mullen, Richard Neer, Florence Tager, Alan Thomas, and Rebecca Zorach. Many of the revisions and second thoughts in these papers reflect their wise counsel.

THE MOMENT OF THEORY

RACE AS MYTH AND MEDIUM

My hope is that as a consequence of this event, this winds up being what's called a "teachable moment."

> —*Barack Obama, statement to the press, July 23, 2009, regarding the arrest of Henry Louis Gates Jr. by the Cambridge police*

The truth is that there are no races: there is nothing in the world that can do all we ask "race" to do for us.

> —*Anthony Appiah, "The Uncompleted Argument: Du Bois and the Illusion of Race"*

What is metaphysics? A white mythology which assembles and reflects Western culture: the white man takes his own mythology (that is, Indo-European mythology), his *logos*—that is, the mythos of his idiom, for the universal form of that which it is still his inescapable desire to call Reason.

> —*Jacques Derrida, "White Mythology: Metaphor in the Text of Philosophy"*

My mother bore me in the southern wild
And I am black, but O my soul is white.
White as an angel is the English child
But I am black as if bereaved of light.

> —*William Blake, "The Little Black Boy"*

It is a great honor to be invited to give the 2010 Du Bois Lectures, and one which I am quite certain I do not deserve. As Barack Obama observed on being awarded the Nobel Prize in the first year of his presidency, the honor is being conferred more as an act of hope than a recognition of achievement, and I

hope that these lectures will come at least part way in fulfilling those hopes. I hardly need to belabor the fact that I am not an expert on race, either as a historical or theoretical issue, and my credentials as a scholar of African American culture are quite minimal: my contributions in this latter area consist of a couple of essays on the films of Spike Lee, and one minor intervention on the question of memory and slave narrative.[1] Beyond that, my credentials as a scholar of race mainly rest on some investigations of space, place, and landscape that have focused on the deeply conflicted terrain of Israel-Palestine, a site where the issues of race are considerably complicated by a long history of religious conflict and colonialism.

Among my hopes in preparing these lectures was the thought that by taking up the vast topic of race and racism from a relatively distant, even innocent, perspective, I might be able to produce some insights that would be less than obvious to people who have been deeply immersed in these questions throughout their careers. The very disparateness of my previous work in this area might also, I thought, make it possible to say something about the very different texture of the problem of race in America, on the one hand, and the enduring global conflict between the West and the Arab world, focused in the racial and religious maelstrom known as Israel-Palestine, on the other hand. No doubt this is far too ambitious an agenda, but it is one that I hope can be useful even in its failure to achieve total comprehensiveness. At the very least, its comparative and international scope may help us to define more sharply the nature of race in relation to other forms of discrimination, and to grasp the interconnectedness of various forms of racism. I want to take seriously Franz Fanon's insistence that there is a deep structural and affective link between various forms of racism. Although "it might seem strange," remarks Fanon, "that the attitude of the anti-semite can be equated with that of the

negrophobe," he has never forgotten the lesson of his Antillean philosophy teacher who admonished him one day: "When you hear someone talk about the Jews, pay attention: he is talking about you."[2] I want to extend this lesson to Blacks and Jews and even to my own trace of Irish ethnicity: when they talk about Arabs and Muslims, they are talking about us.

My pathway into this complex subject is not, however, a direct one, and it is hard for me to imagine that anyone on Earth would be capable, on their own, of grasping it in its entirety. One way to limit the subject is to focus on specific historical moments in which the problem of race is dramatized with especial clarity, when racism, instead of concealing itself as it normally does, "rears its head" in a way that provides what Obama calls a "teachable moment," an event that provides an opportunity for sober reflection and not just passionate reaction.[3] At the same time, however, I want to raise some critical questions about the very idea of the "teachable moment." This is partly a question of the relation of particulars—events, cases, examples—to the generalized "lessons" that may be drawn from them. It is also a question about pedagogy and authority: Who is the teacher and who are the learners in the teachable moment? Because I have already declared the severe limits of my own teacherly authority on this subject, I will not presume to tell you very much that you do not already know about the subjects of race and racism. My aim will be more experimental and tentative, namely, to set out a few suggestions for reframing these subjects in a perspective that I do know something about: the fields of media aesthetics, visual culture, and iconology, the theory of images across the media and the arts.

I also want to call into question the paradigm of the teachable moment as such, insofar as it takes for granted that the aim is *only* to replace "passionate reaction" with "sober reflection." The teachable moment, as I am told by my students who

teach in elementary schools, is ordinarily understood as a rather paternalistic and parental event, an occasion for inculcating elementary lessons in civilized behavior—taking turns, asking permission, and respecting others. All these are important lessons to be sure, but I want to suggest that there is a more critical and interesting version of the teachable moment, when pedagogy fails and the lesson is unclear, when everyone has something to learn. In this version of the teachable moment, the teacher and her normative assumptions and lesson plans are thrown into confusion and doubt, and some form of "newness" (to echo Homi Bhabha) has a chance to "enter the world."[4]

I have written these lectures in the conviction that we are in the midst of a historically significant "teachable moment" in our understanding of race, racism, and racialization. This is a moment that is global as well as local, one that therefore produces new constellations of traditional racial identities such as (to name the peoples that will be central to my discussion) Blacks, Jews, Arabs, and White Folks. It is a moment characterized by a new dynamics of racialization grounded not just in visible signs such as skin color but also in the reconfiguration of kinship relations, citizenship status, and spatial (dis)location. It is, most emphatically, a moment when the paradoxical *unteachability* of the racial lesson seems to have reached a crisis, when on every side we hear declarations about the obsolescence of the very idea of race, while the symptoms of what can only be called racism seem, albeit under a veil of disavowal, to be as durable as ever. Everyone knows, in other words, that we are supposed to be in a post-racial moment, at the same time that they know in their hearts that racism is alive and well.

In the second and third of these lectures I will analyze a few selected events that may help us to understand "the moment of Blackness" in contemporary American culture, and "the Semitic moment" in contemporary Israel and Palestine. Needless to

say, both of these moments have long historical genealogies and broad geographical parameters. The contemporary status of Blackness can only be understood in relation to Africa and Europe as well as to America, and it stretches back well into the nineteenth century, where (as is well known) it was metaphorically interwoven with the fate of the Jews and the narratives of Zionism.[5] The status of "Semites" and anti-Semitism today can only be grasped in relation to the larger issue of what Gil Anidjar calls "the Jew, the Arab" in their larger relation to Europe and Christianity as well as America, and to the global reach of the contemporary "clash of civilizations" manifested in the so-called War on Terror, centered in the ongoing crisis of Israel-Palestine.

Before I move to these cases, however, I want to dwell on the "moment of theory" in our contemporary understanding of race, and here I return to the paradox I mentioned just a moment ago. We live in a time when race is widely regarded as a myth and an illusion, when we have finally gotten beyond the clichés of identity politics, racial "essences," and biological determinism and entered into a "post-racial era." At the same time, however, race has since the 1980s become a topic for philosophical reflection in a way that it never was before. As philosopher Paul C. Taylor puts it, "oddly, or perhaps not so oddly, philosophers have been relatively uninterested in race. Sociologists, anthropologists, and others have been thinking about it for quite some time, but only in the last few years have people like K. Anthony Appiah, Linda Martin Alcoff, and David Theo Goldberg taken up the peculiarly philosophical problems that arise from thinking about race-thinking."[6] I would qualify Taylor's remarks by suggesting that the new philosophical attention to race is to be found mainly in a specific tradition of Anglo-American philosophy, especially in its analytic, ordinary language, and pragmatist traditions. Certainly it would

be ludicrous to suggest that a topic of central importance to
W. E. B. Du Bois, Jean-Paul Sartre, Franz Fanon, and Michel
Foucault had somehow failed to count as "philosophical." But
perhaps Taylor is right to make the smaller point that in the his-
tory of discussions of *American* racism, it may be that the sub-
ject of race during the previous eras of Jim Crow and the Civil
Rights Movement involved such immediate practical urgencies
that there was no time for philosophy—or at least for the aca-
demic variety that he professes. Maybe our moment, the post-
racial era, is precisely the moment for race theory. I very much
doubt that this is an adequate explanation, but it may be useful
to begin by stating the obvious, if only to question it.

The theoretical framework that I want to bring to the sub-
ject of race is not, strictly speaking, philosophy, but what Fred
Jameson has distinguished by the name of "theory"—a form
of general reflection that, in contrast to most branches of phi-
losophy, is critically aware of its own mediation by language.[7] I
have elsewhere attempted to expand this definition by enlarging
the reach of theory to include nonverbal media, including the
visual arts, cinema, and performance, as not merely objects for
theoretical reflection, but themselves as forms of nondiscursive
theorizing. I call this "medium theory" in order to emphasize
its location in a middle place between "high" and "low" theory,
between empiricism and a transcendental reflection, and to dif-
ferentiate it from "media theory," which is mainly concerned
with modern forms of mass media as an object of study.

I don't expect it will surprise anyone to learn that the emer-
gent field of visual culture has quite a bit to say about both the
visible stigmata of race and the invisibility of what Charles W.
Mills has called "the racial contract" that underlies it.[8] Or that
iconology, the study of images, would have something to con-
tribute to a subject that is so centrally involved with questions
of stereotype and caricature, and with the entire range of images

that provide templates of otherness and enmity. Or that media studies, finally, provides an even larger horizon of frameworks for understanding race as a multisensory and multisemiotic field of investigation, one that includes music and performance as well as verbal and visual representation, and is open to technical innovation and (at times) the return of seemingly obsolete, archaic media such as blackface and the minstrel show, the art of the silhouette, or the veiling of women and the hooding of men.

What I do hope to suggest, beyond these rather obvious issues, is to draw a somewhat less obvious conclusion from them: that race is not merely a content to be mediated, an object to be represented visually or verbally, or a thing to be depicted in a likeness or image, but that race is itself a medium and an iconic form—not simply something to be seen, but itself a framework for seeing through or (as Wittgenstein would put it) seeing *as*. This point is most explicit in the visual language of race, which continually invokes the figures of the veil, the screen, the lens, the face, the mirror, the profile, line and color, and its paradoxical fusion in the figure of the "color line." Du Bois's metaphor of the veil is so powerfully influential in discussions of race precisely because it seems to condense in one vivid figure so many of the fundamental contradictions of race understood as a medium. The racial medium is thus "an intervening substance" (s.v., *Oxford English Dictionary*) that can both obstruct and facilitate communication; a cause of misunderstanding and blindness, or conversely, a mechanism of "second sight"; a prosthesis that produces invisibility and hypervisibility simultaneously, as Ralph Ellison's tale of the invisible man tells us. Or it is constituted as a transparent medium of deceptively self-evident perceptions, as in Du Bois's comparison of race to a "thick sheet of invisible but horribly tangible plate glass" through which people can *see* but not *hear* or *touch* each other.[9] Beyond the question of mediated sights and sounds, the medium of race is

constituted as a "material social practice," as Raymond Williams put it, that is manifested at every level of human life, from dress to cosmetics to hair to diet to the carriage of the body, at the same time that every effort to grasp the concrete objecthood of race as the hidden cause behind these practical, visible, and tangible manifestations seems to vanish and dematerialize the closer we come to it.[10]

In treating race as a medium, then, I do not pretend to resolve the question of its reality as a natural or cultural thing, a real object in the world or a collective fantasy.[11] Against Anthony Appiah's famous argument that "the truth is that there are no races" (seen by many as inaugurating the "post-racial era"), I want to argue that race is *both* an illusion *and* a reality that resists critical demolition or replacement by other terms such as ethnicity, nationality, civilization, or culture.[12] The notion of race-as-medium, in fact, relieves us of the necessity of a decision between these alternatives, allowing us to understand the racial medium as (like any other medium) a vehicle for *both* fantasy *and* reality. Contrary to Appiah's claim that "there is nothing in the world that can do all we ask 'race' to do for us" (35), the truth is that there is *nothing else* in the world, or in language, that can do all that we ask race to do for us.

Appiah would argue, I'm sure, that the word and the (for him) incoherent concept of race have done far too much in the world already, serving as the alibi for racism and (at its worst) a scientific pretext for slavery and genocide. The entire post-racial tradition of theorizing that he helped to inaugurate is motivated, in my view, by a vigorous critical opposition to racism that I share wholeheartedly. Appiah is followed (although strangely, not cited) by sociologists such as Robert Miles, who characterizes the abandonment of the race concept as a form of intellectual emancipation: "We are free," he declares, "to analyse the origin and consequences of racism without the distorting prism

implanted by the use of the idea of 'race' as an analytic concept."[13] But who exactly is freed by the post-racial discourse and the abandonment of race as a concept? Both Miles and Appiah make it clear that this is an intellectual emancipation; for Miles, as a Marxist intellectual, it frees him to study racism "within the historical matrix . . . of the capitalist mode of production" (21). For Appiah, the liberation is from illogical thinking and the mystifications of pseudoscience. It is an attempt to complete the "incomplete argument" of Du Bois, who famously spent his entire life struggling to articulate a positive concept of race. Even more important, Appiah believed that "the argument [is] worth making because I believe that we—scholars in the academy—have not done enough to share it with our fellow citizens" (35).

The question then remains: Why do our fellow citizens, not to mention our government and laws, continue to behave as if race still matters? Why can't they understand, as Miles argues, that races do not exist, that race refers to nothing in the world, and that the whole idea has been thoroughly deconstructed? One could provide a deconstructionist answer, and point out that Jacques Derrida always distinguished deconstruction from destruction as a way of *sounding* a concept rather than smashing it. Deconstruction is "not the demolition but the de-sedimentation . . . of all the significations that have their source in that of the logos. Particularly the signification of *truth*."[14] Or one could focus on Miles's own characterization of race as a "distorting prism implanted by the use of the idea of 'race' as an analytic concept." One could understand race as a medium—a "distorting prism"—that requires careful description and analysis, and not a dismissal in favor of some notion of transparent, unmediated "truth."[15] One might find a way to complete Du Bois's incomplete argument by understanding that it was always driven by a desire to affirm race while negating and opposing

racism, a desire that could only be articulated as an endless vac-
illation between the categories of science and the sociohistori-
cal, between nature and culture. Du Bois's whole intellectual
career, described so well by Appiah, could then be seen as a
heroic attempt to *mediate* these antinomies.

In reframing race as a medium, it may be useful to introduce a
modified version of Jacques Lacan's famous triad of psychologi-
cal and semiotic "registers": the Symbolic (the realm of law, lan-
guage, and negation or prohibition); the Imaginary (the domain
of images, fantasy, and visual experience and the positing of
projected illusions), and the Real (the unrepresentable territory
of trauma). But I would like to add a fourth term, "Reality," to
the Lacanian scheme. Race in this framework emerges as a real-
ity that is constructed out of the Symbolic and the Imaginary—
that is, out of words and images, the sayable and the seeable,
discourse and concrete things, spaces and institutions, prohibi-
tions and taboos, on the one hand, and sensuous experience
on the other. This is a reality, then, that has to be understood
as *precarious*, depending, in Slavoj Zizek's words, "on a deli-
cate balance between reality-testing and the fantasy-frame."[16] In
other words, the perception of race is a constant interweaving of
projections and impressions, empirical experience and halluci-
natory effects. In this sense race is, like gender, sexuality, class,
species, or any other form of recognition and misrecognition
of an other, a product of the braiding together of objective and
subjective capacities, raw data and search templates, actual per-
sons and schematic stereotypes. Fantasy or imagination is *not* in
some kind of simple antithesis to reality but, in fact, is the nec-
essary framework in which any kind of reality testing could take
place. That is why, as Homi Bhabha points out in his essay "The
Other Question," the racial stereotype is not merely the inert
content of hallucinated perceptions but a catalyst for repetitious
confirmation, as if the perception of race could never be satisfied

that it has a grip on its object but must continually seek, test, and of course, all too often reject new evidence.[17]

The precarious reality of race as a weaving of disparate elements into a complex and shifting totality is captured quite accurately in the pre-Enlightenment understanding of the concept of racial "complexion." As Roxann Wheeler points out in her brilliant book *The Complexion of Race*, "skin color and race as we know them today have not always been powerful tools to convey difference." Before it was reified as a synonym for skin color, "complexion" reflected its etymological roots as a *complex*, a "weaving together" of elements of "temperament or disposition; it arose from the interaction of climate and the bodily humors (blood, bile, phlegm, and choler). Skin color, then, was only one component of complexion."[18] A medium, similarly, is always complex, a weaving of materials, practices, techniques, and effects—a "material social practice," to return to Raymond Williams's classic definition.

Race, then, is most emphatically *not* in the position of what Lacan called "the Real"; it is rather a matter of constructed, mediated, represented "reality"—visible, audible, and legible.[19] The Real, by contrast, is the unrepresentable gap or blank space that opens up when the medium is fractured, when the Symbolic and Imaginary tear apart, the site of affect and the effects of trauma. The Real, as you have probably surmised, is the location not of race but of rac*ism*. Racism is what hurts. It is the disease, possibly an autoimmune disorder and certainly an infectious malady. Race is the ambiguous medicine/poison, the *pharmakon*, for inflicting or alleviating the pain caused by racism. Race is the set of symptoms or signs—the diagnostic tool—that provides access to the disease known as racism.

In saying this, I follow the brilliant intuition of Jean-Paul Sartre in arguing that anti-Semitism (and racism in general) "is something quite other than an idea. It is first of all a *passion*."[20]

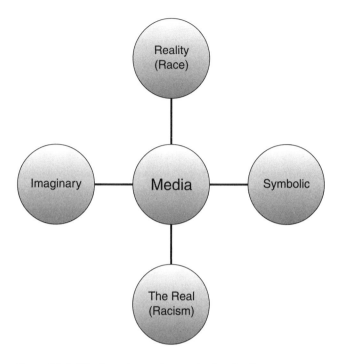

Figure L1.1. The Lacanian registers, plus "reality."

This does not mean, of course, that racism remains only a passion, confined to the bodily reactions of disgust and horror. It is, as Sartre goes on to argue, a nourished and nurtured passion, a paradoxical love of hatred that evolves into "a conception of the world" (17) that "may be expressed by statements of reasonable tenor, but which can involve even bodily modifications" such as impotence or revulsion—"an involvement of the mind, but one so deep-seated and complete that it extends to the physiological realm, as happens in cases of hysteria" (11).

To Sartre's insight I want to add a reflection on the grammar of the very terms that designate the phenomena of race and

racism. We are misled, in my view, by the deceptive form of the pairing of race and racism, as if they had the same relationship as matter and materialism or ideas and idealism.[21] In these latter cases, we tend to think of the root term as primary and the "-ism" as the derivative phenomenon. It is because there is a material, physical reality in the first place that we construct a conceptual or ideological edifice deriving from this brute fact, and we call it "materialism." With race and racism, it is exactly the opposite. Racism is the brute fact, the bodily reality, and race is the derivative term, devised either as an imaginary cause for the effects of racism or as an attempt to provide a rational explanation, a "realistic picture" and diagnosis of this mysterious syndrome known as racism. Race is not the cause of racism but its excuse, alibi, explanation, or reaction formation. Race, to return to the Lacanian schema, is the Symbolic-Imaginary construction of a fragile "reality" to explain, contain, and manage the Real known as racism, and sometimes to unleash it in unimaginable acts of violent hatred.

There is no question, therefore, that the concept of race is inevitably contaminated by racism and that this is an essential part of its dark history, as if there were a kind of leakage between the passion and the idea, the Real and the reality. That is why race is not a mere abstract idea but an "iconic concept," a word and notion that functions as a kind of talisman filled with magic, a power recognized in the vernacular expression "playing the race card" as a kind of shape-shifting joker that can take the place of any card that has a fixed, legible identity. The work of artist-philosopher Adrian Piper is particularly eloquent on both the shape-shifting character of racial identity, especially in the phenomena of her own experience in and refusal of racial "passing," and in the moment of fatal denomination as "Black" or "White."[22]

I will return to this issue in the pages that follow as I examine the process by which race is "condensed" and "thickened"

in a way that transforms it from a medium to be seen *through*—a frame for seeing *as*—into a form, image, or object that takes on sensuous properties and a life of its own. Racism may be, as Derrida famously claimed, a perversion of the "talking animal,"[23] but it is also a perversion of the *seeing* and perceiving animal, deeply inscribed in the sensorium where it is reinforced, elaborated, and (I would argue) deconstructed by the discourse on race.

Foucault put the matter very clearly: "The relations between the visible and invisible—which is necessary to all concrete knowledge—changed its structure, revealing through gaze and language what had previously been below and beyond their domain."[24] Knowledge—of disease, madness, race, sexuality, or power—is a woven texture of the seeable and sayable, the visible and the articulable, images and words. The model of race as a symbolic-imaginary, verbal-visual complex is thus not merely a psychological matter, but a public and palpable feature of the material world, of the epistemological and historical field in which knowledge is constructed. "Knowledge," notes Gilles Deleuze, "is defined by the combinations of visible and articulable that are unique to each stratum or historical formulation."[25] It is manifested in the systems of statements (both common sense aphorisms and formal laws) and the bricks and mortar that make up everything from segregated neighborhoods to apartheid walls and checkpoints.

When I invoke Lacan's dyad of the Symbolic-Imaginary as constitutive of a *reality*, then, I am thinking of these terms in relation to Foucault's "seeable and sayable," the strata of institutions and statements, buildings and regulations. As the English poet William Blake puts it: "Prisons are built with the stones of law. Brothels with the bricks of religion." Race is built with the bodies of myths as well as myths about bodies, and it is constituted as a reality that cannot be erased by fiat. That is why we *see*

and *recognize* racial identities and accompany them with statements and narratives, and why the notion that we can be "color blind" is so problematic. From a psychoanalytic standpoint, in fact, color blindness might be seen as a form of what Freud calls "scotomization," a psychic disavowal equivalent to a "blind spot."[26] As John L. Jackson Jr. argues, "color blindness . . . might feel psychologically helpful in the short term . . . but will only prove socially and politically catastrophic over the long haul."[27]

If it makes sense to think of race as a medium, then, it will be important to further stipulate that it is not only a visual, bodily, and spatial medium. It is a *time-based* medium that both has a history and itself narrates a history. The best way to put this briefly is to state what has now become a commonplace among so-called post-racial theorists, that race is a myth. Walter Benn Michaels, among others, has put this in the most emphatic terms by arguing that race is an obsolete and useless concept, the only function of which is to distract us from the real and much more important issue of economic class. "The dominant scientific view now is that race is a 'myth,'" argues Michaels, a phantom concept that may, like phlogiston, have once had a certain credibility in nineteenth-century science but which has long since been emptied of all cognitive content and is now merely a relic of a benighted era.[28] Versions of Michaels's argument are common among race theorists. Analytic philosophers from Anthony Appiah to Paul Gilroy to Joshua Glasgow argue that "race is an illusion unworthy of our credence" (Glasgow, 1) that should be retired from discourse and replaced with something more rigorous and cognitively appropriate. These theorists are generally unimpressed with the move from biological to social constructivist theories, which they feel simply evades the problem by dispersing race into an endless laundry list of characteristics such as ethnicity, nationality, and the catchall notion of "culture."

These arguments all have varying degrees of force, but they miss, I think the major problem to be explained in the so-called post-racial era, and that is the *persistence* of race as a political and economic issue, as well as a term linked to the all-too-durable phenomenon of *racism*. Sartre's reflections on anti-Semitism include the claim that "the Jew does not exist" as a real, essential thing in the world, but he was equally convinced that anti-Semitism was very real indeed. Similarly, Fanon states baldly that "the black man does not exist," while arguing strenuously for the very substantial existence of Negrophobia. If race is a myth as well as a medium, then, it seems to be very difficult to make it go away. Even Joshua Glasgow admits that although "the concept of race seems irredeemably corrupted," it remains curiously "too valuable to do without" (1).

My conclusion, then, is that race is indeed a myth but one that, like all myths, has a powerful afterlife that continues to structure perception, experience, and thought and to play a real role in history. Myth, as Northrop Frye noted long ago, is a kind of master narrative, literally translated from its Greek origins as "a song about a god." And like all the Greek gods, therefore, it involves the personification of a passion, and in this case, an epic poem about the fortunes of the passion known as racism. When a literary scholar like Walter Michaels declares that race is a myth, then, it is important to remind ourselves what literary scholars have known for a very long time: A myth is not simply a false belief, an epistemological mistake. It is a powerful story that endures over many generations, subject to endless reinterpretation and reenactment for new historical situations. It may have the cognitive status of a pseudohistory on the order of the classical Ages of Man or the Enlightenment's "state of nature" leading to various forms of "social contract," but it also has the status of a real force in history and in the unfolding history of thought.

Alongside the myth of race, then, there is a countermyth of a world without race, a world where the word and the idea no longer have any role to play, where we have "seen through race" and the illusory, fantasmatic character of the concept has been exposed. This is what Derrida called "White Mythology," the production of a metaphysics of pure reason and Enlightenment: "The white man takes his own mythology . . . for the universal form of that which it is still his inescapable desire to call reason."[29] Blake's "The Little Black Boy" offers the most eloquent poetic deconstruction of this mythology, expressing it in the voice of an innocent Black boy who parrots the lesson of White Mythology—"I am black but O my soul is white"—and then retracts it by revealing Whiteness itself as a racial identity. The body of the "little English boy" whose Whiteness is supposed to indicate his angelic, non-racial character is revealed to be just as much a "cloud" as the "shady grove" of Blackness. "When I from black and he from white cloud free," says the Black boy, then we will *both* dance around the "Tent of God." But blackness or opacity, surprisingly, will not completely disappear in this heavenly, enlightened realm, but continue to play a role as a shelter from the divine heat and light:

> I'll shade him from the heat till he can bear,
> To lean in joy upon our fathers knee.
> And then I'll stand and stroke his silver hair
> And be like him and he will then love me.

It turns out that the Black boy's *soul* is not White, but darkened into a shade by its learning to "bear the beams of love." The Black boy has passed through what Keats would have called the "Vale of Soul-Making" (a nice euphemism for the suffering of negritude and slavery) and developed a protective veil (to echo Du Bois's formulation) that provides him with second sight, and the White boy with shade. The White boy's whiteness, by

contrast, is a sign not of his closeness to God but of his distance. His sheltered bodily life, exempt from the stigma and stigmata of race, renders him vulnerable and unprepared at the moment of encounter with the heat and light of divine justice. The "English child" may have been "white as an angel" in his earthly life, but his apparent exemption from race turns out to be an illusion. The twists and turns of this little story may help to make it clear why the post-racial era of the last quarter century is also the time when "Whiteness" was at last revealed as a form of racial identity.[30]

The space-time coordinates of race as medium and myth are powerfully condensed in the most durable definition of the concept of race as what philosopher Paul Taylor calls "race-talk" and "race-thinking." For Taylor, "'race-thinking' is a way of assigning generic meaning to human bodies and bloodlines" (15). These are invariably the two dimensions of race and racial identity. On the one hand, the spatial medium of race designates the outward physical body in its material presence in space, as both a seen and heard object, a visible and acoustic image or impression—skin color and voice, physiognomic profile and audible presence.[31] On the other hand, the temporal mediation of race is carried by narrative, genealogy, and tales of ancestry: the invisible medium of blood, transmitted from generation to generation, remediated and reinforced by memory and history. It is no accident, as Skip Gates has shown, that at the very same moment the notion of a *genetic* definition of racial identity has been almost completely discredited by contemporary biology, the tracing of racial *genealogy* and the multiple strands of ancestry that converge in every human being has never been more exact.[32] The question to be answered by the temporal racial profiling offered by genealogy is not so much "what are you?" but "*who* are you?" or, to put it in the vernacular: "Who's your daddy and your mommy?" In this regard, then, it may be

important to question Appiah's claim that Du Bois's references to "common blood" are a kind of backsliding into biological notions of race. Appiah believes that Du Bois was confused about this, imagining that he had achieved a "sociohistorical conception of race" when in fact he treats the bloodline as a crudely physical reduction:

> [Du Bois's] references to "common blood"; for this, dressed up with fancy craniometry, a dose of melanin, and some measure for hair-curl, is what the scientific notion amounts to. If he has fully transcended the scientific notion, what is the role of this talk about "blood"? (25)

But Du Bois's concept of "blood" is not especially scientific; it is more accurately seen as a metaphor for *kinship*, which is exactly the parameter of race that turns it from a spatial, visible, and physiognomic medium to a temporal one configured around narrative, memory, history, and (of course) a genealogy with its tales of ancestry. "Blood" is not a uniquely scientific category; it is vernacular biology and thus biopolitical in the perfectly ordinary sense of parenting, reproduction, and filial relations. Every time Black people address each other as "brothers and sisters" they invoke this vernacular sense of common ancestry and reinforce the racial myth that is the temporal dimension of the racial medium.

It is important to note here that Taylor does not quite say that body and blood are the essential elements of race as such. They are, rather, the essential ingredients of *race-talk* and *race-thinking*, which in his view come to pretty much the same thing.[33] As a Deweyan pragmatist, Taylor is concerned with practical reality, not with ontology and metaphysics. What he calls "the language of race" is the crucial issue, not the nature of race itself. But suppose the language of race is all there is? Suppose the relation of language and race is not one of signifier

to signified, not a matter of a medium that represents an object in the world or in the mind, but a more tightly interfused analogy. Taylor comes very close to making this claim when he notes that "the analogy between race and language . . . points us toward another reason to focus on race-talk instead of on the things that the talk points us to" (13). But suppose the "things" that race-talk points to—bodies and bloodlines at the most abstract, but actual practices, institutions, and events as well—are not simply "things" but media in their own right? "Race-talk," Taylor notes, "has been one of the principal media of modern Western society and culture." But suppose it is not just the "talk" but what the talk is about that has the status of a medium.[34] The body, for instance, is not merely an object in the world but, as Taylor notes in a happy phrase, a "medium-sized" object, and one which is "always already" a "bearer of meaning. They wait like paper to be inscribed with meaning" (15). And these meanings need not be exclusively linguistic. Bloodlines are not drawn with syringes but with stories, portraits, and family trees. The collapsing of the distinction between race and language does not mean that race is "just talk" but that it is also performance, and music, and narrative, events, episodes, and epochs—in short, bodies that feel and blood that flows—by way of memory and genealogy—from one generation to the next.

If race itself is a medium and not just the thing represented in a medium, then perhaps we can stop putting it in scare quotes to demonstrate that we are at every moment aware that it is "nothing but a social construction" or "merely a myth" in the sense of a false belief.[35] What I am proposing here would retain these formulations minus the diminutive, apologetic terms of "nothing but" and "merely." It would understand race as a critical component of social reality and (like all other media) a formation subject to historical change. After a long period in which

the important thing was to debunk and deconstruct the reality of race, could it be that we are now on the threshold of a new "conservation of the races," to echo the memorable phrase of W. E. B. Du Bois?[36] Could it be, since we are now in a "post-racial era," that we can find a way to be against racism while regenerating the concept of race itself?[37] And could this development be, in turn, related to a similar phenomenon that is widely recognized in the field of media studies, namely, the paradoxical claim that we are in what Rosalind Krauss has called "the post-medium condition" at the same time that we are immersed in the greatest period of new media invention since the onset of the printing press and the nineteenth-century revolution Walter Benjamin called "mechanical reproduction"?

If so, we would then need to ask what the revolutions in the concept and reality of race have to do with the parallel revolutions in media in our time. I have argued elsewhere that we have now passed beyond the age of Benjamin's mechanical reproduction into a new era of "biocybernetic reproduction" in which two scientific breakthroughs, the invention of the computer and the deciphering of the genetic code, have created a radically new media environment for politics, aesthetics, and of course, the medium of race.[38] We need to ask ourselves, therefore, what the effect of things like the Internet, DNA analysis, and asexual reproductive technologies such as cloning have done to that peculiar combination of fantasy and reality that goes by the name of racial identity. The most obvious answer is that the new media have reinforced the deconstruction of race as *both* a biological and social concept. In *Digitizing Race*, Lisa Nakamura notes that the invention of the Internet in the 1990s coincides with the rise of the Clintonian neoliberal consensus that it was best to abandon the Democratic Party's historic commitment to racial equality "in favor of concerns that were perceived as more 'universalistic.'"[39] Critical race theorists Michael Omi and

Howard Winant summarized the alleged obsolescence of race-talk in the aftermath of the race riots provoked by the beating of Rodney King in 1992: The "neoliberal project avoids (as far as possible) framing issues or identities racially. . . . To speak of race is to enter a terrain where *racism* is hard to avoid. Better to address racism by ignoring race, at least politically."[40]

The decline of racial identity in the 1990s is thus reinforced by the tendency of new media to undermine both medium specificity and personal or physical identity, either as a matter of bodies or bloodlines. The new men and women of the cyber age are creatures of racial, sexual, and gender mobility. The same is often said of medium specificity. Friedrich Kittler argues, for instance, that the invention of the computer provides a common platform which undermines the distinctiveness of cinema, sound recording, and the keyboard interface, dissolving all medium specificity into streams of ones and zeroes, just as the discovery of DNA dissolves racial specificity into a network of codes that may have little to do with a subjective sense of identity. The Internet provides infinite opportunities for anonymous role playing and the adoption of avatars whose racial and sexual identity is completely fabricated and mutable. Asian Americans become the "model minority" with "their low usage of welfare and political docility," not to mention the stereotype of Asian computer geeks who have "overcome the barrier of color . . . to become model consumers of commodities as well as creators of economic value."[41] But the new dominance of "color blindness" had the predictable effect of instituting a new version of Du Bois's veil.[42] The derealization of racial identity, manifested most spectacularly in Michael Jackson's morphing performances and plastic surgeries, was accompanied by undiminished forms of de facto racism, domestically in the continued economic degradation of the Black underclass and internationally in the opening of a post–cold war crusade

against the Arab world with a racially divided country known as Israel-Palestine at its symbolic center. While American consumers played games of identity masquerade and tourism, and the United States congratulated itself on being "the multiracial leader of a multiracial world,"[43] the lingering disease of racism was preparing to metastasize into new forms.

What are those new forms? A better question might be, *where* are the new forms of racism? What social groups and categories have now been installed in the position of the racial other to be controlled and excluded, or (perhaps even more important) the racial *enemy* to be defeated? Some obvious candidates immediately spring to mind, defined by ethnicity, religion, national origin, or simply on moral and behavioral grounds: African American men, whose incarceration rates constitute a de facto version of Jim Crow;[44] Arabs, Muslims, immigrants, and terrorists, and others who threaten U.S. interests on the "front lines" of the War on Terror, whether it is located in Iraq, Afghanistan, Pakistan, Yemen, or the Mexican and Canadian border. The thing that is notable about this list is how miscellaneous and incoherent it is. Anyone, it seems, is now a candidate for racialization—that is, for characterization as a group whose bodies, psyches, and bloodlines are seen as inimical to the "real America" that is routinely invoked by political figures like Sarah Palin. If in Europe the primary fear is of the "new Moorish conquest,"[45] in the United States the most conspicuous candidates for American racialization are Hispanics or Latinos, who come from a wide distribution of national origins and who are united mainly by language, but who nevertheless have been "blackened" repeatedly in contemporary immigration debates, just as the Irish were in their day. A recent book explains how the United States racializes Latinos through the familiar stereotypes of criminality, illiteracy, and immorality.[46] The flip side of this process is the way the mass media discusses the new

masses of unemployed, uninsured, and homeless Americans by insisting that they are "just like us"—that is, they are not "other," not colored, not foreigners, but real Americans, which is to say, White folks. Why is it so important to stress the Whiteness of the victims of the Great Recession? Is it not because the default position of American racism would be to assume that if people are poor, unemployed, and in need of government aid, they must be some kind of racial other? This recession, then, must be taken seriously because it affects us White folks.[47] Black folks, as usual, need not be racialized; they are securely locked in the ghetto by their visibility and by the continued force of institutionalized forms of racism that are easily disavowed in an era of post-racial consensus. After all, haven't we just elected an African American president? What more proof do you need that we live in a post-Black, if not post-racial era?

The process of racialization becomes even more virulent when it is focused, not just on the other, but on the *enemy* who threatens "the American way of life." This is where the Arab and the Muslim comes in, and where Islamophobia joins forces with the syndrome Edward Said identified as "orientalism," to reinforce the stereotyping of Arab cultures as irredeemably violent, corrupt, irrational, and hostile to the values of Western civilization. If we try to give a visible face or a profile to this enemy, however, it is notoriously elusive. There are too many blue-eyed and light-skinned Arabs; too many Arabs and Jews look alike; and the jihadist doesn't even necessarily have an Arab name. The stereotype of the terrorist, then, becomes one of anonymity and facelessness, the ski-masked warrior or the "friendly" native who turns out to be carrying a suicide bomb under his or her clothing.

The master image of alterity and enmity in our time is the biopolitical metaphor of the clone. Throughout the post-racial era, this cultural icon has epitomized the convergence of

computational and biological science and the deconstruction of singular biological identity by processes of indefinite replication and reproduction. The clone provides the radical zero-degree of otherness in the terrifying figure of the uncanny double, the self as its own worst enemy, and the enemy as an endlessly self-reproducing life-form as expressed in the metaphorics of viruses and sleeper cells.[48] It may turn out that similarity is more dangerous than difference, that homophobia—literally, the fear of likeness—and its post-racial counterpart, clonophobia, is even more threatening than any anxiety about the sexual other.[49] In the meantime, the anonymous, faceless racial other is the posthuman artificial duplicate who stalks over a hundred Hollywood films during the past twenty years.

One can see, then, how the post-racial era unleashes an epidemic of racialization, in which a variety of ethnicities and identities are mobilized to satisfy what looks like a structural need for an Other and an enemy. Carl Schmitt's contention that "the specific political distinction to which political actions and motives can be reduced is that between friend and enemy"[50] seems to become an even more operative requirement when there is no stabilized and familiar racial other or enemy to be relied on, no reliable "color line" that can be policed. The anonymous enemy who could be anyone and anywhere, who could be sitting next to me on an airplane or hiding in a cave in Tora Bora, becomes the political enemy whose elusive presence justifies the continual expansion of the national security state and its appropriation of increasing emergency powers. More and more power accrues to the sovereign in the state of emergency, and practices such as torture, assassination, and the bombing of civilian populations are justified as necessary for "exceptional" times.

We are forced to ask, of course, what use the concept of race can have in an era when it is widely regarded as a mythical notion in the simplistic sense of a false idea and when anyone,

no matter what his or her skin color or ancestry, can be racialized. Could the post-racial era turn out to be, paradoxically, the pan-racial era when everyone is ethnicized, subject to racial marking, when Whiteness itself is revealed as a racial identity? This hypothesis would fit, of course, with Richard Dyer's exploration of Whiteness, Nell Painter's *History of White People*, and Walter Michaels's genealogy of the "souls of white folk,"[51] but it would be in danger of evacuating the whole concept of race and reducing it to the status of anyone who is "minoritized" or simply regarded as an object of prejudice. Under these conditions, is there anything left to conserve of the concept of race?

My answer is: Yes, everything must be conserved. The whole unfolding of the conception of race as a scientific and political-cultural concept must be remembered and reframed, especially at a time of racialization run wild. We need to totalize the concept of race in Sartre's sense of understanding it as a determinate "complexion" or convergence of multiple vectors in thought and practical activity, as well as a window into the subtle and intricate dynamics of racism, which is, as no one denies, alive and well. Race-thinking and race-talk have to continue, then, as a pragmatic account of a language game, not an ontological one—unless we understand ontology as a "being in the world" and not some timeless, transcendent ground of being. We must understand race as an operational concept tied to racialization as a both a systematic and an ad hoc process, and understand racialization as a procedure that reduces peoples to populations and "bare life," demotes them in the hierarchy of civilizations. A race now must be understood as Sartre grasped long ago, as a product, not a cause or source, of racism. And it must preserve the two essential features of the race concept as it has evolved historically, namely, the media of bodies and bloodlines, the spatial and temporal axes of the racial concept. The racialized body, then, would be regarded not as necessarily

tied to a specific color or a profile, much less a genetic code, but to any colorization or profiling or coding that suffices to mark an individual as belonging to an identifiable group. Kara Walker, for instance, depicts all bodies as black silhouettes, eliminating the color line in favor of the lineaments of physiognomic profiling, the contours of the silhouette. All her figures are thus racialized, although some must be read as figuratively and representationally White even though they are literally and materially black. And the racialized bloodline would simply be a question of real or imagined genealogy, not genetics.

How could we go about totalizing the concept of race as a product of race-talk and race-thinking, as well as a critical response to the reality of racism? My solution is to understand race as a concept that is traversed by four different moments of force—teachable moments in the sense of "vectors." Two of these we have already identified in the dialectic of bodies and bloodlines, bodily "schematisms," to use Fanon's terms, and historical genealogies. But these terms operate within a conceptual force field defined by the intersection of two axes, the biopolitical and the sociopolitical, or what Donna Haraway calls "nature-culture." On the nature axis, we find the biopolitical tendency to naturalize human relations as elaborate forms of animal behavior defined by categories of sexuality, gender, reproduction, and (at the limit) species identity. The sociopolitical axis, by contrast, is dominated by the categories of culture (including language, religion, and customs) and class (including the power relations of colonialism and, at the limit, slavery). Race, then, instead of being regarded as a univocal or essential concept with a fixed definition, becomes a *complex* or (to recall the premodern language of race) a *complexion* of these forces.

Du Bois comes very close to saying this when he summarizes the illogical and contradictory character of the "race-concept" and admits that "perhaps it is wrong to speak of it at all as a

'concept' rather than as a group of contradictory forces, facts, and tendencies" that it was his life's work to "rationalize" and make into a concept.[52] Race-thinking finds racism located in the vortex at the center of what I want to call a "compass of race" whose magnetic poles are the unsurpassable difference between nature and culture. I know it will be thought imprudent to say this since cultural studies has so firmly established that there is no more nature, just as there is no more race (and never was) and no such thing as medium specificity. But cultural studies was wrong about all these claims. Or rather, it won too much by conceding that there could be such a thing as "second nature," a deep and abiding cultural formation that would *count as* a natural way of life for a people or community and that, despite all our sophisticated disavowals, *first* nature would continue to assert herself in the face of human efforts to control her.

If we position race at the center of a compass of cognate and antithetical terms, then we find a familiar set of relations, each of which produces a distinct inflection in the concept of race. The most radical and virulently racist is, of course, the cold North Pole of species difference in which the racial other is treated as a brute, reduced to bare life, and subject to extermination and

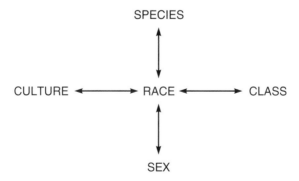

Figure L1.2. A compass of race.

genocide. This vector tends to treat races as what Ian Hacking calls "natural kinds," which they most certainly are not, and also to pick out racially identified populations as "statistical kinds" (which they sometimes are) that display medically significant differences in susceptibility to certain diseases.[53] The Holocaust provides the twentieth-century paradigm of the racist model, but it has abundant successors in contemporary strategies of ethnic cleansing and the accelerated production of stateless persons who live in internment camps.[54] None of these forms of racial discrimination relies upon the long-discredited "racial sciences" of the nineteenth century or their Nazi followers. They are perfectly content with vernacular expressions or the abuse of statistics, as in the notorious argument of *The Bell Curve* that African Americans are less intelligent than Whites.[55]

The opposite pole of the racial compass is that of gender and sexuality. This is the place where racial difference is performed in tableaus of sexual violence and prohibition: the rape of the enemy's women and the sodomizing of his men. This is the racial taboo that tells the racist, that he would never marry their women, but he might want to rape them, a form of what Ian Hacking (following anthropologist Mary Douglas) has called "pollution rules."[56] One need look no further than the Abu Ghraib photographs to see that these scenarios have been played out in the most vividly literal forms in the contemporary combination of racial and religious war known as the War on Terror. The pole of gender and sexuality is also the location of the eroticizing of racial difference, and the contest between what Cornel West has called "racial reasoning" in the case of Anita Hill versus Clarence Thomas, wherein race "trumps" gender one more time.[57]

The eastern and western points of the racial compass cut across these quasi-natural, biopolitical categories of species and gender, defining the force-field produced by the tension between culture and political economy, ethnic identity and social class.

Here the differences between peoples are not are not regarded as natural, but artificially produced, often by force and violence, especially the force of habit, and the violence of inequality. On the east let us place the category of class, of the distinction between rich and poor, powerful and weak, master and slave, colonizer and colonized. These need not be visible distinctions, but they often are. On the west we place the list of contingent "cultural" factors—religion, ethnicity, language, nationality, geographical location, and so on. It is not surprising that we find a tug of war between these ways of inflecting the concept of race. The tendency of the "class" pole, exemplified by the old tension between Marxism and racial theory, is to evacuate the race concept, to treat it as an illusion, a myth that distracts us from the reality of economic and political inequality. (This claim to "reality" is, of course, a myth in its own right, and a forgetting that the whole notion of class in Marxist thought was based on the precedent of racial struggle.)[58] The tendency of the culture pole is to elaborate the race concept, to treat it as an illusion that is difficult if not impossible to erase from human consciousness and which therefore must be continually revised, reframed, and grasped anew in its concrete manifestations.

We might ask what need there is for a concept of race when, after all, we have a whole constellation of terms—class, culture, species, and gender—ready to hand. But the question should itself make the answer obvious: race is the only term, the uniquely necessary term capable of mediating these other terms, providing the central point of intersection at which they converge in a "complexion" and from which they diverge and radiate outward into extreme forms of racism. Appiah was almost right in saying that "there is nothing in the world that can do all we ask 'race' to do for us"—except race itself.[59]

And this is perhaps the most powerful sense in which race functions as a medium, well beyond its role in concrete forms

of visual, verbal, and musical performance. Race is the uniquely mediatory concept that allows thought to encompass and totalize (in the Sartrean sense) the intricate complexion of love and hate, alterity and enmity that make up the phenomenon of racism. Putting the word in scare quotes, adding an asterisk, or banishing it from the language will not make racism go away. On the contrary, it will only serve to heighten what John Jackson has termed the "racial paranoia" that inevitably rushes in to fill the cognitive vacuum produced by the refusal to say or even think the word "race," which I write here in quotation marks for the only time in these lectures.[60]

Race theory (the talk and the thinking of race) might be thought of as what Sartre called an "etiology," a diagnostic tool for investigating the causes of racism. Insofar as race (or race-talk) is thought of as the *cause* of racism, one is engaged in what is called an "etiological myth . . . intended to explain a name or create a mythic history for a place or family."[61] One can see this most clearly simply by asking oneself if Jews or Jewish identity are the cause of anti-Semitism or if Black people are the cause of Negrophobia. As we have seen, the origin of racism, in the sense of its "final cause," is not race. Racism itself is built upon a discourse of origins, especially "original purity" (or original sin),[62] and often relies on origin myths about fictional entities such as "real Frenchmen" or "real Americans." Race is, by contrast, what Edward Said called a "beginning," as distinct from an origin.[63] That is, it is the beginning of thought and even thoughtfulness about racism. The concept provides a way of seeing through race to its racist origins, taking account not only of its sources in inequality, bondage, and xenophobia but also of its creative, productive capacity to generate new communities of resistance and structures of feeling.

As a more or less visible, palpable medium between peoples and a myth that holds them together (or apart) over time, race

persists and evolves historically. I should stress, then, by way of conclusion, that the argument I have mounted here against post-racial thinking is by no means the main point of these lectures. This debate, mainly centered in American culture and the meaning of Blackness, has been ably waged on both sides and is far from over. The post-racialists are certainly correct to say that something has changed about the concept of race, particularly in relation to Blackness in the United States. The argument for the persistence of race and of racialized Blackness is certainly correct and, by now, independent of racism not only in forms of Black "authenticity" but in the most critical and complex articulations of race in politics and the arts. My problem with the post-racial is simply with the "post-," which strikes me as a placeholder for a more positive account of what is happening to the concept of race in our time. We have to ask ourselves, as Cornel West and Ian Hacking do, why race still matters when it has repeatedly been exposed as a pseudoscientific illusion and an ideological mystification. The answer lies in the peculiar position of race in the unavoidable human practice of classifying and discriminating kinds of things. If there are "natural" or "real" kinds (e.g., the difference between cows and horses), then there are also "superficial" kinds (the category of "White things in the world").[64] But what about the intermediate cases, the statistical, perceptual, habitual, and traditional kinds that are neither strong nor superficial or whose strength has been exerted in real political ways, regardless of their logical superficiality? This is surely another way of understanding race as a *mediating* concept, in its unique role *between* the strong and weak versions of the human instinct, as Claude Levi-Strauss put it (quoting E. B. Tylor), "to classify out the universe."[65]

As for the concept itself, this may be the place to admit one more category into the characterization of race as a medium by

noting that although race is surely a concept, it is much more than that. It has the status of a conceptual icon, a potent, magical, talismanic word that can be uttered in the service of a diagnosis or as a symptom of racism; it can be used as an analytic device or a polemical, rhetorical weapon. We have seen this in the historical process described by Roxann Wheeler as the condensation or congealing of the race concept into a visible, perceptible, and sensuous image, the transformation of "complexion" from a *complex* of factors into a *color*, a physiognomic character, a body of stereotypes. As a thought experiment, one might ask, "what do I see when I think about race?" In the United States, the answer for many White folks tends to be Blackness, or a darkening image of otherness and enmity—an obscure "black thing" that defies understanding. A related experiment might be to ask the question, "what do I feel when I think about race?" Here we are likely to encounter the "congealing" of the blood metaphor in a literalization of bodily affect, what Sartre describes as the roots of racism in passion, filled with anxieties about physical pollution and contamination.

There is no other social abstraction quite like race, no other idea quite so difficult to see *through* rather than *with*. Ideological and moral terms are invariably loaded with affective value. But race produces a radical ambivalence in its user. Paul Gilroy calls it "fissile material."[66] It operates, in fact, over what I have called the three "registers" of the cultural icon: fetishism, totemism, and idolatry. As fetish concept, race is collected, hoarded, and kept close to the body; it invites a compulsively repetitious confirmation in both positive and negative practices. As totem, it reinforces a code of collective solidarity, of brotherhood and sisterhood that threatens to become "groupthink" under certain conditions or becomes (as Levi Strauss said of totemism) "good to think." As idol, race becomes a god term, the alibi for murder, slavery, and other forms of human sacrifice.[67]

But naming race as an "idol of the mind" (and a fetish and totem as well) does not have the effect of disenchanting it or making it go away. The idol of race cannot be smashed, and the effort to smash it simply makes it stronger. Better to adhere to Nietzsche's wise advice and "sound the idol with a hammer, as with a tuning fork" to listen to its hollow resonances and retune them in accordance with a music to come.[68] The teachable moment of race theory has come down to this: We cannot seem to do without this concept, and we must conserve it for future uses that we can at this point only imagine. We must learn to see through, not with the eye of race.

In the next two lectures I will sketch two evolutionary moments in the concept of race as icon, medium, and myth, the post-racial moment for Blacks in America in the epoch bracketed by Bush and Obama; and the hyper-racial moment at the center of global conflict in Israel-Palestine.

THE MOMENT OF BLACKNESS

> We are apt to think in our American impatience, that while it may have
> been true in the past that closed race groups made history, that here in
> conglomerate America *nous avons change tout cela*—we have changed
> all that, and have no need of this ancient instrument of progress. This
> assumption of which the Negro people are especially fond cannot be
> established by a careful consideration of history.
>
> —*W. E. B. Du Bois, "The Conservation of Races" (1897)*

Let us define "the moment of Blackness" in America as liter-
ally as possible, as the era that runs from slavery to Jim Crow
through the Civil Rights Movement. The moment of "post-
Blackness" would then be "our time," the period signaled by
William Julius Wilson's "declining significance of race," by
Daniel Patrick Moynihan's suggestion that race-thinking be
demoted to the status of "benign neglect," or even as far back
as the development of Richard Nixon's "Southern strategy" of
producing political power out of the White backlash against
civil rights. It would be signaled at the level of race theory by
Anthony Appiah's argument that race is an illusion, and the
subsequent turning of philosophical attention to the peculiar
features of a concept that is widely understood to be illusory
but that nevertheless persists at the level of vernacular usage and
critical debate.[1]

Perhaps the first thing to say about the moment of post-Black-
ness and post-race is that we have heard about them long before
they became installed as the labels for the post–Civil Rights era

in the United States. In fact, Du Bois's own words, first uttered in 1897 and which I offer as the epigraph to this lecture, could be cited as a warning to post-racial theorists today: "we are apt to think in our American impatience, that while it may have been true in the past that closed race groups made history, that . . . we have changed all that, and have no need of this ancient instrument of progress. This assumption of which the Negro people are especially fond cannot be established by a careful consideration of history. . . ." Du Bois emphasizes that "the Negro people" are especially and understandably fond of the assumptions of post-racial thinking. They have more than their share of this "American impatience" because they have been the most conspicuous victims of the visible stigma of the color line. But it would be important then to insist, as Du Bois goes on to do, that the concept of race as "an ancient instrument of progress" covers more than the Negro race. The moment of Blackness (if we granted that this made sense) is not necessarily synonymous with or equivalent to the moment of "race" as such.

One could concede, therefore, that we are in a "post-Black" era in the United States without jumping to the conclusion that we are in a post-*racial* era throughout the world. Blackness might be thought of as simply one band of the whole spectrum of color consciousness, and color consciousness as only one among several modalities in which racial identity could be conceived. Blackness is not a biological essence but a specific "complexion," in the sense of this word as recovered by Roxann Wheeler, a complex interweaving of temperament, genealogy, and experience, especially the experience of being "seen as" Black. The metaphor of the veil, for instance, treats race primarily as an optical phenomenon or "corporeal schema" and leaves out the temporal, narrative, and genealogical thinking— Fanon's "historico-racial schema"—that is figured by "blood." This diachronic dimension cuts across the visibility of the veil

to constitute a realm of invisibility and "passing," a realm that is notoriously policed by legal tactics such as the "one drop rule" (i.e., that one drop of black blood is sufficient to establish black racial identity).

The races Du Bois sought to conserve included more than the Black and, ultimately, more than the "colored," notably including the "White race" and all its varieties. His list was, to be sure, the familiar Red, Yellow, Black, and White at the top of the taxonomy. But that taxonomy is then divided into numerous subfamilies: Slavs; Teutons; the English; Negroes; the "Romance nations of Southern and Western Europe"; the "Semitic people of Western Asia and Northern Africa, the Hindoos of Central Asia and the Mongolians of Eastern Asia, as well as 'minor race groups' such as the American Indians and the Esquimaux and South Sea Islanders" (40–41).

If race as skin color was an illusion, then, it was a very special kind of illusion, one that emphasized the realm of visuality (Fanon's "epidermal schema") and the self-evidence of "seeing as believing." That is why the metaphor of the veil was so central to it, and why the veil was not only a medium of opacity and blockage but, like the medium of photography, an instrument of "second sight" and the revelation of what would otherwise have remained invisible and concealed; or like the medium of cinema, a screen on which both realistic and fantastic images could be projected. Seeing race was, as Wittgenstein would have put it, a form of "seeing as,"[2] and thus a way seeing new, unsuspected aspects of perception, the very process that might make race what Du Bois sought to conserve, "an instrument of human progress."

Has this veil been lifted in the post-Black era? Has skin color ceased to be an important determinant of the perception of social identity or an index of economic status? Does the election of Barack Obama signal that color is no longer a factor in

American politics? Not hardly. The remarks of Senate majority leader Harry Reid to the effect that America might be ready to elect a light-skinned Negro to the presidency testify to continued relevance of color as an index of racial identity.[3] Of course, at the same time the election of Obama (another teachable moment?) testified to the prevailing taboo on race-talk. Despite the continual calls for an honest conversation about race, that is, a conversation that would lift the taboo on even mentioning the subject outside of scare quotes, it was clear that race was the last thing Obama wanted to discuss. Even to bring up the topic in the post-racial era is to be accused of either beating a dead horse that should be safely buried or of being a racist oneself. Although I doubt that the post-racial moment can simply be reduced to a taboo on the word race, this certainly has to be one of its main elements.

As for Obama's election as a sign that the color line has been erased, a more accurate account would say that the line still exists but, as Jacques Derrida would have put it, "under erasure." That is, the line is still there, still visible but somewhat blurred, partly repressed, and crossed over in both directions with increasing ease. Like the word race, it must be bracketed by scare quotes to distance it from the speaker, who thereby signals that he is not *using* the word, only *mentioning* it while disavowing responsibility for or contamination by it.

We will get to the meaning of Obama's election presently, but first, as the major premise of this whole argument is that race is best considered as a medium—that is, not merely a *content* to be mediated but itself a medium of representation and expression—I want to say something about the relations between the post-Black and post-racial era, and what is called the "post-medium condition." As you may have surmised by now, I am somewhat impatient with the whole rhetoric of the "post-" that has dominated attempts to historicize the present

since the 1970s. The postmodern and the postcolonial, for instance, both strike me as placeholders, temporary substitutes for a positive historical description that has not yet found its proper name. The postcolonial might be more properly named a neocolonial period, in which military occupation and economic exploitation of less powerful countries have proceeded under a new set of ideological alibis involving democratization, human rights, and economic development. When it comes to postmodernism, I take Bruno Latour's point that because we have never been modern, postmodernism is simply a preposterous parasite on an illusion.[4]

As for what Rosalind Krauss calls "the post-medium condition," the era in which traditional artistic métiers such as painting, sculpture, architecture, and so on have been replaced by a hodgepodge of "multimedia" experiments such as performance and installation art, it is important to note a few salient features of her invocation of this term. The first is her stated wish to "draw a line under the word *medium*, bury it like so much critical toxic waste, and walk away from it into a world of lexical freedom. 'Medium" seemed too contaminated, too ideologically loaded, too dogmatically, too discursively loaded."[5] I hope it is clear how closely Krauss's rhetoric matches the "post-racial" arguments we have been tracking. One could easily substitute the word "race" for "medium" without missing a beat. Could it be that the word "medium," like "race," has a set of fetishistic, totemic, and idolatrous connotations, albeit in the smaller world of art and aesthetics?

But Krauss's second move is where things get interesting, and that is her realization that she cannot do without the term "medium" after all. Despite its association with Clement Greenberg, with formalism, and a reified materialist notion of the medium as "nothing more than the unworked material support" of an "aesthetic practice" (6), Krauss finds the same thing

that numerous race theorists have discovered, that it is not so easy to dispose of a critical concept and that it makes more sense to *preserve* it (as Du Bois urged) or to "desediment" it (Derrida's preference) in order to trace its complexity as an instrument of progress at the level of both theory and practice. Like racial specificity, medium specificity resides in something more complex than a material object. To remind you of Raymond Williams definition, a medium (like race, needless to say) is a "material social practice."[6] Or, to echo Krauss, a medium (like a race) is a "recursive structure" and "complexion" that discloses patterns of internal differentiation and a history of origin, innovation, and obsolescence.

The relation of race and medium, then, is more than their analogical position in the rhetoric of the "post-." If race is not just *similar* to a medium but literally *is* a fundamental medium constitutive of human sociality and subjectivity, then the parallel between the postmedium and post-racial condition has to be understood as more than a mere coincidence, and the conservation of both concepts may in fact be mutually interdependent. In order to test this hypothesis, I now want to turn to the teachable moment in the history of race and media that was constituted by the election of Barack Obama as president of the United States in 2008.

First, we may as well identify the obvious lesson. Obama is not just the first Black president; he is also the first "wired" president. In that sense he is an avatar of both the post-racial and postmedium era. His post-racial identity is manifested by his "hybridity" in both the visual and auditory registers. Senate majority leader Harry Reid captured Obama's audio-visual image precisely in his remark that the nation was ready for a "light-skinned Negro," especially one who did not necessarily talk like a firebrand Black preacher but was capable of modulating his voice between Black dialect, on the one hand, and the

measured tones of a University of Chicago law professor, on the other hand.[7]

As a "wired" politician, Obama's Internet mastery might be compared to John Kennedy's understanding of the power of television. The difference, however, is that television is a relatively specific medium, whereas Obama's range of media mastery extends from social media (distributed "user-to-user" networks such as Facebook, YouTube, Twitter, and direct e-mail) to traditional broadcast media to the even more ancient medium of live oratory before a mass gathering.

Of course it must be immediately evident that there is something highly paradoxical in summarizing both these sides of Obama's identity as post-racial and postmedial. On the contrary, race was a persistent issue throughout the Obama campaign, from the early days before the Iowa caucuses when most Black people were supporting Hillary Clinton and regarded Obama as "not Black enough" to the culminating days of the primaries in spring 2008 when the Jeremiah Wright scandal threatened to make him seem "too Black" in his connection to a fiery Black preacher from the Civil Rights era. Obama's greatest speech during this campaign was, arguably, the one he did not want to give, his hour-long reflection on the history of race in America in Philadelphia on March 17, 2008. It is notable that this speech had the audacity to remind Americans that their sordid history of racism goes back to the Founding Fathers in the "original sin" of slavery and that the racial question was not resolved by the Civil War, only metamorphosed into the new forms of segregation and Jim Crow laws. Nor, according to Obama, did the passage of the Civil Rights Act of 1964 finally achieve the "more perfect union" of a post-racial era. What he could have said (but did not) was that at the level of party politics it actually created the conditions for the Republican "Southern strategy" that continued to exploit racism while disavowing it. What

Obama did explicitly connect to the question of race, perhaps for the first time in American presidential discourse, was the issue of religion. Reflecting on the role of the Black church and the special role of that institution as a central force in the struggle for racial equality, he noted that "the most segregated hour in American life occurs on Sunday morning," when the Black church assembles and "embodies the black community in its entirety—the doctor and the welfare mom, the model student and the former gang-banger. . . . The church contains in full the kindness and cruelty, the fierce intelligence and the shocking ignorance, the struggles and successes, the love and yes, the bitterness and bias that make up the black experience in America."[8] If race is a medium, then the term applies equally well to religion itself, which is literally a "binding together" of a community around a body of words and images, beliefs and practices. Obama insisted that he could "no more disown" the Reverend Wright and the Black church than he could "disown the black community"—or (as he pointedly added) disown his "white grandmother," a woman who he confessed "has uttered racial . . . stereotypes that made me cringe."

The myth of a post-racial America, then, has to be understood in connection with an even less credible myth, the idea of a postreligious and secular America in which church and state are firmly separated. The return of religion (along with race) in global politics, centrally in what can only be called the Holy War on Terror,[9] should make this irrefutably obvious, if the internal politicization of American religion did not. As for the postmedium condition, Obama's campaign would be better understood as a hypermedial event synthesizing the entire range of mediated political encounters from the intimate, face-to-face gathering to the enormous mass rallies and television spectacles financed largely through small donations gathered over the Internet.

Perhaps the most dramatic demonstration that the racial medium remained central to Obama's rise to power was the moment when the two major forms of racism operative in the world today converged on his image during the election campaign proper. I'm speaking, of course, of Negrophobia and Islamophobia, the fear and hatred of Blacks and Arabs (mindlessly equated with Muslims, an equation aided by the phenomenon of the "Black Muslim" as the dangerous American Moorish invader). The campaign to portray Obama as a Black Muslim was, of course, officially disavowed at the same time it was unofficially encouraged by the Republican Party, a contradiction that burst into the open when a frightened woman at a McCain rally blurted out her anxiety about Obama's Muslim identity, and McCain was forced to set her straight by reassuring her that Obama was not and is not a Muslim but is rather a "decent family man." The famous *New Yorker* cover of July 21, 2008, that portrayed Michelle Obama as an Angela Davis-style revolutionary and Barack in Muslim garb giving each other what Fox News called "a terrorist fist pump"[10] put the whole strategy of racial and religious innuendo under a magnifying glass. This image alarmed all my leftist, liberal, and anti-racist friends who felt that the image would surely reinforce the prejudices of the vast majority of Americans. My own sense was that it exposed the myth of the post-racial and post-Black era with stunning clarity, calling into the open strategies of stereotyping and caricature that would otherwise have been concealed and disavowed.

What was the Obama election about, then, if not about the persistence of race, media, and what I have been calling "the racial medium" as an essential feature of American culture and politics? Far from showing that Americans have "gotten beyond" race (much less, beyond racism), it demonstrated the continuing power of both the concept of race and the passion of racism to mobilize political power. We need to remember

that despite all Obama's virtuosity as a speaker and the media mastery of his campaign; despite his ability to perform the racial masquerade in both directions, "passing" for White *or* for Black depending on the needs of the moment; despite his obvious intelligence and mastery of the issues; despite the fact that he was running against a discredited party headed by the most unpopular president since Herbert Hoover; despite an opponent who was thoroughly distrusted by his own party and who ran an incompetent campaign, the high point of which was the nomination of a certifiably incompetent (but reliably racist) candidate for the vice presidency; despite an economic crash largely traceable to the economic policies of the incumbent party just weeks before the election; despite all these factors in his favor, Obama was elected by a relatively small, if clear, majority. John McCain led in the Gallup polls until September 15, 2008. If not for the economic crash, Obama might well have lost. And the fragility of his majority was demonstrated dramatically in the congressional elections of 2010.

At the level of the imaginary and symbolic constituents of political reality, then, Obama's election has to be seen as something like a miracle, an amazing fluke, and certainly not as a sign that America has left behind its racist past.[11] And this is so especially when one considers not just his visible racial identity and his genealogy—the "body and blood" factors of racial identity. In addition, to anyone who is used to "thinking with his ears," as Adorno recommended,[12] there is the sound of his name, which not only signals the fusion of the two long-standing racial enemies of White Christian America, Blacks and Arabs, but even more specifically echoes the proper names of the archenemies of the United States during the preceding period of the War on Terror, Saddam Hussein and Osama bin Laden. In the oral poetics of the political medium, the election of Barack Hussein Obama amounted to the election of a tyrant,

a terrorist, and a Black Muslim to the presidency of the United States.[13] All these labels and more were quickly mobilized by the Right immediately after the election, to which they added for good measure portrayals of Obama as Hitler, as Stalin, as a rogue chimpanzee, and as an illegal immigrant, and depicted the White House as the site of the new American plantation, complete with a watermelon patch.

The historical relationship between the white-pillared neo-classical Southern mansion and a White House originally built by slaves will give us pause presently. But first I would like to reflect on one of the earliest teachable moments in the Obama administration, the arrest of the director of Harvard's Du Bois Center on July 20, 2009. This event immediately drew national media attention, which grew into the predictable (excuse the cliché) "firestorm" when President Obama, in a press conference primarily devoted to health care, made the mistake of suggesting that in arresting a prominent Black intellectual in his own house, the Cambridge police "acted stupidly." The fact that all charges were immediately dropped by the Cambridge police suggests that, on the face of it, the police knew that they had made a mistake. No matter. Obama was accused of reverse racism for daring to criticize the actions of the White police officer who arrested the professor, and his words were inflated into a declaration that the police in general are stupid. Despite Obama's characteristically measured comments and his gentle reminder that there is a sordid history of racial profiling and police brutality in this country, he was accused of playing "the race card" in a situation about which he was unqualified to speak. When it became clear that the storm of criticism, mainly emanating from the right-wing media, was not going to calm down, it also became clear that Obama would have to do something further. We all remember, I suspect, Obama's second press conference on this incident, in which he came very close

to apologizing for his "poor choice of words" and expressed a hope that the unfortunate event could be turned into a "teachable moment." He subsequently invited the police officer and the professor for what was called a "beer summit" to try to restore civility to the conversation.

I want to remind you of a point I made at the outset, that the whole idea of the teachable moment, which I have been conjuring with throughout these lectures, has a double meaning. The phrase is often used in elementary school, where it designates an opportunity for the teacher to engage in a civilizing mission, often emphasizing good manners or elementary hygiene. It presumes a wise pedagogue who knows what is right and how to seize an opportunity to teach it. But there is another meaning to the teachable moment that is quite different and indicates an event that reveals a conflict or contradiction that may not lend itself to resolution by teacherly authority. This is the moment when the truly wise teacher recognizes that she may not have all the answers and that the event requires a more sustained examination, something considerably more than the invocation of calm and good manners.

Of course the second, deeper sort of teachable moment may not even get off the ground if the first, calming moment is not established as a framework for getting to it. But the danger is that the first kind of moment will be taken as the final goal of the lessons, that the only objective will be to calm things down, rather than to get to the heart of the conflict that provoked it. This, I'm afraid, is the only "lesson" that Obama seemed to be interested in—a calming of passions and an attempt to defuse a polarized situation as nothing more than a "misunderstanding" between "two good people."[14]

What would we learn if we pursued the second strategy of the teachable moment and tried to unearth the real issues that led to this unfortunate incident? First, at the simple facts of

the matter: We would learn that the police dispatcher repeatedly asked the caller to identify the race of the two men with suitcases trying to force the door of the professor's house. The dispatcher was already deploying the racial template before any officer had arrived on the scene. Second, we would learn that the official pretext for the professor's arrest was not suspicion of breaking and entering but his expressions of anger ("disorderly conduct") at being subjected to a police intrusion in his own home. One lesson that would seem to follow from the false arrest of Professor Gates is that it is now against the law in America for some kinds of people to express anger at a police officer, a legal doctrine that would normally be found only in a police state. Third, we would learn that this officer was in charge of teaching "racial sensitivity" to his colleagues in the Cambridge police department, which might lead us to wonder what would count as *in*sensitivity for this institution. Fourth, and finally, we would learn that rather than apologizing for his actions, this officer insisted on the propriety of his behavior and was then rewarded by being called a "good person" by the President of the United States and invited to the White House to have a beer with the man he had falsely arrested.[15]

This whole scene of the Black professor, the White cop, and the hybrid, post-racial president has to remind us of the three central personages in Sartre's classic study, *Anti-Semite and Jew*. In this case, the Black man is in the position of the Jew, and the cop (and the whole apparatus of right-wing outrage that mobilized behind him) is in the position of the anti-Semite. Obama plays the role of what Sartre calls "the democrat": the liberal, tolerant mediator. The Jew in this situation "knows," as Sartre points out,

> that the democrats and all those who defend him have a tendency to treat anti-Semitism rather leniently. First of all, we live

in a republic, where all opinions are free. In addition, the myth of national unity still exerts such an influence over the French that they are ready for the greatest compromises in order to avoid internal conflict, especially in periods of international tension—which are, of course, precisely those when anti-Semitism is the most violent. Naïve and full of good will, it is inevitably the democrat who makes all the concessions; the anti-Semite doesn't make any. He has the advantage of his anger. People say, "Don't irritate him." They speak softly in his presence. (70)

Obama raised speaking softly to the level of a fine art in his first year in office, evidently trusting in "hope" for political compromise and national unity in place of the "audacity" that put him in this position in the first place. The poet William Butler Yeats put it even more emphatically: "The best lack all conviction, while the worst / Are full of passionate intensity,"[16] an apt motto for the relation of post-racial and racist elements in American society today.

This teachable moment of police misconduct has its counterpart, of course, in the much more flagrant and disturbing moment of the arrest and brutal beating of Rodney King by Los Angeles police officers in 1992. This episode, we should recall, has sometimes been taken as marking one version of the onset of the post-racial era and the emergence of a neoliberal consensus.[17] One could easily construct a comforting narrative in which the arrest of a Black professor in Cambridge stands as a reassuring contrast to the Rodney King arrest, showing just "how far we have come" from the bad old days of police brutality toward black people. But it is important to remember that had the Rodney King arrest not been miraculously captured on video tape, it certainly would have disappeared from memory and history. It is only when anti-Black racism becomes *visible*, it seems, that White folks can find a way to

take it seriously. Mere verbal testimony never seems to suffice, and the Cambridge event was reduced to a simple "he said, he said" dispute. But the Rodney King video tape, especially when accompanied by the obtuse remarks of certain members of the all-White jury that the police were simply "doing their job," had the effect of setting off massive riots in Los Angeles. It is impossible to forget Rodney King's own intervention in the event, when he went on television to plead for calm and to ask plaintively, "Why can't we all just get along?" Although the events are deeply different in their level of importance, the lesson Obama tried to teach in August of 2009 is, at bottom, not all that different from the question Rodney King raised seventeen years earlier: Why can't we all just get along? The answer could hardly be clearer. We can't "just get along" because racism is alive and well in the United States, and the whole myth of the post-racial era has been an effort to cover this up or wish it away by condemning race-talk and race-thinking as its cause rather than its (potential) cure.

This brings us back to the image of the plantation and the White House at its center. It is a remarkable fact that, at the very same time the post-Black and postmedia era was at its peak as an American cultural consensus, two Black artists working independently had the inspiration to bring back the scene of the Southern plantation, complete with its entire cast of characters and plots. I am speaking, of course, of Spike Lee's film *Bamboozled* and the panoramic tableaux of Kara Walker. While these two remarkable artists were reviving what many took to be an archaic set of images drawn from the era of slavery and reconstruction after the Civil War, they revived at the same time two media that were seen as equally archaic. Spike Lee resuscitated what Michael Rogin has called "America's first culture industry," the blackface minstrel show.[18] And Kara Walker returned to a minor and mainly private nineteenth-century art

form, the black paper silhouette, to produce astonishing tab-
leaux of an imaginary plantation society acting out what can
only be described as the unconscious of American racial and
sexual fantasy.[19]

It is not a surprise that the eruption of these archaic media
and their associated racial image repertoires provoked a highly
negative reaction in post-racial America. The teachable moments
associated with Spike Lee's and Kara Walker's work understand-
ably provoked the response: Why can't we just forget about all
that? This is not where Black art was supposed to go in the
post-Black era. Black art was either supposed to disappear, along
with the historically passé movement known as "African Ameri-
can literature" (implicitly declared over by my colleague Ken-
neth Warren in the 2007 Du Bois Lectures, *What Was African
American Literature?*),[20] or it was supposed to provide positive,
emancipatory images for that mythical entity known as "the
Black community."

Michele Wallace has traced the negative reaction to Kara
Walker to the conformism of this community, arguing "individ-
uality has never been highly regarded in the African-American
community" (*Narratives of a Negress*, 175), especially when it
involves airing the dirty linen of that community in front of
White people. I remember vividly my own teachable moment
on this point when, exactly twenty years ago, just down the
street at the Carpenter Center, I gave a lecture in praise of Spike
Lee's groundbreaking film *Do the Right Thing*, which had been
released amid the usual firestorm (sic) of negative criticism.[21]
A prominent African American scholar from Boston stood up
after my talk to say that she was not surprised to find a White
liberal like myself praising a filmmaker like Spike Lee who traf-
fics in racist stereotypes. Fortunately, I did not have to say very
much in response because numerous Black people in the audi-
ence leaped to the defense of the film. I bring up this episode,

not to vindicate my prescience about Spike Lee, but to encourage a further reflection on the concept of the teachable moment. I do not think Michele Wallace is right about the Black community; in my experience it is no more conformist than any other group in America and is in fact, like most communities, more like a "family quarrel" than a social formation united around common values. The teachable moment emerges, in my view, when an event arises that exposes and dramatizes this quarrel, makes it visible in a way that makes new understanding, even revelation, possible. I say "possible," of course, because transgressive, innovative art never brings with it a guaranteed result, only the high probability of a scandal, the provocation of resistance, and a rise in the level of audience discomfort. And none of these results is a guarantee of historical durability, or of an enduring lesson to be learned from the offensive work.

My wager is on the enduring importance of these two artists, for three distinct reasons. The first is simply the aesthetic excellence, the sheer virtuosity of the work. In Kara Walker's case, this involves the wholesale transformation of an archaic medium into an intensely contemporary form of expression. Simply from the standpoint of its radical originality and technical skill, Walker's work commands attention, even before we attend to the metaphoric significance of the silhouette as a "Black art" par excellence. When this dimension is taken into account, the depth of her engagement with the medium becomes evident, especially insofar as it goes back beyond its bourgeois nineteenth-century precedents to the legendary Greek origins of drawing itself in an act of love, as the sketching of a silhouetted shadow to preserve the trace of the beloved when both the body and the shadow have departed.[22] The highly explicit eroticism of Walker's tableaux and their engagement with violence and the lower bodily functions is sublimated and abstracted in images that are only bearable because of their reductive, schematic rendering. Like

the scenes of torture in the puppet shows of William Kentridge's *Ubu and the Truth Commission* or Art Spiegelman's translation of the Holocaust into an animal cartoon, Walker's plantation-era pornography is located precisely on the cutting edge of aesthetic possibility, where the symbolic/imaginary constructions of race break open into a glimpse of the Real, the heretofore unconscious and invisible contents of racism.

In the case of Spike Lee, the argument for his aesthetic virtuosity is by now well established. A master of every film genre from documentary to comedy to the heist film to biopic and satire, Lee has shown his ability both behind the camera and in front of it, in everything from the writing of dialogue to the mobilizing of extraordinary talent in the process of casting. In *Bamboozled* he carried this mastery to a new self-referential extreme. Not only did he revive an archaic, obsolete medium as Kara Walker did, but he also brought back a form of theatrical and cinematic performance that has been strictly taboo in Hollywood since well before the Civil Rights Movement. And in *Bamboozled* he did so with a self-referential flourish in the casting of the star of the New Millennium Minstrel Show: Savion Glover's unparalleled skill as a tap dancer carries us from the street to the television studio to the tragic dance of death that transcends and redeems the satiric buffoonery of the "coon show."[23]

It is this tragic denouement to *Bamboozled* that suggests another point of convergence for these artists, and that is the ethical focus on what Aristotle called "serious actions" involving recognizable human agents. Of course Aristotle would have banned from the stage the kinds of spectacles that Lee and Walker compel us to witness, but that is partly a function of building a performance around familiar stories that require only an appeal to the audience's conscious memory. In the case of the racial melodramas staged by these two artists, the need to penetrate the veil of unconsciousness, disavowal, and invisibility, and

the insistence on seeing what racism looks like, not just hearing about it by report, is essential to the ethical project. Both artists compel their audiences to "face up" to blackface, and to reenter the racialized space of the plantation. In *Bamboozled*, even the White audience and the creator of the minstrel show are Blacked up by the end, and the film insists on looking without blinking at the animated toys, the "Black collectibles" that are the material residue of the moment of Blackness. Similarly, Kara Walker creates a world in which everyone, White and Black, is rendered as flat, black, shadowy silhouettes, and racial difference is reduced to a schematically literal profiling in the outlines of faces, clothing, and hair.

From an ethical standpoint, the crucial move shared by these artists, as many critics have noticed, is their insistence on placing themselves and their audiences *inside* the spectacle, preventing a detached, voyeuristic witnessing. Walker's tableaux take us deep into the pathological fantasy life of the plantation, the nightmare underside of *Gone with the Wind*, while compelling the spectator's own shadow to mingle with the silhouetted figures on the wall. That literal feature of the installations, and the fact that the vignettes are all too legible and recognizable, makes it very difficult to deny that we, as spectators, feel that we have seen this before. But where? The only answer can be that they come out of our own dream life, not just Kara Walker's. When the governor of Virginia issues a proclamation declaring a month dedicated to reviving nostalgic fantasies of the Confederacy as a way of attracting tourists to visit his state, we know that what Lauren Berlant calls a "national fantasy" is being evoked.[24]

Spike Lee similarly injects his authorial function directly into *Bamboozled* in the figure of Pierre Delacroix, the television writer who invents the New Millennium Minstrel Show, and announces the satiric genre of the film he is in directly to the audience. He puts the audience on stage as well, dramatizing

the uncertainty and ambivalence of our own responses. It is "difficult to decide just how hard to laugh"—as if laughter were a voluntary response—at the combination of bizarre high jinks, surreal wit, absolute horror, and funky comedy that unites these two artists.

The final thing that unites them is, of course, their historical significance as the two most egregious exceptions to the hegemonic account of a post-Black, much less post-racial, era. Just when we thought Black artists were about to disappear into the melting pot or the Rainbow Coalition, just when we had been assured that the moment of Blackness and the "race problem" in America was well behind us, these two inconvenient figures come along to suggest that there is more to be done. Between them, Kara Walker and Spike Lee made it clear that a new teachable moment in race, media, and visual culture was dawning, a moment in which we might have to learn, in Darby English's marvelous phrase, "how to see a work of art in total darkness."[25] In Du Bois's classic essay "The Conservation of Races," he had ruled out one form of conservation as taboo: "No people that laughs at itself, and wishes to God it was anything but itself ever wrote its name in history" (45). Can one imagine a similar statement being made by or about Jews? Perhaps it was the post-Black and post-racial consensus that made it safe and therefore possible, perhaps even *necessary*, for this version of the conservation of race to make its appearance.

The moment of Blackness was, of course, never exclusively confined to the African American population of the United States. It was disseminated most notably in the apartheid struggle in South Africa, which was accelerated by the example of the Civil Rights Movement in the United States. And it was thoroughly interwoven with the history of racial exclusion of the Irish and the Jews in America. Under the blackface of the nineteenth-century minstrel show were the faces of Irish

immigrants, and among the high points of cinematic blackface was the appearance of a Jewish cantor, Al Jolson, in *The Jazz Singer*. Perhaps even more important was the way in which the Black struggle against racism was modeled on Zionism and the biblical narrative of exile, return, and liberation. Black nationalism and the "back to Africa" movement constituted one version of this narrative. The other, pioneered by Du Bois, continued by Martin Luther King, and repeatedly invoked by Barack Obama, treated America itself as the "Promised Land." Both these narratives could be (and have been) appropriated in the invention of a new race, the White race, that would reclaim "the real America" as its exclusively promised land, one that regarded "the State" as "the protector of the integrity, the superiority, and the purity of the race."[26] The "discourse on race struggle," as Foucault pointed out, was a double-edged sword, a matter of both "glory and infamy."

> It would be a mistake to regard this discourse on race struggle as belonging, rightfully and completely, to the oppressed, or to say that it was, at least originally, the discourse of the enslaved. . . . It should . . . be immediately obvious that it is a discourse that has a great ability to circulate, a great aptitude for metamorphosis, or a sort of strategic polyvalence. (76)

That is why I have argued that we need a "compass" of race, a way of tracking its movements and transmutations in space and time and of tracing the vectors of religion, language, and culture; of biopolitical categories such as species and gender; and of the socioeconomic forces of class. Marx wrote to Engels in 1882: "You know very well where we found our idea of class struggle; we found it in the work of the French historians who talked about the race struggle" (quoted in Foucault, 79). Anyone who wishes to forget about race in order to concentrate on class should remember this genealogy, as well as the one

that grows out of so-called cultural vectors: "Two races exist," remarks Foucault, "whenever one writes the history of two groups which do not have the same language or the same religion. The only link between them is the link established by the violence of war" (77). What happens, then, when two groups that have a deep kinship in the genealogy of racial identity converge as the bearers of distinct religious and linguistic identities in a land that is sacred (albeit in different ways) to them both. That is what I will call "the Semitic moment," the subject of the next lecture.

THE SEMITIC MOMENT

The Jews who settled in Israel will give birth in less than 100 years to a collective unconscious quite different from the one they had in 1945 in the countries from which they were expelled.

—*Franz Fanon,* Black Skin, White Masks

There are no Palestinians.

—*Golda Meier*

There can be no reconciliation unless both people, two communities of suffering, resolve that their existence is a secular fact.

—*Edward Said*

Two races exist, whenever one writes the history of two groups which do not . . . have the same language, or in many cases, the same religion. The two groups form a unity and a single polity only as a result of wars, invasions, victories, and defeats, or in other words, acts of violence. . . . And finally, we can say that two races exist when there are two groups which, although they coexist, have not become mixed because of the differences, dissymmetries, and barriers created by privileges, customs and rights, the distribution of wealth, or the way in which power is exercised.

—*Michel Foucault, "Society Must Be Defended"*

My first trip to Israel-Palestine, a country that I always feel compelled to designate with a hyphen, was in the spring of 1970. My wife was pregnant with our first child, and we were there to visit her best friend from college, who had married an Israeli and decided to become an Israeli citizen herself. She was filled with idealism about the energetic young country and hopeful that the still-fresh memories of the 1967 War were the harbinger

of a new era of peace. "When we say 'hello,' here," she assured us, "we use the word 'shalom,' which means peace." Of course we quickly learned that the Arabs used a very similar greeting, salaam, which means the same thing.

My wife's friend had married into a Sephardic Jewish family that had recently emigrated from Libya. Her husband's first language was Arabic, and we were given to understand that he had traveled extensively, probably on intelligence-gathering missions, throughout the Arab world. One evening over dinner, the conversation turned to the question of anti-Semitism. My wife's friend, an Ashkenazi Jew from New Jersey, lamented what she saw as the intractable hatred of the Arabs, whom she suspected of wanting to exterminate the Jews in a new Middle Eastern version of the Holocaust. Her husband vigorously disagreed. "You don't get it," he said. "The Arabs don't hate us because we are Jewish. They hate us because we have taken their land, and we are not going to give it back."

This was my first teachable moment in four decades of involvement with Israel-Palestine, a country that I have visited numerous times since 1970 and that never fails to attract and repel me simultaneously. I think of it as a teachable moment not because the lesson it offers is all that clear but precisely the opposite. It is a moment that has continued to haunt me because I am not absolutely confident that I know who was right about the causes of Arab hatred of Jews. All my impulses led me to side with the Sephardic husband's cold, brutal realism. The Arabs hate the Jews not for who or what they are but for what they have done. At the same time, it had to cross my mind that, at some point what people do, what they have done and keep on doing, becomes equivalent to who and what they are. In other words, Arab anti-Semitism might have begun as a resentment of a conquered and colonized people toward the invaders who have taken their land, but there is nothing to prevent that emotion

from settling into an ontological condition, a fixed disposition that is functionally equivalent to anti-Semitism.

And perhaps not just functionally equivalent. After all, classic European anti-Semitism was never simply a question of "being," of who and what the Jews "are." It was also grounded in narratives of what they allegedly did, and what they are supposedly continuing to do. They murdered God, as Christian anti-Semites liked to say, and they are sacrificing kidnapped Christian children in an obscene parody of the Eucharist—the notorious "blood libel." (Fanon was mistaken to think that Jews, in contrasts to Negroes, had never been accused of cannibalism.)[1] European Jews were regarded as outcasts from God, a stiff-necked people whose only use was an economic one as moneylenders and merchants. They were regarded as a foreign body in the midst of Christendom periodically to be purged when they were perceived as becoming too powerful or wealthy.

And perhaps most significant, for much of the history of European anti-Semitism, the Jews were regarded as an "Oriental" race, if not identical with the Arabs, then mainly distinguished from them by religion, not race. In A. B. Yehoshua's marvelous novel *Journey to the End of the Millennium*, set in North Africa and Europe in the year 999, the major conflict is not between Jews and Arabs but between northern and southern Jews. The southern Jews in the novel are on a trading expedition that takes them from North Africa to Paris to Belgium, where millennial tensions are threatening the tiny Ashkenazi community with a pogrom. The Arab Jewish merchant is seen as a much bigger threat to this community than the Christians, however, because he has two wives. He must be welcomed into the community as a fellow Jew, but his nephew, who is engaged to be married to a European Jewess, is being compelled to make a choice between his bigamous uncle and his monogamous bride. This choice requires an official decision by a council of

rabbis and elders, a decision that leads to a fateful schism within Judaism itself, one that still resonates in the conflict between Ashkenazi and Sephardim, European and "Oriental" Jews.

The so-called Semitic race, then, is a wonderful object lesson in the artificial, historically constructed character of race, at the same time that it teaches us that artificial constructions become naturalized and have fateful real-world historical consequences. A blanket anti-Semitism that did not discriminate between Jews and Arabs was a powerful feature of European Christianity for centuries, and it continued as a feature of "scientific" racism in the nineteenth century. As Anouar Majid points out in his aptly titled book *We Are All Moors*,

> the Jew . . . was long the Moor within European civilization— the dark, anti-Christian menace that threatened the unity of pure nations. . . . For most of modern history, Jews and Muslims have been cultural allies and fellow victims of the European social order. Indeed, when given the opportunity, many Jews proudly embraced their kinship with their fellow Semites and Orientals.[2]

So is racial identity grounded in what people are or what they do? Is "Blackness" located on the skin or in the eye of the beholder? Is the "being" and "doing" of a people internally constructed by the way they perform their racial identity in language, customs, and narratives? Or is it imposed upon them by racist identifications that can in turn produce compliant or resistant forms of behavior? Do the "Semites" really exist? Or are they a phantasmatic projection of that equally chimerical concept, the "Aryans"?

Simply to put the question is to understand what is perhaps the most important lesson of the teachable moment with which I began. It is grounded in both, which is why the very concept of race has to be understood as a *medium*—not just as a content to be mediated or represented, but itself a framework

and support for the representation and perception of other social groups. Race is a "between-ness" located conceptually in the space between subjective and objective perceptions and judgments. And as a medium, it has both spatial and temporal axes: on the one hand, what Fanon called an "epidermal schematism" that can be expanded to include physiognomy, hair, clothing, and a whole range of performative characteristics; on the other hand, the "historico-racial schema," which is the medium as bearer of narratives, myths, rumors, and characterizations. All these strands are then woven together in what premodern conceptions of race called a "complexion," literally, an intricate labyrinth of physical, emotional, and intellectual dispositions.[3] This is why Martin Luther King Jr.'s famous declaration that he had a dream of a time when people "will not be judged by the color of their skin but by the content of their character" slightly missed the mark.[4] Racists do not have to rely solely on the color of someone's skin to arrive at a judgment. The problem is located not in the perception of color but in the structure of judgment—or rather, *pre-judgment*. The racist doesn't just rely on epidermal schematisms but on intricate complexions that include narratives and labels, prejudicial templates of characterology—lazy, shiftless, deceptive, lustful, cunning, sly, greedy, stupid, overintellectual, over-emotional: I am here mixing the behavioral characteristics in the search templates of Negrophobia and anti-Semitism. And beyond these specifiable visual and verbal schematisms, there is in the racist sensibility a claim to a kind of "sixth sense," an intuitive perception of the racial other (cp. "gaydar") that operates as the je ne sais quoi of racist sensibility.[5] As a temporal medium, moreover, racial classification is not only about what people are and what they do but also what they did, generally in a mythical past in which some primal crime was committed, say, by the sons of Ham (looking on their father's nakedness) or the sons

of Moses (killing Christ), or the Ishmaelite sons of Abraham (worshipping strange gods).[6]

All this may be summarized in Paul Taylor's pungent condensation of "race-talk" and "race-thinking" to two fundamental elements: bodies and bloodlines.[7] That is, race understood as a spatial medium consisting of visible, physical distinctions including those of spatial location, rootedness in a place; and temporal, narrative distinctions that establish genealogies, memories, histories, and mythologies, everything from jokes and anecdotes to sagas. This way of thinking about race-thinking will, I hope, liberate the discussion from excessive fixation on the nineteenth-century debate over the scientific foundations of racial classification. For one thing, scientists themselves were divided over this issue, and the virulent racists who tried to treat race as a species category were in a distinct minority. Science was never the real core, much less the cause, of racism. At best it was an alibi for racism, an attempt to justify slavery and genocide. But racist arguments from "bodies and blood" have never required scientific authorization; they are quite content with folklore, tradition, common sense, and of course a hardworking bureaucracy prepared to rationalize and enforce racial divisions. This practice, which constituted state racism and "purity of blood" from the Spanish Inquisition to the Third Reich to South Africa, has mutated in our time into forms of economic and social discrimination that are far less explicit and, indeed, operate principally by disavowal and what might called the "submerged state."[8] The existence of a carefully veiled state racism in the United States and Israel, for instance, is routinely disputed by assertions about democracy, free markets, equal opportunity, and equal access to justice. The only problem with these familiar talking points of the "post-racial" era is that they are drastically undermined by the facts on the ground of drastic economic inequality and rates of incarceration.[9]

This means, of course, that race-talk and racism have a much wider scope than we have supposed, and they cannot be quarantined off as a momentary aberration of the nineteenth century that lingered on into the twentieth. When one asks, for instance, if the ancient Greeks were racists, the answer from historians is almost invariably no: race and racism are distinctively modern phenomena.[10] George Frederickson, for instance, argues that "it is the dominant view among scholars who have studied conceptions of difference in the ancient world that no concept truly equivalent to that of 'race' can be detected in the thought of the Greeks, Romans, and early Christians."[11] Classical scholar Richard Neer puts it more precisely: "The Greeks were not racist, not in our sense. Biology was not destiny as it was for, say, Gobineau. But they were capable of being total assholes all the same. They just found other ways to be horrible" (e.g., slavery, torture, massacre, and the treating of human beings as "naturally" destined to be treated as animals).[12] But what is racism "in our sense"? Why are Gobineau's views regarded as the definitive example of racism "in our sense," and how does biology become the uniquely necessary criterion for the category of race?[13] Race-thinking is, to be sure, always a thinking about "nature" and "the natural," but that doesn't mean that it relies on scientific biology. A racist does not consult a scientific textbook before treating his fellow man as a brute. Culture itself is a "second nature" of customs, habits, and common sense that seems perfectly normal and natural to its members.

The idea that race-thinking and racism are specifically modern, then, has to be consigned to the dustbin of history along with (as Bruno Latour has shown) the entire myth of the modern as the motor of history itself.[14] Or to put it in the converse, suppose that the dustbin of history is exactly where we live. I want us to be able to see and to say that the Greeks were racists too and that renaming their prejudices as "ethnic

discrimination" is no more effective than our habit of putting the word *race* in scare quotes or trying to talk about something else.[15] Ethnicity is a colonial term deployed to make distinctions among various "subject races" and might be seen as a symptom of racism rather than an alternative for it.[16] Slavery, for Aristotle, was a natural condition grounded in distinctions of species and gender: "The use made of slaves and of tame animals is not very different," and women are naturally designed to be ruled by men. In fact, the reason "barbarians" make natural slaves is that, among them "no distinction is made between women and slaves, because there is no natural ruler among them: they are a community of slaves, male and female. Wherefore the poets say, 'It is meet that Hellenes should rule over barbarians;' as if they thought that the barbarian and the slave were by nature one."[17] Why are we not surprised to learn that the sacred right of the Southern states to hold slaves was justified not only with biblical arguments about the sons of Ham but also with analogies drawn from the Peloponnesian War?[18]

If we are going to follow Du Bois faithfully in his project of the conservation of the races, we need a pragmatic, operational account of race and racism (as I argued in the first lecture of this series) as the nodal point of culture and class, sex/gender and species. Race is, in other words, a medium not only in the sense of a set of "material social practices" that construct an "intervening substance" between peoples; it is also as a concept, the unique mediating term that fuses, and sometimes confuses, all these moments of force. Racism, for its part, is the convergence of these vectors in a vortex of passion, a black hole of collective affect that ranges across anxiety, disgust, fear, and hatred—all of which, of course, may be accompanied by their opposite numbers such as love, envy, pity, and complacency. How is it that Herodotus can say that the Ethiopians are the most beautiful people in the world and live in close proximity

to the Gods, but no Greek artist can portray an Ethiopian with African features?[19] Why is it that Negrophobia in the United States expresses itself in complex formations of "love and theft," as Eric Lott has demonstrated?[20] And why do kitsch landscape designers in Israel continually return to the image of a depopulated Arabian pastoral as the most desirable setting or manufacture postcards of desert scenes with Bedouins in the middle distance? Homi Bhabha has given us a single powerful word to describe this peculiar feature of racism, and that is "ambivalence."[21] I presume that no one will care to argue that ambivalence is a uniquely modern emotion or that it depends on nineteenth-century science.

All this is not to say, of course, that all racisms are alike. What they share is the common structure of mediation by bodies and bloodlines, and the encompassing force field of culture, class, sex, and species. The particular inflection of these factors in a place or time can be highly variable, but it is this underlying structure that makes them comparable. Anti-Semitism, for instance, relies almost not at all on the criterion of skin color. As Fanon puts it in *Black Skin, White Masks*:

> The Jewishness of the Jew . . . can go unnoticed. He is not integrally what he is. We can but hope and wait. His acts and behavior are the determining factor. He is a white man, and apart from some debatable features, he can pass undetected. He belongs to the race that has never practiced cannibalism. . . . But with me things take on a *new* face. I'm not given a second chance. I am overdetermined from the outside. I am a slave not to the "idea" others have of me, but to my appearance. (95)

I don't think Fanon is trying to compete here for the "Bigger Victim Award"; he knows very well that an *idea* about a people, an internalized prejudgment about their "character," can be at least as powerful a motive as the color of their skin (and he

was surely aware of the physiognomic profiling of Semitic facial characteristics). The Holocaust was the manifestation of an idea more than a visible appearance, although the Nazis certainly tried to compensate for the invisibility of Jewishness with a vast repertoire of graphic stereotypes and caricatures, an army of bureaucrats tracing bloodlines, and of course the most notorious visible mark, the yellow star.

The Nazis, despite the Hollywood legend of their pursuit of the "Lost Ark" as a weapon of mass destruction, showed little interest in Judaism. Hitler, as Gil Anidjar notes, regarded "the Mosaic religion [as] nothing other than a doctrine for the preservation of the Jewish race."[22] As for the Arabs, they were lumped together with Jews as "Semitic peoples," as they had been both by the canonically racist Ernst Renan, and the anti-racist W. E. B. Du Bois.[23] What unites the Semites is the shared role not just as "others" to Christian Europe but as *enemies* to Christendom, and figures of what Anidjar has called "the internal and external borders of the Christian West" (6). The difference between the internal and external enemy is most vividly captured by Shakespeare in the figures of Shylock and Othello. The Jew as internal enemy is configured as a foreign body that is potentially poisonous and deadly to the host but which must be tolerated as a necessary evil, especially when it comes to questions of money. The Arab, by contrast, is a figure of military prowess, the object of crusades, and a potential conqueror who, in the last couple of decades, has resurfaced as the specter of a "new Moorish conquest" in the form of immigrant workers from the Middle East.

Given this scenario, it is hardly surprising that a strategy of dividing and conquering a common enemy would take shape and that the West would encourage a war between the Semites, between Jews and Arabs. If, as the old saying goes, the enemy of my enemy is my friend, then the Jews were clearly the logical

choice to play the role of the advance guard in a new modern crusade to liberate the Middle East. Napoleon saw clearly that the return of European Jews to Palestine would provide a military foothold and a buffer state for Europe in the heart of the Arab world. And his purely secular and military motives were reinforced by the Christian narrative of apocalyptic end times in which the Jewish return to the Holy Land would fulfill the prophecies of Christ's kingdom on Earth.[24] As early as the 1840s, the Mormons were sending missionaries to Palestine, who reported back their sense that the prophecies of Joseph Smith were being fulfilled in the simultaneous return of the Jews to Palestine, along with the arrival of the Mormons in the Promised Land, the new Zion called Utah.[25] From the Nazi point of view, a side benefit to this whole master narrative would be the expulsion of the internal enemy from Europe and the extermination of those unlucky ones who remained behind.

The nameable results of this grand strategy are Israel-Palestine and Zionism, the nation-state and the nationalist movement that led to its creation. As should be clear, however, the tangled web of religious, political, and racial elements defies any simple reduction. The 1975 United Nations resolution that equated Zionism with racism was never quite satisfactory, even to a devoted defender of the Palestinian cause like Edward Said. "I was never happy with that resolution," remarked Said. "Racism is too vague a term. Zionism is Zionism."[26] Said insisted on a more nuanced approach, one that would acknowledge the positive and creative aspects of Zionism, its fabulous success in energizing an international Diasporic movement around a vision of emancipation, self-determination, and democracy, and its glowing vision not of racial hatred but of racial self-love in its quasi-mystical affirmation of a "homeland" for the Jewish people, an eternal homeland that would include all of the Jewish generations, living, dead, and as yet unborn. Said's insistence on

reckoning with the specificity of Zionism was partly a matter of practicality—of "understanding the enemy" rather than merely comforting oneself with insulting anti-Semitic stereotypes.

It was also, in my view, an essential aspect of Said's humanism and his steadfast antiracism, as well as an indicator of his long-range strategic vision, which was emphatically *not* the destruction of Israel and the triumphant return of the Palestinians to conquer and reoccupy their homeland, which would be nothing but a crude imitation of what Zionism itself had accomplished. In this sense, Said's diagnosis of Zionism was itself filled with ambivalence: admiration, even envy for its unquestionable achievements alongside a deep anxiety that Israelis and Palestinians were heading down a path to mutual self-destruction, a kind of bizarre suicide pact that could all too easily take the rest of the world along with it. This, in my view, is why his writing was as much an inspiration to Jewish critics of Israel as to Palestinians and, of course, why at the heart of his political vision was the idea of a binational state in which Jews and Arabs would live together in peace, and where the universal moral mission that lay at the heart of Judaism would be preserved, along with its common ethical and religious roots in Islam, its common love for the Holy Land of Israel-Palestine, and—dare one say it?—its common roots in Semitic racial identities—the shared history glimpsed in the poetry of Mahmoud Darwish and the novels of Yehoshua. For Said, the inevitable medium for the Semitic convergence was music, as expressed concretely in the project of the East-West Divan, a collaboration with Daniel Barenboim to bring together Israeli and Palestinian musicians—perhaps ultimately to perform the "tragic symphony" that he saw uniting these two peoples.

This idea, all too easily dismissed as impossible, is one that increasingly looms on the horizon as Israel pursues its impossible dream of racial and religious purity while pretending to

be a secular, democratic, liberal state. And we should make no mistake about the link between Zionism and racism, even as we acknowledge the differences. To the extent that Jewish identity is treated as a biological, natural property, a matter of parentage and "blood," it embraces the most fundamental feature of traditional race-thinking. As a practical matter, the last few years have made the goal of a two-state solution less rather than more probable. Ironically, the desires of the extremes, of rightwing Zionists and those of Hamas and secular leftists, have begun to converge insofar as they dream of a single geopolitical entity—"Eretz Israel," on the one hand, and a single country in which two nations and two races coexist, on the other hand. The fading of the two-state solution and its gradual replacement by Said's impossible dream of a binational, secular democracy with a constitution guaranteeing equal rights to all its citizens may be the deepest meaning of what I am calling "the Semitic moment." It would be the ultimate irony if the ancient enemies of Europe could make peace on the basis of their shared history, including their shared identification as Semites and their shared piety about a material place. One might think of this as the "Irish model," wherein a violent division of peoples along religious, nationalist, and colonialist lines could arrive at an admittedly fragile resolution grounded in shared history and rootedness in a land.

This result appears to be highly unlikely at the present moment, but it could become a reality the moment that the two-state solution finally collapses and the fundamentally racist conception of a "Jewish state" is separated from the question of the survival of the state of Israel. The Palestinians, having become what Edward Said called "the Jews of the Jews," have now developed their own form of nationalism—even a Zionism—complete with exile, Diaspora, and a longing for return. Their aspirations must be met one way or another, either in

a single binational, nonracist state grounded quite literally in their shared love of the land, or in a two-state "solution" that will have to be imposed by the United States for its own strategic purposes.

The historical agency in this latter scenario resides in the United States, the country Noam Chomsky describes as the "military ruler of the world."[27] Chomsky's "solution," which echoes that of military pragmatists such as General Petraeus, would of course condemn Palestinians in the West Bank and Gaza to a permanent and internationally legitimated form of colonial servitude without control over their own borders, the internal spaces of their country, or its natural resources. At the same time, it would condemn the Palestinian Diaspora and Palestinians inside Israel to a permanent condition of exile and apartheid. The racist obscenity known as "the demographic time bomb" (literally, the Palestinian birthrate) would be defused by a de facto and de jure racist state. The only things that stand in the way of this deplorable outcome are (1) the fact that, for quite a long time already, Israel-Palestine has been a single state in every practical sense of the word, repeatedly confirmed by the "facts on the ground" known as the ever-growing settlements;[28] and (2), a sense of common humanity and elementary justice, and perhaps a shared sense of historical suffering and destiny. The question in this latter scenario is not *whether* a single state is possible (it is already a material fact) but *when* it will be acknowledged as a legitimate reality, an Israel-Palestine where Jews, Christians, Muslims, and Arabs can live together as equals in peace. In other words, the question is the traditional biblical one expressed in Psalm 35: "How long, O Lord?" Could it be that the teachable moment has arrived and that it can no longer be dismissed as mere idealism or utopian imaginings?

Perhaps this utopian possibility is what causes the specifically Semitic inflection of the racial medium to play such a

paradigmatic role in other historic times and places–other moments when religion is racialized, or one racial narrative is compared to another, or one ethnonationalist aspiration builds on another. Consider, for instance, that Zion and Canaan land are metaphorically disseminated racialized spaces that don't just apply to the Middle East but that historically motivated the colonization of America and South Africa, and that racialized space is always a question of "seeing as." Zion is the name of the underground base that shelters the last remnants of the human species in the science fiction epic *The Matrix*. Cubans call the bearded revolutionaries that come out of the eastern end of the island "Palestinos"; in Northern Ireland, the iconography of Israel-Palestine is redistributed at the border between Catholics and Protestants; Mark Twain saw the Palestinians as American Indians; George Catlin saw certain American Indians as a lost tribe of Israel; Blackness in America has narrated the Black emancipation from slavery as the Jewish flight from Egypt. And now the Semites have literally converged in Israel-Palestine, locked in a deadly embrace. Could it be that when Jacques Derrida declared South African apartheid to be "racism's last word," he was preparing us for a Semitic moment of truth, a teachable moment to come in Israel-Palestine?

I would not be the first to register the deadly ironies that make racism and the return of the apartheid mentality visible in Israel-Palestine. Artist Larry Abramson, for instance, comes from a family of liberal South African Jews who participated in the anti-apartheid struggle and finally left to make a new life in the supposedly progressive, democratic, and nonracist state of Israel. Abramson's paintings express the contradictions he has encountered in graphic terms that go well beyond the immediate circumstances of Israel-Palestine and engage with the appropriation of European abstract painting as a kind of screen to reinforce the invisibility of the Palestinians. (See "Binational

Allegory," Part II, Chapter 2 in this volume.) Settlement architecture, as Eyal Weizman has shown, is designed to render the Palestinians *hyper*visible by constructing settlements as fortifications that occupy mountaintops (what the Bible calls the "high places") and keep the Palestinians under constant surveillance.[29] Apartheid functions, in other words, as a regime of both extreme visibility and transparency (from the use of watchtowers to pilotless drones and helicopters) to one of strategic opacity and the illusion of normality. Like Ellison's *Invisible Man*, the Palestinian is simultaneously seen and unseen, noticed and ignored.

And if the analogy with apartheid is dismissed as being inexact and inappropriate, one might reflect on the following list of similarities compiled by Saree Makdisi:

> Every single major Apartheid law from South Africa has its equivalent inside Israel (let alone the occupied territories); for example, the South African Population Registration Act of 1950, which assigned to South African citizens different racial identities on the basis of which rights would be granted or withheld has an equivalent in Israeli laws which assign to every Israeli citizen different "national" identities, on the basis of which rights are granted or withheld. Just as the Group Areas Act distributed the South African population in the territory of the state, so there are laws and regulations in Israel distributing Jewish and non-Jewish populations unequally through the space of the state (within its pre-67 borders, never mind the West Bank). Just as South Africa banned mixed-race marriages, so is it impossible in Israel for a Jew to marry a non-Jew. And so on.[30]

The main consequence of these paradoxes—a liberal, democratic state that practices apartheid, an insistence on continual surveillance of and obliviousness to the Palestinians in their midst—is the Israeli ambivalence about just what is to be done

with the Palestinians. Many Israelis think the Palestinians should simply leave, move to one of the Arab countries; and they condemn the Arab countries for failing to "take care of their own" as Israel has done with the Jewish Diaspora. Others propose that the Palestinians simply submit passively to the fact that they are a defeated people and accept that their only hope is to be quiet and accept their subjugation. This would probably work if it weren't for the numbers: it would mean one half of the population of Greater Israel (West Bank and Gaza included) would be living in subjection to the other half—not an ecologically or politically sustainable situation. So what is left is the ever-retreating mirage of a two-state solution, a kind of carrot dangling in front of the donkey to keep him moving without getting any closer to his goal. This mirage could become a reality in a moment, however, if the United States decided to impose a two-state solution on Israel (unlikely), or if the Palestinians simply declared statehood and received recognition from the United Nations. Or it could vanish the moment that the two-state solution collapsed, with fatal consequences for the *Jewish* state but perhaps ultimately the best prospect for a united, peaceful, democratic Israel-Palestine where people could get on with their lives. Ehud Olmert has prophetically envisioned this outcome: "If the day comes when the two-state solution collapses, and we face a South African-style struggle for equal voting rights (also for the Palestinians in the territories), then, as soon as that happens, the State of Israel is finished."[31] One wishes that Olmert had completed his thought with a bit more precision: it is the Jewish state, not the state of Israel, that would be "finished" if the two-state solution collapses.[32] It is perhaps worth pointing out here that even if the Jewish state were to implode in a binational country where the "population bomb" would go off, the drastic inequality of wealth and political power that the Jews enjoy would continue for many

years to come. Jews in post-Zionist Israel would, in other words, become rather like Whites in the United States, who are clearly becoming a racial minority but continue to dominate economic and political life.

I want to return now to the question, and the teachable moment with which I began: Is this about race, or is it about land? We have already noted in "The Moment of Blackness" (Part I, Lecture 2 in this volume) how bodies and bloodlines serve as the mediations of racial identities. For Israel-Palestine, the bloodlines are still central (especially in the "law of return," which might be described as a positive version of the "one drop rule" in African America). But the primary physical and visible manifestation of race in Israel-Palestine is expressed in the land and landscape, in the spaces of separation exclusively reserved for Jews only. Blood is mixed with soil—"seed with sod"—as the racial medium of the segregated Semitic convergence. So the answer to my opening question has to be yes, it is clearly both race and land, or perhaps race *as place, space, and land-scape*; there is no either/or. Racial identity, and the identity of its physical spatial mediations, is not a static, immutable category but a product of racialization. If the Jews were not a race when they arrived in Israel, they have made themselves into one. If the Arabs were not anti-Semitic when the Jews first arrived, many have now become so. And if the Jews were not racists before they came to Israel but a model of liberation and toler-ance, they have spent a half century earning the title of racists with their treatment of the Palestinians and their self-transfor-mation from Zionists pledged to being a light to the world to an actual situation where half of their Arab brothers are living in conditions of intolerable inequality. As Fanon predicted, "the collective unconscious" of the Jews who settled in Israel would indeed be very different; he was only wrong in saying that it would take one hundred years. The transformation from victim

to victimizer, from an object of genocidal strategies to a perpetrator of ethnic cleansing was almost instantaneous, starting in 1948, as Ilan Pappe has shown.[33] The big question is, how did the Palestinians become the Jews of the Jews, as it were, victims of the victims of the Holocaust? And how did the Jews, survivors of the Nazi genocide, work themselves into a position of building an apartheid wall down the spine of their country, conducting a military occupation and a legalistic state of siege that amounts to a policy of ethnic cleansing that displays all the telltale signs of apartheid?[34]

Eyal Weizman describes the situation:

> The logic of "separation" (or to use the more familiar Afrikaans term, "apartheid") between Israelis and Palestinians within the Occupied Territories has been extended, on the larger national scale, to that of "partition." At times, the politics of separation/partition has been dressed up as a formula for a peaceful settlement, at others as a bureaucratic territorial arrangement of governance, and most recently as a means of unilaterally imposed domination, oppression, and fragmentation of the Palestinian people and their land.

Naming these spatial practices frankly as apartheid must be accompanied by a crucial qualification, however. Apartheid depended on the Bantustans to supply a cheap labor force. In recent years, Israel has weaned itself off reliance on Palestinian labor; the plan now is simply to make them so miserable that they will leave. The goal is really quite biblical: to cleanse the land of the alien race. Note that it doesn't matter whether the Palestinians are Muslim or Christian; their "Arab" identity is enough to mark them for expulsion.

Abe Foxman, the head of the Jewish Anti-Defamation League, has the most ingenious answer to the question of how Zionism became a racism, and that is to focus on its *normality* as

a nationalistic movement. "Every nationalism is racist," claims Foxman, including American, French, and Palestinians in the charge. Therefore, if you believe that "the only nationalism in the world that is racist is Jewish nationalism, then you're an anti-Semite."[35] Foxman should write a play entitled "How I Learned to Stop Worrying and Love Racism."

Nevertheless, there is a lesson in what Foxman says that Edward Said took to heart. First, he steadfastly resisted all appeals to anti-Semitic rhetoric by supporters of the Palestinian cause. And when he was asked how he could support any form of Palestinian nationalism, even in a binational state, his answer was that he wanted there to be a Palestinian nation so that he could then exercise his true vocation as an intellectual and subject it to ruthless criticism (not that he pulled his punches against the nascent leadership of the Palestinian state or refrained from criticizing Arafat and the PLO).

Said's search for a mediating critical position calls to mind his concern that Israel-Palestine was locked in a suicide pact. This pact manifests itself most literally in the turning of the Palestinian resistance to the futile[36] and morally hideous tactic of suicide bombing, but it is echoed in an Israeli ritual that reinforces what I call "the Masada complex." Among the many teachable moments in my visits to Israel was an expedition in 1987 to the ancient fortifications overlooking the Dead Sea. Our guide recited the canonical lesson that is repeated dozens of times every day to visitors to the site. A heroic Jewish resistance movement against the Roman occupation fought bravely on this spot in 66 CE and committed mass suicide rather than accept defeat and enslavement by the Roman victors. In case the moral was not clear, the guide drew it for us: Masada is a symbol of modern Israel. If ever a foreign power threatens to conquer us again, we will prefer suicide to defeat. But this time we will take the rest of the world with us. The tacit acknowledgment

that Israel has nuclear weapons and is prepared to use them was not lost on any of us.

Reenactments of this scene of instruction appear repeatedly in Avi Mograbi's superb documentary film *Avenge but One of My Two Eyes*, the title taken from the words of Samson's prayer before he pulls down the temple in a suicidal act of revenge against the Philistines. But Mograbi also captures a moment of resistance to the teachable moment when a young Jewish American woman protests the lesson as she argues with the guide that it is against Jewish law to commit suicide, not to mention the fact that the women and children did not commit suicide but were murdered by their men. Mograbi's film is a sustained critique of what we might call the "Samson complex" in contemporary Israeli culture, the arrogance and moral coarseness that accompanies absolute military superiority over the Palestinians, combined with a certainty about the religious righteousness of their cause, a certainty that was reinforced during the recent invasion of Gaza by coaching from right-wing rabbis.[37] The Samson complex also involves a racial and sexual lesson as it is a cautionary tale about sleeping with the enemy or, indeed, showing any kind of human sympathy for their plight.

Of course, there will be objections to seeing these issues in terms of "race-talk" or "race-thinking." Replacement explanations on the basis of politics, economics, the cultural backwardness or intransigence of Arabs, the fanaticism of Hamas or Hezbollah, or the all-purpose brand of "terrorism" provide Israelis (and their American sponsors) with a way of disavowing the racist logic that unites all these claims. The deployment of narratives and images from biblical holy wars (e.g., the portrayal of the Palestinians as "Philistines" who must be driven from the land, along with all their "graven images," "high places," and other traces of their existence) will be read, like the parallel case

of the "barbarians" in Greek culture, as having "nothing to do with race." But race is the only concept we have that is capable of encompassing the multiple vectors of religion, culture, politics, and a "naturalized" sense of what constitutes a people. Race is the cognitive crossroads that makes these convergences and their practical application intelligible.

That is not to say that race *explains* the Semitic moment of the Israeli-Palestinian impasse. It only makes it intelligible and perhaps *teachable*, exposing it as a mediated construction of race, a "complexion" of images and narratives, both the reality and the fantasies of racial struggle. The real-world explanation for the impasse would have to take into account the role of U.S. neocolonialism and the fact that, as Chomsky argues (joining the ranks of those who see only cold realpolitik calculations), the United States could impose a two-state solution on Israel. It is difficult to imagine a greater irony than the spectacle of an African American president saying the following words about his Black pastor's blistering critique of the racist and neocolonial policy of ethnic cleansing that is going on in Israel:

> [The Reverend Wright] expressed a profoundly distorted view of this country—a view that sees white racism as endemic, and that elevates what is wrong with America above all that we know is right with America; a view that sees the conflicts in the Middle East as rooted primarily in the actions of stalwart allies like Israel, instead of emanating from the perverse and hateful ideologies of radical Islam.[38]

But Reverend Wright was correct. Racism *is* endemic to this country and, along with homophobia, is deeply ingrained in the mentalities of right-wing political and religious movements. He also understood the sophism that exonerated Israel of all responsibility for "the conflicts in the Middle East." In a way Obama was right, implicitly acknowledging that Israel is only

an extension of U.S. Middle East policy—a "stalwart ally."[39] In this sense, it is not Israel that is ultimately responsible. *We*, the citizens of the United States, are responsible for the conflicts in the Middle East. It is our armies that occupy Iraq and Afghanistan, nobody else's. It is our military umbrella that shields innocent, peace-loving Israel from its violent, savage neighbors. And it is our responsibility, as citizens of this country, to break through the illusions of the common Zionist narrative coupled with neocolonial realpolitik that unites Israeli and American "interests" in the region.[40] The racism endemic to this country has been woven into Israeli racism; our mythology is their mythology, and our madness is their madness. That is why even a prestigious military realist like General Petraeus can be forced to shut up when he points out that Israel's behavior is making the United States' position in the Middle East increasingly dangerous and ultimately untenable.[41]

Racism is the nodal point, the vortex of passion that brings religion and existential fear of the enemy into toxic convergence in Israel. The racist agenda of the Holocaust is continually reinforced in a hysterical cycle that verges on mass paranoia. The horrible truth is that Israel does not even want the Palestinians as slaves. Slavery would involve caring enough for your labor force to maintain its capacity to reproduce itself. Israel just wants the Palestinians to go away, hence the protracted process of enclosure and expulsion, of an ethnic cleansing carried out under the banner of security. Racial purity (e.g., the survival of a Jewish state) trumps any prospect of a peaceful solution. Ironically, the most realistic prospect of maintaining this sort of purity would be acceptance of Palestinian claims to nationalism. Israel's survival as a moral polity (not to mention as a viable political entity), as something other than a buffer state for American neocolonialism, would seem to depend on awakening itself from its racist nightmare.

The way out of this nightmare is not by way of a disavowal of race, a claim that it has no role or explains nothing. Admittedly, it does not explain everything. But the concept of race as what Du Bois called "an ancient instrument of progress" might provide an alternative way of telling the story of Israel-Palestine and of thinking beyond the ever-elusive carrot of a two-state solution toward a binational *culture*, if not a binational state. If the two-state solution is simply conceived of as an end in itself, it will do little more than make the Middle East a little bit safer for General Petraeus and establish the nascent Palestine as a deeply crippled polity. Much more will be needed in the form of a massive economic rehabilitation of Palestine, compensation for the stolen lands of the Palestinians, and some form of the right of return for those Palestinians who have legitimate claims to property in Israel.

There will also need to be a recognition of what Hannan Hever has called a "post-Zionist condition," in which the international Jewish community does some soul-searching.[42] This is already well underway among many younger American and Israeli Jews, and it involves looking backward to some critical turning points in the establishment of Israel. The Zionist imaginary was not only about conquest, colonization, and expulsion of native inhabitants. There was also a core of idealism about a new Semitic brotherhood that was supposed to build upon universal humanistic values and (of course) socialism. In a recent Israeli documentary tracing the lives of three generations of Jews in Israel, an early kibbutznik remarked, "We thought Arabs and Jews would live together in peace."[43] These idealists managed to convince themselves that the 1967 War was a war of liberation *for the Palestinians*, who were seen as welcoming the victorious Israeli army as it swept through Ramallah. Even more deeply rooted was the heritage of kinship and tolerance of Judaism in the Muslim world, vividly dramatized in a documentary

film about Hebron that explores the phenomenon known as the "milk cousin." In Hebron as recently as the 1920s, Jewish and Arab families lived in such close proximity that mothers would pass their babies across racial boundaries to neighbor women who would nurse the infants until the birth mother's milk had come in. Descendants of both Jewish and Arab families who lived side by side in Hebron give the testimony: "It was the arrival of the European Jews, who kept to themselves, that started the trouble."[44] Did the European Jews bring along with them a peculiar form of anti-Semitism that lumped Muslims and Arab Jews together? Did Hebron witness a reenactment of the ancient quarrel narrated by A. B. Yehoshua in *Journey to the End of the Millennium*?

It is important to understand, then, that race is not just the key to understanding racism but that it may also be a foundation for any notion of "racial harmony" involving both acknowledgment and respect for difference. And I do not mean by this some kind of liberal multiculturalist tolerance but a notion of racial solidarity built upon the intricate and infinite historical filiations, including the shared love of the land. Raja Shehadeh's wonderful book *Palestinian Walks: Forays into a Vanishing Landscape* concludes with an encounter between the author and what should be his most despised antagonist, a Jewish settler. Surprisingly, the settler is a fellow walker on the land and offers to share a nergileh (water pipe) with Shehadeh. As they draw on what turns out to be opiated hashish, Shehadeh observes the following:

> All the tension of the times, the worry about going through area C, the likely prospect of encounterieng soldiers or settlers, or getting shot at or lost, was evaporating. With every new draw of the nergila, I was slipping back into myself, into a vision of the land before it became so tortured and distorted, every hill, watercourse and rock, and we the inhabitants along with it. . . .

> I was fully aware of the looming tragedy and war that lay ahead
> for both of us, Palestinian Arab and Israeli Jew. But for now, he
> and I could sit together for a respite, for a smoke, joined tempo-
> rarily by our mutual love of the land.[45]

Needless to say, such scenes are rare, perhaps the most ephem-
eral expression of a teachable "*Semitic* moment." More typical,
alas, are the scenes captured in *Checkpoint*, another Israeli doc-
umentary film that captures the numbing daily routines of the
more than five hundred permanent and flying checkpoints that
erupt like cancerous sores all over the Palestinian countryside.[46]
In one of the most shocking scenes from this film, a young
Israeli soldier makes a defiant speech to the camera, articulating
what he takes to be the unquestionable reality of the situation:
"Ramallah is a zoo, but the animals cannot get out. We are the
zookeepers." When the camera operator murmurs a protest at
his candor, he responds emphatically, "We are humans, they are
animals. And I don't care who you show this to. You can show
it to the head of the general staff for all I care."

The paradoxical effect of this young soldier's attitude is the
racializing of the Palestinians in the most extreme terms, as a
different species. If the Palestinians were not quite a nation,
much less a race before 1948, more than half a century of occu-
pation has made them into a race, complete with a diaspora and
an ensemble of racist denigrations. This people, so similar to the
Jews in their high rate of literacy and their shared attachment
to the land, have been transformed into a "chosen people" by a
history of oppression, exploitation, and dispossession.

Race, as I have been arguing, is a medium that installs a veil
between peoples, a veil whose warp and woof are the threads
of natural and cultural distinctions (on the one hand, blood,
sex, and soil, and on the other hand, customs, religions, and
social inequality). This veil, as Du Bois so presciently saw, plays

a double role. It is a mask of opacity that prevents peoples from seeing and understanding each other, that presents a surface where images of the other are inscribed, painted, and projected. At the same time, however, it is the vehicle of a "second sight" that has the potential to overcome that opacity, to move from a situation where peoples see each other (to echo the biblical phraseology) "through a glass darkly" to a moment where they have a possibility of seeing each other "face-to-face." To put this in more practical terms, the medium of race is always open to *remediation*, to a secondary representation, a double take, a critical reflection that has the potential to provide a teachable moment.[47] The most literal and physical version of this sort of remediation discussed here has been the ritual of blackface minstrelsy, which doubles the "epidermal schema" of skin color, renders it a performance and mimesis that emancipates it into a space of critical reflection. This, at any rate, is what I take to be the fundamental gesture and aspiration of Spike Lee's *Bamboozled*, with the added twist that the "second sight" of blackface turns out to be a tragic miscalculation. There is no guarantee, in other words, that the remediation of the racial medium will produce enlightenment, any more than there is a guarantee that the teachable moment will be truly educational or emancipatory. It may wind up being merely pedagogical, a ritual repetition of the same old racist lessons, or it might revive a serious reconsideration of the basic moral and political question raised by Rodney King: Why can't we all just get along?

That will not prevent artists from trying, however, and it would require another lecture to survey the numerous ways that artists on both sides of the racially fractured land known as Israel-Palestine have remediated the veils that divide them. Probably the most obvious and literal is the transformation of what Palestinians and some Israelis call "the apartheid wall" into a support for artistic expression. Murals, graffiti, photographic

surveys, and cinematic projections have all been deployed to produce a virtual disappearance of the wall or to reemphasize its brutality. Many Palestinians regard painting the wall, even with slogans and images of resistance, as an inevitably compromised act of ornamentation, and prefer to keep the wall unadorned. Either way, the aim is the same: to make racism visible and legible by making the gray concrete veil hypervisible or by rending the veil to reveal a new potential reality or the trauma of the Real. Miki Kratzman's magnificent photographs accomplish both of these tasks, exposing the naked brutality of the wall and the futile efforts to conceal it with trompe l'oeil landscape paintings that "disappear" both the inconvenient Palestinian presence and the process of disappearing itself. (See Chapter 1, "Gilo's Wall and Christo's Gates," and Chapter 3, "Migration, Law, and the Image," in this volume for further reflections on these images and other artworks that make visible and contest Israeli practices of apartheid.)

Jacques Derrida, as I mentioned earlier, called apartheid "racism's last word," in the sense that it provided "the unique appellation for the ultimate racism in the world." Apartheid was "the last" in the sense of "the worst" and "the latest" form of racism, a word that "no tongue . . . ever translated," "as if all tongues were refusing to give an equivalent, refusing to let themselves be contaminated" by translating it. Perhaps the apartheid wall, with its obscene echoes of the Warsaw Ghetto and the Berlin Wall, will earn the title of racism's last *medium*, its very existence a teachable moment for rethinking the fate of the most dangerous and most endangered race on this planet, namely, the *human*.

TEACHABLE OBJECTS

My emphasis to this point has been on the historical and temporal character of race. The idea of the moment, whether the seemingly trivial, passing, and momentary occurrence like the arrest of the director of the Du Bois Center at Harvard or the momentous event of Barack Obama's election, has been the main structuring idea. But it is clear that race is a matter of space as well as time, of material things (bodies, buildings, commodities, works of art) as well as actions and events. In the second half of *Seeing Through Race* my aim is to refocus our attention on the *things* we see through.[1] And "throughness" must be understood here in a double sense as referring to a transparency in which the medium or intervening substance seems to disappear in favor of a clear view of something on the other side, or to an opacity or obstruction in which the thing we see through either gets in the way, produces a distortion, or enhances and magnifies our understanding in a new way. To see through something is to see *by means of it* as well as to see past it or beyond it. The metaphor of race as a lens, for instance, captures precisely this ambiguity. A lens can distort or invert what is seen through it, but it can also rectify a distortion or overcome myopia. Du Bois's veil is partially opaque but translucent enough to make a "second sight" possible. Racial stereotypes are reductive distortions of individual singularity, but they can also function

as self-fulfilling prophecies that induce stereotyped behavior, or acts of critical performance and mimesis, as Spike Lee demonstrates in the send-up of minstrelsy in *Bamboozled*.

William Blake's wonderful aphorism "We are led to believe a lie, when we see with, not through, the eye," implies a clear distinction between seeing *with* and seeing *through*. The human eye itself becomes the medium, and its natural, bodily limitations must, in Blake's view, be constantly corrected by a visionary perception that looks beyond the material constraints of physical vision to the spiritual or human truth of the world. But this can only be done if one takes a clear-sighted and critical view of the objects through which one is seeing, including that strange object known as "the eye." We need, in other words, to learn to look *at* as well as *through* the objects that we see *with*. Spike Lee's unblinking gaze at "Black collectibles" and the materiality of blackface performance in *Bamboozled* amounts to just such a turning toward the media and the images that we see *with* and *through* and the specific objects in which medium and image coalesce.[2]

The second half of *Seeing Through Race* will take up some of these objects: works of art, walls, gates, borders, landscapes, and other racialized spaces that endure beyond the moment when they are created and that offer potential lessons by virtue of that endurance. It will conclude with a reflection on the phenomenon of idolatry and its evil twin iconoclasm. Idols are the supreme example of the racialized object, as they provide occasions for human sacrifice and genocide, typically in the service of racial or tribal purification. We have already examined the way that the very concept of race functions as an "idol of the mind" that bedevils imagination and perception, preventing recognition of the humanity of other peoples. It seems only appropriate, then, to conclude by turning our gaze toward the phenomenon of idolatry itself and to attempt a conversion of these dark, dangerous images into teachable objects.

GILO'S WALL AND CHRISTO'S GATES

Of all the media and genres of images and objects, landscape is the one that makes the constitutive blindness and invisibility of the visual process most evident. We notice this even in the most common injunction in the presence of a landscape prospect: "look at the view." What does that mean? How can one look at a view? One looks at objects, figures, faces, bodies, and signs. Our visual system learns to pick out *things* that have names: this tree, that house, those fence posts. So what are we looking at when we look at the view? Everything and nothing. The view is the totality of the objects in our visual field, the relations among them, the entire system or syntax that underlies the language of vision. Looking at the view is like looking at the grammar of a sentence while forgetting what it is saying. Or it is like "looking at looking," a process that invariably reveals to us the paradoxical invisibility of vision itself. We will never quite see what vision is, no matter how precisely we may describe or depict it.

The paradoxical character of seeing landscape, looking at the view, is materialized for us most vividly in the phenomena of walls and gates, the things we build around ourselves to obstruct the view, and the holes we punch in those obstructions to allow ourselves to pass through, visually and bodily, what we have erected precisely to prevent such a passage. The wall and the gate (or the window) are what give the fort-da game of "now you see it, now you don't," of "peekaboo," a physical field of play. They are the architectural manifestations of the scopic

drive as a push and pull between what geographer Jay Appleton calls "refuge" and "prospect," the impulse to see and show, on the one hand, and to conceal and hide, on the other hand.[1]

Consider two recent works of landscape art that dramatize this paradoxical process, the Gilo Wall in Jerusalem and Christo's *The Gates* in New York City's Central Park.[2] The Gilo Wall was built on a hillside at the outset of the second Palestinian intifada in 2000 to protect the Israeli settlement of Gilo in East Jerusalem from snipers in Beit Jala, the neighboring Christian Palestinian village on the hillside facing it.[3] When the wall proved both ineffectual and ugly, blocking the highly prized "oriental landscape" of Beit Jala, the settlers began defacing it with hostile graffiti. In response, the municipal authorities decided to "soften" the wall by commissioning an "artistic replica of the disappearing view."[4] A group of recently arrived Russian immigrant artists were hired to paint the wall because it was realized that most established Israeli artists would have refused the commission as a blatantly ideological exercise in kitsch beautification. The rise of walls between Israelis and Palestinians has generally been greeted with critical and deconstructive responses by artists on both sides of the ever-shifting "border" between Israel and Palestine. Artists Without Walls, a forum of Israeli and Palestinian artists, produced an intervention in April 2005 involving "real-time video projections on both sides of the security wall" at Abu Dis, in which "each side of the Wall had the view on the other side projected on it."[5] This group has also performed an action known as the "Wall of Tears," in which notes with wishes for peace were inserted into the cracks, a reminder of the ritual practice at the Western or Wailing Wall in Jerusalem.

The Russian artists, impoverished and grateful for the commission, brought with them what they describe as a "sad" style of painting derived from socialist realism, which they regard as a

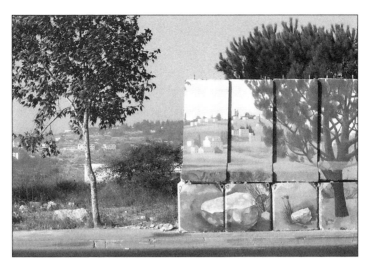

Figure C1.1. Gilo Wall. (Photo by Miki Kratsman.)

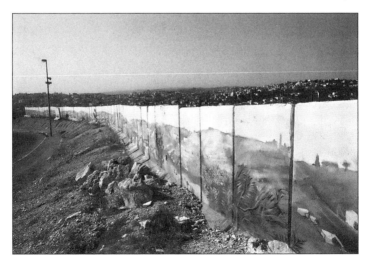

Figure C1.2. Gilo Wall, overview. (Photo by Miki Kratsman.)

relic of "the Soviet system . . . of living with lies." In interviews they expressed considerable ambivalence about the project: the "hiding" of the landscape with a simulacrum struck them as "morally wrong," yet somehow "they also felt that they were helping the Gilo residents morally."[6] This ambivalence has its aesthetic component as well, in the sense that the obviously kitsch character of the painted landscape is somehow overcome in the moment of critical viewing that looks "askance" at the wall and subjects it to a reframing.

When viewed from above and the side, the Gilo Wall reveals itself as a seam or scar in the landscape, a border that simultaneously divides a lived, social space and overcomes that division by veiling it with an illusion. The wall is precisely an erection of a racialized blind spot in the landscape that, unlike the larger security wall that is being built to protect Israel from the Palestinians, conceals itself with a veil of illusory transparency and then reveals itself when one moves to the edge of the veil, in the vulnerable open space between the Gilo settlement and Beit Jalla. From this angle one sees immediately the contrast between the real and the depicted Palestinian village. The real village is populous, covering the adjacent hillside with housing. The painted village is a picturesque Arabian pastoral, a depopulated landscape. It shows with remarkable candor the long-standing wish of many Israelis to simply "disappear" the Palestinians along with the signs of their habitation. But not, it should be noted, to disappear them completely. The mosques remain as reminders, a comforting acknowledgment of what and who will have vanished, a kind of melancholy recognition of disappearance that is the central aesthetic emotion of the Romantic picturesque.

This is in sharp contrast to the other kind of candor, the destruction wrought by the Israeli security wall, which extends and extrudes the brutalist architecture of the settlements for

some hundred miles, slashing into the West Bank, cutting off Palestinian farmers from their fields, splitting families and friends with the naked simplicity that reminds us of the Berlin Wall and (even more ominously) of the wall around the Warsaw Ghetto.[7] When completed, the euphemistically named "fence" made of concrete slabs ten meters high will take up much more space in the tiny land of Israel-Palestine than the entire city of Jerusalem. This "separation barrier" comes, of course, with numerous gates, and the West Bank more generally has become a land of (usually blocked) gateways. In January 2004, according to the UN Office for the Coordination of Humanitarian Affairs (OCHA), there were 59 permanent Israeli checkpoints in the West Bank, 10 partial checkpoints, 479 earth mounds, 75 trenches, 100 roadblocks, and 40 road gates, all designed to disrupt or halt the circulation of Palestinian traffic.[8]

The wall is routinely declared to be a merely temporary measure, but it is also widely suspected of being the key tactic in a

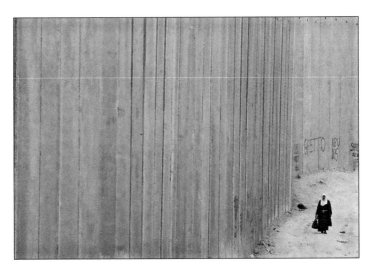

Figure C1.3. The security wall at Abu Dis. (Photo by Miki Kratsman.)

permanent annexation of Palestinian land that will make the emergence of a viable Palestinian state in a contiguous, sovereign territory an eco-sociological impossibility. Which is worse, the Gilo Wall that disappears itself at the same time as the Palestinians securing an illusion of peaceful neighborliness in the landscape, or the brutal frankness of the security wall? The answer, as Slavoj Zizek might put it, is that both are worse, the one for its deceptiveness, the other for its frankness. But for me, the Gilo Wall takes the prize for the most provocative piece of Israeli landscape art in recent years because it opens a space for critical reflection, an ambivalent zone of concealment and revelation. In a peculiar and unexpected way, this recycling of socialist realism and the picturesque turned out to be an inspiration for the cooperative work of Palestinian and Israeli Artists Without Walls in their effort to deploy real-time hyperrealism to disappear the security wall from both sides.

Christo's *Gates* invite an equally complex and elusive meditation on the dialectics of landscape and vision, and the critical potential of kitsch. The *Gates* drew tourists from around the world, some drawn no doubt by the fame of Christo's previous landscape installations and the very ephemerality of the construction. The *Gates*, unlike the Israeli security walls, were erected with a strict time limit. They literalized by temporalizing the fort-da game of appearance and disappearance in the landscape. But the initial reaction to the *Gates* seems to have been one mainly of puzzlement and disappointment. I confess that my own reaction was one of being underwhelmed; feeling that I did not know what to look at or what to make of it. Of course, the *Gates* were "pretty." The saffron fabric, when fluttering in the wind, produced a kind of ornamental fringe adding a surplus enjoyment to what is arguably the single most famous artificial landscape garden in the world. But Central Park was already beautiful. What did the *Gates* add to it? What

Figure C1.4. Christo, *The Gates*. (Photo by author.)

could they possibly be saying to us that the park itself had not already said?

Many reactions to the *Gates* were symptomatic of this frustrating elusiveness, the refusal of the *Gates* to "say" anything or even to *show* anything very surprising.[9] They marked out the winding paths, of course, but we already knew that the paths of the park are sinuous, variable in width, snaking picturesquely over the hills and through the woods and across the fields. Did we need Christo to show or tell us this? This elusiveness may have been the reason there were so many comparisons of the *Gates* to other things, comparisons that often seemed to be disrespectful. The *Gates* were "seen as" giant croquet wickets or as a kind of walk-through equivalent of the curtained tunnels of a car wash. The color of the saffron fabric was objected to as unfortunately similar to the orange fabric that adorns the

temporary fences of construction sites. And the larger purpose of the *Gates* was disturbingly vague, perhaps even vacuous. The *Gates* seemed to suffer in contrast to Christo's *Wrapped Reichstag*, which took a deeply troubled historical monument, the central symbol of Germany's traumatic role in the twentieth century, and seemed to transfigure it, releasing it from the spell of nationalism and resurgent fascism, delivering it as a kind of gift to be unwrapped for a new stage in German history.

But what message did the *Gates* have for us? To me, the kind of harmlessness and innocence, even the prettiness of the *Gates*, seemed at first glance to render them trivial, a passing sensation whose primary virtue was its ephemerality. It was especially disturbing to me that Central Park, a purportedly public space, had only a few months earlier been declared "off limits" by the city of New York for a massive political demonstration against the Republican Party during its August 2004 convention. The reason given was the danger of damage to the Great Lawn, which would have been trampled and perhaps torn up by the large crowd if the demonstration had been accompanied by rain. "So," I said to myself, "it is okay to take over the entirety of Central Park for a harmless art project, a bit of innocuous urban beautification. But it is not okay to use Central Park as a gathering place for political demonstrations." Like many others, I thought that the time for the *Gates* was past, that it would have made sense when Christo initially proposed it back in 1979, when it would have helped to transfigure what had become a dangerous jungle, a hideout for muggers and murderers, into a liberated and pacified public space.

But the dialectics of landscape and vision are not always revealed to us at first glance. Sights and sites are memory places that may continue to work on us long after our first—in this case, our only—glimpse of them. And in fact I think that Christo's the *Gates* will continue to resonate for some time to come, if only

because their very elusiveness and vagueness will elicit a continued "filling in" by the imagination, an interpolation of meaning, and a long incubation of images in memory and the photographic record. Part of this filling in will be prompted, I suspect, by the formal character of the *Gates* itself, which mirrors the formal structure of the entire park in its combination of a rigid, geometrical, rectangular frame with a fluctuating, undulating interior.

This formal mirroring of the whole in the part is what arrests and entices the beholder simultaneously, one moment urging the walker to stop at each gate, to use it as a frame for a new vista, to pause and reach up to the saffron veil just high enough for an adult to reach on tiptoe, and then to be propelled onward, to stride through each gate. Like those minimalist corridors to nowhere designed by Robert Morris in the 1960s, the *Gates* lure us onward and stop us in our tracks at the same time.

Figure C1.5. Close-up of Christo's *The Gates*. (Photo by author.)

Figure C1.6. Christo's *The Gates* as corridor. (Photo by author.)

They create open-air corridors that end, not in an inaccessible cul-de-sac (as with Morris) but in the open, in a state of indeterminacy, "looking at the view"—that is, at everything and nothing at the same time. The uncertainty about which of these things we are supposed to do is, I think, one of the things that initially struck beholders as a kind of vagueness and pointlessness, as if we were being presented with a whole new set of playground equipment in Central Park that was designed for a game we have not yet learned how to play.

But the game is only beginning, as Christo's work, often dismissed and misunderstood, has demonstrated time and time again. The retro-spect is, in Christo's work, just as important as the immediate pro-spect, and in fact the ephemeral, temporary prospect is only constructed as a kind of "photo op" for an open—in principle endless—series of retrospective "takes."

We have to ask ourselves, what did the *Gates* make visible that was previously hidden from view? What appeared that could not have been seen without them?

I ask these questions not because I think I have all the answers but in order to provoke exactly the sort of retrospective assessment that seems constitutive of landscape "prospects" as such. Here are a few of my own answers, a list that should be seen as necessarily incomplete:

1. The formal dialectic of rectangularity and sinuosity (which may be dismissed as all too obvious) is a provocative for a deeper reflection on this feature as a key to the specific character of Central Park, its ground plan and internal ground-level views with the interplay between foliage and architecture; irregular interior and regular, vertical framing. It also activates an awareness of Central Park's embeddedness in a deep tradition of landscape aesthetics that is defined by precisely this alternation between the stable structure and the moving, dynamic appearance, between artificiality and naturalness, between design and control and unbounded randomness. This is a tradition that transcends period and national styles of landscape architecture, evoking the neoclassicism of Alexander Pope, whose "Windsor Forest" is predicated on a concordia discors of light and shadow, form and flux:

> Here hills and vales, the woodland and the plain
> Here earth and water seem to strive again
> Not Chaos-like, together crushed and bruised,
> But, as the world, harmoniously confused.

It also reminds us of Robert Smithson's analysis of picturesque Central Park as a "dialectical landscape"[10] that brings geological and paleontological forces into conjunction with the inscribed surfaces of modern civilization. *The Gates* makes the form of the landscape stand up on two legs, pictorializes it like the empty

frame of a Magritte painting in the midst of the view or a Morris Louis abstraction, veils it in translucent waves of color, and then depictorializes it by inviting us to walk through the frame again and again.

2. One of the original features planned for Central Park, ultimately rejected by Olmsted, was a set of entrance gates that would have been monumental, heavily ornamented, and closed against the public at night; Olmsted recognized that the park would turn into a wilderness when the sun went down, and the gates were originally designed as a public safety measure. The notion of democratic openness prevailed, however. As Olmsted put it, "how fine it would be to have no gates."[11] Christo's *Gates* is a reminder of this piece of the deep history of the park. The installation evokes the notion of the gate as a barrier to passage and an open invitation to it at the same time. The translucence of the saffron curtains is the coloristic analogue to this double message. Rather than an illusion of transparency (compare the trompe l'oeil on the Gilo Wall), translucence allows the passage of sunlight and shadow through a moving surface, an effect that almost every visitor registered as a source of delight, especially when a burst of sunlight would illuminate the fluttering fabric with the tracery of bare winter branches from the trees overhead. Christo reminds us that curtains are not just there for privacy; they are "part-objects" that simultaneously occlude and illuminate, foregrounding the mediation of visual experience as such. Their resemblance to the orange warning fabric around a temporary construction site is, in this light, not a blemish but a deeply suggestive feature.[12]

3. The long temporal process from 1979 to 2005 of bringing this work to fruition rendered at least partly visible what the park is as a civic, political, and economic institution. Central Park is a public space, but what exactly does that mean? The coincidence of Christo's aesthetic appropriation of the *entire*

park with the forbidding of public appropriation of *any* part of it had the happy effect of deconstructing any simple illusion about the control of this space. Although Central Park was originally designed as free gift to the public, it was also an incredibly complex political institution and was largely designed to provide a magnificent front yard for the newly minted millionaires of Knickerbocker-era New York, who rapidly bought up all the surrounding real estate. An Irish shantytown and a well-established African American village (complete with a church) had to be forcibly removed by the police. Like the Palestinian landscape, like all of North America, Central Park is the site of "disappeared villages" and the ghosts of vanished races. One thing the *Gates* make hypervisible in the landscape of the park is the movement of the air, the necessarily invisible (or translucent) medium through which all spatial perception must travel. In the fluttering saffron draperies one seems to feel the motions of these invisible presences, the specters of visitors and residents past and present who have moved along the pathways, passing through Olmsted's sacred public space in order to purify themselves with an escape into "nature" from the constraints of the city. These invisible presences, felt only in the breezes, are the genius loci, the "spirits of the place" that reveal themselves passing through the gates, which can then be "seen as" something like Native American dream catchers. Although the park is now technically "public land," it may be rented for private use, and areas may be temporarily fenced off for private functions. Christo rented the entire park, in effect privatizing the whole thing, in order to erect a construction that symbolically evoked the control and fencing of land, proliferating a vast number of the most salient feature of walls, borders, and controlled checkpoints, and then transfiguring them into their exact opposites—gates without walls, gates that open up corridors that lead us into infinite space. In a time when commodities and credit circulate more

and more freely in a global economy, and human bodies are confronted increasingly with walls, borders, checkpoints, and closed gates, one is compelled to admit that Christo's timing for the *Gates* was uncannily perfect.

But this timing is not something that can be attributed to the intentions of the artist. It must, rather, be thought of as something like artistic *luck*, a coincidence that brings an image into the world at the right historical moment for its specific impact. It is not so much that the *Gates* would have lacked force if it had been installed at another time but that its force would have been different. If the installation would have taken place in the autumn of 2004, the memory of the ban on public assembly would have been fresher and more vivid, but the visual impact of the saffron curtains against the fall colors would have been muted; the *Gates* had the greatest impact, of course, on those days when snow was on the ground. Or the installation could have been erected in 1989, when the demolition of the Berlin Wall was underway, in which case its political contemporaneity might have seemed even more obvious. This was a work of time—twenty-seven years, to be exact—that could have found other moments. (for instance, as I write, the United States Senate is debating the idea of building a wall along the Mexican border). And the *Gates* would, at any time, have been seen (and dismissed) by many as merely ornamental, nothing but a bit of charming excess, a tourist gimmick. That is their eternal charm: their gaiety, harmlessness, and utter frivolity. Eighteenth-century landscapists talked of "binding and unbinding nature's loose tresses," as if the Earth were a female body to be beautified with fine clothes and jewels.[13] It is this very frivolity, along with the durability of the project, that makes *The Gates* open to history in a way that a more directly political work could not be. Sometimes in retrospect a certain cunning seems to reveal itself.

What about the coincidence of Christo's *Gates* and Gilo's Wall? In one sense, it is purely a subjective connection, an accident produced by the fact of my traveling in the West Bank in December of 2004 and visiting New York in February of 2005. But in another sense it was an accident waiting to happen, a product of (let's call it) *critical* luck to go with Christo's artistic luck. If "seeing a landscape" or "looking at the view" is constituted by acts of erasure and blindness ("don't look at that trash in the foreground"), a critical seeing is always an act of double vision. Either one looks and then looks again at what was hidden or forgotten, or one looks at a view while remembering another view, if only at the level of the most basic recognition: *these* are hills and vales; *those* are trees and rivers. A repetition that can occur in space ("comparing scene with scene" as Wordsworth put it) or in time:

> Once *again*
> Do I behold these steep and lofty cliffs
> That on a wild secluded scene impress
> Thoughts of more deep seclusion; and *connect*
> The landscape with the quiet of the sky.[14]

And sometimes this comparative gaze is constructed on contrasts, a *coincidence of opposites* that brings together scenes because of their radical difference. Christo's *Gates* and Gilo's Wall speak to one another across an abyss of difference that makes their voices resonate all the more deeply. The *Gates* are situated in a harmless, even therapeutic landscape, a pacified urban refuge expressive of open, democratic access and restorative pleasure. Gilo's Wall is the boundary of a dangerous, contested border between enemies sworn (it sometimes seems) to mutual destruction, united and divided by both racial hatred and a certain consanguinity. *The Gates* seem to ornament and enhance the benevolent genius loci of the park, letting its living

and dead presences play together across its vistas and winding paths. Gilo's Wall, by contrast, seeks to pacify the danger zone, projecting a future prospect in which there will be no dangerous living Palestinians, but only the picturesque ruins left behind by their vanishing. It wants to cleanse the holy landscape of its ghosts and disappear their living descendants.

The futility of Gilo's desire for disappearance is captured by a third work of landscape art, a Mexican-style[15] mural on the new security "fence" erected around the Palestinian town of Qalqilya. The figures at the foot of the wall are John Berger and his granddaughter, photographed during a visit to the West Bank.[16] Like the Gilo mural, this painting conjures with the disappearance of the wall, but in a violent act of splitting rather than picturesque pacification. At the center of the scene, a face

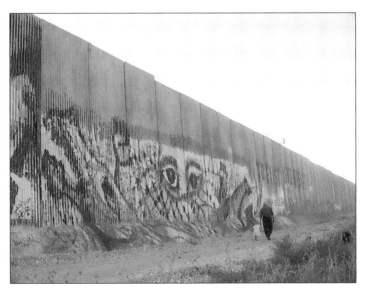

Figure C1.7. John and Melina Berger by the Israeli Wall, Qalqilya, Palestine, October 2005. (Copyright Maria Nadotti.)

wrapped in a kaffiyeh, the arms (reminiscent of Samson pushing aside the pillars) thrust up and out, seeming to topple the walls that fall toward each side of the figure. A closer look reveals the walls to be olive trees, the central symbol of Palestinian root-edness in the landscape, which makes the figure into a kind of insurgent dryad, a genius loci that refuses to be cut down.[17] A text to the right gives voice to the masked figure: "To exist is to resist." We know from Robert Frost that there is something in nature that doesn't love a wall, but this image suggests that there is something within walls themselves that wants to breach them and bring them down. (Perhaps this is just an image of what Marx would call the "congealed labour" of the Palestin-ian workers who help build the walls that hem them in.) To this extent, the Israeli and Palestinian murals are saying the same thing, the one by an illusion of pacification, the other with an equally illusory—but all too realistic—vision of violent destruc-tion. Christo's *Gates*, like the work of Artists Without Walls, provides critical and utopian breaches in the walls that divide peoples, openings for the welcoming of ghosts and strangers.

BINATIONAL ALLEGORY

ISRAEL-PALESTINE AND THE ART OF LARRY ABRAMSON

The first time I saw one of Larry Abramson's paintings, my immediate reaction was: "No. You can't do that." I was looking at his 1999 composition, *Elyakim Chalakim*, which struck me not as a modernist collage but as a *collision* of disparate elements that refused to synthesize yet insisted on appearing together, as if forced to coexist by a pure act of arbitrary artistic will. And the collisions struck me as not merely iconographic (the abstract black square and the representational figure, a generic emblem of a cutout crescent moon). There were also the flat black-and-white forms against a further bifurcated background of broad horizontal and vertical strokes; a single broad stroke curving down from the black square and returning to it, appearing again at the top of the square, as if a kind of embryonic or fetal-shaped form was behind the square, a pod nestled between the vertical and horizontal swipes. And then this fetal form, obviously painted in one bold gesture before the application of the black square/white crescent overlay, seemed to be sprouting something at both extremities: below, a tentative, hesitant gesture of narrow, branching strokes, like legs or roots reaching down but not finding a ground to stand or plant themselves; above, a translucent oval shape in which a tangled rhizomatic cluster of barren branches appears, as if cocooned in a nimbus or aureole. Meanwhile, extraordinarily thin streaks or dribbles of paint run (mostly) vertically down the canvas, suggesting (especially at

the lower edge of the black square) a kind of drainage, as if the square had "wounded" the fetal form beneath and left it leaking blood or amniotic fluid. Finally, just when I thought I had taken note of everything, my eye picked up stray horizontal strokes at the left and right edges, suggesting a space beyond everything in this multilayered surface. And above all, at the center of the black square, heretofore unnoticed, a tiny flaw, a quasi-organic shape: a starfish or perhaps an illegible stain, like one of those anamorphic apparitions that disrupt the perspectival order of Renaissance painting.[1]

In this thick and rather naïve description I have been following Michel Foucault's advice to "pretend not to know" the proper names and labels to apply to a painting; the point of this pretense, Foucault explains, is to use a tentative, provisional and almost "anonymous" language in the encounter with a painting before rushing to the safety of art historical tags for style, iconography, emblematics, and for lack of a better word, meaning. I do this because I think the painting, however knowing and learned its author, solicits an obtuse reading of the sort I have proposed, one that does not know how to read what has been stroked and inscribed and drawn and affixed to this canvas. The painting seems to resist any single template of unification; it shimmers between alternative "aspects" that "dawn" (as Wittgenstein would put it) only to be displaced and shattered.[2] These registers of visibility are compounded by disparate modes of legibility that simultaneously invite a decoding (the black square as a token of abstract modernism, specifically Malevich) and a re-encoding or encryption (the tiny blemish on the black square) that resist decipherment.

All this produces an effect that goes well beyond "multi-stability," the familiar optical illusions like the duck-rabbit, which shuttle between contrary seeings or readings. Perhaps we should call it "polystability" to indicate the numerous levels of

Figure C2.1. Larry Abramson, *Elyakim Chalakim I*, 1999. Oil on canvas, 195 x 75 cm. (Private collection.)

ambiguity and dynamic tension—iconographic, stylistic, and material—that coexist in what is after all just one painting.[3] It is a painting, however, that provides an exemplary threshold, a sense of the way this artist's work creates a space capable of accommodating contradiction and dissonance.

Abramson's composition shuttles between the two main forms of the literary and pictorial genre known as allegory, providing both a fairly transparent "picture language" in which every image can be translated into a corresponding word and a veiled, hidden assemblage of hieroglyphics that conceal a secret or forgotten meaning. If we begin, for instance, with the most prominent clue to the painting's meaning, its title, we can make out a very rough, schematic picture language in which we see a frontal portrait of the *figure* of Elyakim Chalakim with his head and legs, his arms in the air, and the black square as his breast-plate, the crescent moon as his scimitar. This figure appears as a kind of frontally posed icon. A second glance, however, suggests that despite the strikingly vertical orientation this is a *landscape* that opens out through a gateway (between the arms that now become pillars) onto an unseen vista beyond the painting; the figure suddenly has his back to us and is looking out toward a scene that is blocked from our view, except for the sky and the paradoxically barren tree of life (or is it knowledge?) on the horizon. This view on the composition is readily activated when compared with Abramson's *Nevo I* (1984), which depicts the obstructed path of Moses on the way to the Promised Land.

Of course, now I know more than I did when I first encountered this painting. Thanks to the deeply informed writings of art historians such as Gannit Ankori, Gideon Ofrat, and others, I have learned how to read these paintings as allegories of the history of modern painting. The black square is Malevich's; the virtuosic swipes, the relics of expressionism and action painting; the crescent is a cutout; the branching figure in the bubble of

light can be read as a brain, rendered in the translucent net-
work of abstract brush strokes reminiscent of De Kooning's
late paintings. And I have learned that the figure in the paint-
ing, Elyakim Chalakim, is a kind of a golem, a Frankenstein,
"a body consisting of parts . . . rising from the garbage heap,"[4]
who turns out to be not the destructive golem-warrior, but a
great poet-prophet who sings of reconstruction and harmony.
(Abramson's inspiration for this figure was a children's trading
card in which Elyakim Chalakim was literally and concretely
depicted as an assemblage of tools, appliances, and trash.)[5]

I have also learned that Abramson is regarded by some—
probably mistakenly—as a religious painter, drawing deeply
on Jewish legends: Moses viewing the Promised Land from
Mount Nebo, where he is to die; Cain slaying his brother Abel;
Onan's defiant wasting of his seed; and the terrible story of the
child-murdering rebellious wife, Lilith. In view of his subver-
sive stance regarding these legends, it would probably be more
accurate to call him a painter of the *sacred*, as distinct from
the religious—an artist concerned with the totemic objects and
images that pour out of the profane "black hole of religion."[6]

Of course, there is more to learn about the insider knowl-
edge of Abramson's painting. I am but a distant observer who
feels like the man who fell to Earth every time he arrives in
Israel-Palestine:[7] a non-Jewish American who speaks neither
Hebrew nor Arabic, a member of the Hibernian race (arguably
a lost tribe) that migrated from Ireland to America during the
great potato famine. As an American born and raised in the
western United States, nurtured in the desert landscapes of
Nevada, Israel-Palestine has always struck me with a sense of
uncanny recognition, recalling my own experiences of growing
up in close proximity to the tribes of dispossessed Paiute Indi-
ans, a people whose similarity to the Palestinians was remarked
upon in the nineteenth century by writers such as Mark Twain.[8]

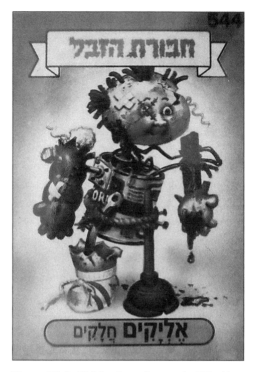

Figure C2.2. Children's trading card of Elyakim
Chalakim.

Perhaps, then, an outsider may be able to see something in
Abramson's paintings that is not evident to the insider.

It is therefore from a very strange vantage point, an "Ameri-
can" one, that I encounter Abramson's paintings The surprise I
have felt in reading about them is the lack of attention to what
seemed to me the most obvious thing about them, their legibility
(or perhaps illegibility) as allegories of a country divided against
itself.[9] Surely this would be too crude and obvious a reading,
but perhaps that is another way of naming the American van-
tage point I bring to this work: we Americans are notoriously

crude and obvious. I hope to complicate this perspective by suggesting that Abramson's paintings are perfect examples of what Fredric Jameson called "national allegories" in his seminal 1985 essay on that subject.[10] That is, they are (as some have noted) riddled with political allusions, entirely in keeping with the activist politics of reconciliation that Abramson has pursued throughout his career. Abramson's painterly practice, I suggest, is a multileveled and highly unstable, provisional allegory (or the disjunctive assemblage of allegorical elements) into figures and landscapes that face the viewer like an icon, unfold before her like a landscape, cross his path like the found objects of *tsooba*,[11] or block her way like the abyss of blackness in Malevich's square. I want to call this "binational allegory" as a way of linking Abramson's art and politics and of seeing his paintings as engaged, not only with the history of modern painting or with mythological symbolism, but also with the very real political and material conditions of the divided Israel-Palestine.

Jameson's concept of national allegory has been the subject of ferocious debate since its original publication in 1985, subjected to a blistering critique by Aijaz Ahmad and others, mainly for its overgeneralizing hypothesis that "all third-world texts are necessarily . . . allegorical, and in a very specific way: they are to be read as what I call *national allegories*, even when, or perhaps I should say, particularly when their forms develop out of predominantly western machineries of representation."[12] I do not enter here into the details of this debate; I invoke it only in order to provide a template for understanding the specific work of Larry Abramson as a mediation between a whole range of antinomies, specifically, the relation of traditional and modern cultures, private and public spheres, poetics and politics, capitalism and socialism, first- and third- (and perhaps second-) world cultures, Europe and the Middle East, Jews and Arabs and Christians.

Simply to list these antinomies is, I hope, sufficient to provoke a different angle of vision on Abramson's work. Perhaps most immediately evident is the clash between modernism and tradition, often glossed over by Israeli art critics oriented toward a European or transatlantic perspective. But should it not strike us at the same time as a dimension of the Israel-Palestine conflict that here is one country, divided between an aggressively nationalist and modernizing political economy, on the one hand, and a more traditional agrarian and artisanal economy, on the other hand, one whose claims to national identity are disputed and even denied?[13]

And shouldn't it also occur to us that the dialectic between modernity and tradition is immanent within the Palestinian and Israeli peoples as well? On the side of the Israelis, there are the contradictory impulses of Zionism itself as a progressive, modernizing nationalist ideology at the same time that it claims a foundational myth in ancient tribal and racial identifications, quite literally "grounded" in the sacred soil of Israel. On the side of the Palestinians, we find one of the most literate and intellectual of the Arab peoples (for which they have sometimes earned the label "the Jews of the Jews"), whose national struggle has been inspired by third-world revolutions and forms of socialism that, at some deeper level, are consonant with the socialist forms of Zionism. All that alongside a deeply religious and tribalistic culture, rooted in the land and subjected to abject economic and political deprivation in the form of half a century of occupation. Both sides of the struggle (and the governmental entity) that is Israel-Palestine or Palestine-Israel are self-divided, increasingly faced with the prospect of civil war between secular and religious movements.

So when we look again at *Elyakim Chalakim* we see a monstrous assemblage of the poet-prophet who might bring together— though never unite in an "organic unity"—the contradictions

of a bipolar nation. We must read this figure politically, then, as an iconic updating of Hobbes's *Leviathan*, the avatar of political sovereignty displaced to a radically divided nation-state. His ethnic identity is conspicuously incongruous: he is a Russian (Malevich), a European (expressionist brushstrokes and pouring), an Arab Muslim, with his scimitar dangling below his suprematist breastplate. He is first, second, and third world. He is both the country as a promised landscape and as a political body, both the ground and the figure of the Leviathan, his arms raised to exercise his sovereign authority with the twin powers of religion and war.[14] But what would a Leviathan look like that contained two countries, two nations, two peoples—in fact, many more than two—Arab Jews, Christian Arabs, Samaritans, Druze, Bedouins, Europeans, Irish, English, Americans, Ethiopians, Yemenites, South Africans, Ashkenazim, Sephardim—a polystability of formal identities? It would look like Palestine-Israel, a monstrous nationalist formation that is struggling to be reborn as a viable binational state. I don't say this is the "message" of Abramson's paintings; he could just as easily be trying to show how impossible it is to imagine a binational state coming out of this conflict. But it is hard to imagine a figure composed out of the "garbage heap" of Islam, Judaism, and Christianity that is not to be read as an icon of their incongruous and violent collision in this singular country.

Edward Said was sometimes regarded as unreasonably utopian in his claim that Israel and Palestine were partners in a tragic symphony that connected them, historically and morally, with irrevocably intertwined destinies. Yet there would be a coldly realistic story to tell here about the way that Israel's policies of colonization in the West Bank lead inexorably to a denouement in which Israel achieves its dream of "(Greater) Eretz Israel," incorporating all of the West Bank, and in the process turns itself into a de facto binational country, if not quite

a binational state.[15] Incorporation of the Palestinians within the Jewish state, however, necessarily involves the creation of a new body politic, a bicultural, biracial, bilingual entity. This biopolitical hybrid (tacitly acknowledged in murmurs about the "demographic problem" that would make at least half the population of greater Israel non-Jewish) is exactly the monstrous collective body-as-landscape that Abramson has personified in the polystable figure of *Elyakim Chalakim*. It is not surprising that this figure has two bodies and two heads, one concealed inside the womblike oval that is the central expressive gesture of the composition, the other limned in the miragelike image of the entangled, barren trees of life and knowledge growing out of the embryonic form.

If this is allegory, then, it is not the "mechanical allegory" with its transparent "picture language" despised by the Romantics, who preferred "organic symbolism." But it is not "organic symbolism" either. It is a semiotic hybrid, a collision of the mechanical and organic, what William Blake called "sublime allegory, addressed to the intellectual powers." As Jameson puts it:

> If allegory has once again become somehow congenial for us today, as over against the massive and monumental unifications of an older modernist symbolism or even realism itself, it is because the allegorical spirit is profoundly discontinuous, a matter of breaks and heterogeneities, of the multiple polysemia of the dream rather than the homogeneous representation of the symbol.[16]

The binational state thus remains for now a dream or a nightmare, depending on your point of view, whereas the binational *country*, the administrative entity governed by force as a single landscape and body politic, already exists: Abramson's painting has shown it with uncanny clarity and precision.

I have only considered one painting, and there is so much more to see and to contemplate, not only in Abramson's work

but also in several generations of Israeli and Palestinian artists and intellectuals—those whom Abramson has called "the desert generation," the title of a group exhibition he organized with Israeli and Palestinian colleagues in 2007, on the fortieth anniversary of the 1967 War and the occupation that ensued—who have shared his dream of a Promised Land welcoming all peoples. This is a dream shared across borders: Cuban artist Tania Bruguera, for example, produced a work reflecting on her recent visit to the area:[17] an empty room, the classic "white cube" of modernist exhibition with nothing in it except a black slab for a bench, and tiny, almost invisible pencil inscriptions on the walls declaring Israel-Palestine a global center welcoming all refugees from all nations. In a more satirical vein, Palestinian artist Shuruq Harb's conceptual performance piece, in which all Palestinians undergo a ritual conversion to Judaism on the same day and thereby become fully enfranchised citizens of Israel, their right of return to their ancestral homes guaranteed.

To do justice to Abramson's vision, we would have to take into account a whole range of meta-artistic activities that have characterized his career as a political artist, from his work with Artists Without Walls to his critical writings on how modernist abstraction and the bright landscapes of Zionism veil the dark reality of what Israel is becoming. That is what makes the crescent moon an emblem of the nocturnal underside, the nightmare of Zionism, "only a paper moon" that becomes the sickle, scimitar, or dagger of Islamic rage. Or the black square as a modernized Russian icon, at once a holy object and a black hole, an abyss of meaninglessness or the plenitudinous Kaaba, or "black box," that stands in Mecca at the vortex of pilgrimage. Or the scrawny vegetative forms, totemic signs of rootedness in the land that he generally portrays as uprooted found objects in trompe l'oeil/ still-life oil paintings. The two most prominent versions of this motif, the *tsooba* plants and the Rose of Jericho, evoke two sides

of the question of rootedness in Israel-Palestine. The samples of flora taken from *tsooba* are the microsignifiers of a deserted Palestinian village that on their initial exhibition were incorporated into a "total work of art," including defaced landscape paintings based on photographs of the disappeared village and secondary impressions of the landscape paintings on newsprint.

The Rose of Jericho, however, strikes me as a symbol of Diasporic uprootedness expressing a longing not for land but for a mere drop of water to bring it back to life. This scrawny little plant has a vast herbal folklore that connects it to Christ's resurrection in early Christianity, to national resurrection in European Zionism, to the Arabs' description of it as the Hand of Mary (*Kaff el Maryam*) and the Hand of the Prophet Mohammed (*Kaff el Nabi*) as a symbol of "the magic powers of the 'hamsa,' the palm of hand that fends off the ravages of evil spirits."[18]

It makes me nervous, however, to accede to any kind of instant legibility in the decoding of these vegetative images, which appear at first glance so humble and prosaic but are capable of sprouting an infinity of meaningful branches. The Rose of Jericho has been compared, with its complex rhizomatic structure, to the human brain itself.[19] For me, a member of the American "desert generation," it recalls the tumbleweed canonized in song as an image of the cowboy "drifting along with the tumbling tumbleweed," the internal Diaspora and restless migration so fundamental to American experience. Of course, it is impossible to enter this herbarium without recalling the totemic plant of Israel itself, the sabra cactus that is "prickly on the outside and sweet on the inside." This plant has become the generic name of the "native" Israeli, born in the Land of Israel and therefore rooted in the ground as a birthright. Small wonder, then, that during the First Intifada of the late 1980s and early 1990s, the marvelous Palestinian Israeli painter Asim Abu Shaqra appropriated the sabra plant as the central motif

in a series of highly expressive canvases avidly purchased by Israeli collectors. Abu Shaqra portrayed the sabra, however, not as rooted in the ground but in a prosaic clay pot that turned it into an ambiguous sign of *transplantation* and portability. For Palestinians, I am told, the sabra is not a highly symbolic plant but a utilitarian object, delicious to eat and useful as a hedge or fence to prevent animals from plundering gardens and groves. It becomes slightly dizzying, then, to consider that the sabra is the humble Palestinian equivalent of the minimalist, brutalist gray "separation barrier" that now divides while conquering the entire countryside of Israel-Palestine. Perhaps it is time to echo Ronald Reagan's challenge to Mikhail Gorbachev to "tear down this wall," and replace it with the porous, organic hedge of the sabra on both sides of the innumerable and mutable borders that cut through Israel-Palestine.

In assembling this mélange of allegorical elements, I do not mean to herd Abramson into the corral of "symbolist," "modernist," "conceptual," "postmodernist," or any of the innumerable ready-made labels of the international art world. Abramson's work means many things to many different audiences and struggles with many different art languages. And his own personal narrative, not that of a sabra but of a transplanted Jew whose liberal parents had struggled against South Africa's apartheid regime and established health-care clinics for that country's discriminated populations, has to give us pause. What can it mean for a person with this background to find himself in an "Israeli Utopia," a site that he critically portrays as a sunlit apartment complex drawn from real-estate brochures, surrounded by an abstract color field landscape, devoid of vegetation or people?[20] How can he bear to hear the Palestinian renaming of the euphemistically described "security fence" or "separation barrier" as an "apartheid wall" that segregates the Palestinians into Bantustans?

It must be in moments such as these that his vision turns toward ruins, darkness, and the chaos of a postapocalyptic destruction site. In a remarkable series of drawings and paintings entitled *The Pile*, executed between 2002 and 2004, Abramson engaged with the German Jewish painter Felix Nussbaum, who was murdered in Auschwitz, leaving behind his monumental last painting entitled *The Triumph of Death* (1944). In an essay about the painting Abramson declared:

> If a History of Art exists it is lying right there, in Nussbaum's painting—in that stinking and non-hierarchical pile of Classical, Neo-classical and Modernist debris . . . under the dancing feet of the angels of death in their chilling celebration. We are all Felix Nussbaum, painters without an audience, giving silent testimony in our underground studios.[21]

This is coming very close to the heart of darkness that underlies the bright, sunlit vistas and nocturnal fantasies of the Zionist project. Jerusalem, Abramson's home city, is probably the most staggeringly complex pile of ruins in the world, a labyrinth of contending cultures and civilizations each with its own archaeological narrative. But Abramson, like Nussbaum, refuses all the narratives, portraying a general collapse that incorporates every architectural style amidst a chaotic tangle of fluted pillars, Jerusalem stone, and modernist reinforced concrete, its steel rods winding through the debris. And in one particularly moving charcoal drawing, *Felix's Pile* (2004), which serves as the endpapers for the exhibition catalog of these works at the Felix Nussbaum Haus in Osnabrueck, Germany, blank voice balloons float amidst the ruins: no voices, no words. Only the empty index of a ghostly, vanished humanity, perhaps an exhalation of a sigh or the "stinking" vapors that arise from the garbage heap of history.

Half of Israel-Palestine already lives amidst the ruins of their country, subjected to a cruel occupation that threatens

Figure C2.3. Larry Abramson, *Felix's Pile*, 2004. Charcoal on paper, 6 parts, overall size 240 x 240 cm. (Collection Felix Nussbaum Haus, Osnabrueck.)

to crush any possibility of normal life, much less political self-determination and nationhood. The other half lives in a schizo-phrenic state of complacency and paranoia, punctuated by moments of panic when their bubble is punctured by a rocket attack and yet another military assault is launched against the civilian population of the West Bank or Gaza. If finally we must put Abramson's art in a niche, I would call it realism, enlivened by a surrealist attunement to the allegorical saturation of the

most ordinary objects and scenes in his environment. There is also a strain of what I want to call "vitalism" in his work, which refuses the finality of death and destruction. Like the Palestinian poet Mahmoud Darwish, this painter wants to make love to the deeply problematic entity known as Israel-Palestine. Abramson has said that his relation to painting is something like that of a necrophiliac, entering the dead body of painting with the aim of bringing it back to life: "Instead of engaging in a pathologist's discourse around the corpse of art, I preferred to enter it, to touch its tissues, to observe its cavities, and invent myself and the world from within."[22] Or as one Israeli critic has put it, "Abramson's original urge was to create a body and revive it, to breathe life into the corpse."[23] There is a curious way, then, in which Abramson's art may be hearkening to the voice of Mahmoud Ahmadinejad, the rabidly anti-Semitic dictator of Iran, who famously declared Israel "a stinking corpse." Larry Abramson is an artist capable of listening to this enemy, not in order to accept his utterly contemptible views, but to glimpse what lies ahead for a people that betrays its historic moral mission, the truly universalist vision of Zionism. Since Jerusalem, and with it Israel-Palestine, is still the geopolitical navel of the world, Abramson's binational allegory contains an urgent lesson for the rest of us as well.

MIGRATION, LAW, AND THE IMAGE

BEYOND THE VEIL OF IGNORANCE

The three words of my title demand a convergence of three fields: (1) law, with its entire edifice of judicial practice and political philosophy; (2) migration, as the movement and settlement of living things, especially humans, across the boundaries between distinct habitats; and (3) iconology, the theory of images across the media, including verbal and visual images, metaphors and figures of speech, as well as visual representations.[1] Law and migration engage the realm of images as the location of both the sensuous and the phantasmatic: concrete, realistic representations of actuality, on the one hand, and idealized or demonized fantasies of migrants as heroic pioneers or invading hordes, on the other.

One peculiarity must immediately strike an image theorist in contemplating this array of problems. Images are "imitations of life," and they turn out to be, in a number of important senses, very much like living things themselves.[2] It makes sense, therefore, to speak of a "migration of images," of images themselves as moving from one environment to another, sometimes taking root, sometimes infecting an entire population, sometimes moving onward like rootless nomads.[3] The animated, lifelike character of images has been recognized since ancient times, and that is why the first law concerning images is a prohibition on their creation, accompanied by a mandate to destroy them.[4] If the relation of the law to migration is mainly negative,

a mandate to block the movement of living things, then the relation of the law to images is exactly analogous. The prohibition on images is grounded in an attempt to sequester a political and religious community from contamination by images and to extirpate those alien forms of imagery commonly known as idols. The image is thus always involved with the other—with alien tribes, foreigners, invaders, or conversely, with native inhabitants who must be expelled. Because other people, both kinfolk and strangers, can only be apprehended by way of images—stereotypes of gender, race, ethnicity, etc.—the problem of migration is structurally and necessarily bound up with that of images. Migration is not a mere content to be represented in images but is a constitutive feature of their life, central to the ontology of images as such.

But there is an important limit to this analogy that we should note at the outset. The prohibition on images, especially the dangerous images of the other, is rarely successful. In contrast to real human bodies, images cross borders and flash around the planet at lightning speed in our time, and they were always "quick" in every sense of the word. Unlike real living bodies, images are very difficult, if not impossible, to kill, and the effort to stamp them out often has the effect of making them even more virulent. The idea of a "plague of images" has become commonplace since Baudrillard, and the difficulty of containing or censoring the migration of images is a well-established fact. The laws that govern the migration of real bodies and borders are without question much better enforced than those against images. Images "go before" the immigrant in the sense that before the immigrant arrives, his or her image comes first in the form of stereotypes, search templates, tables of classification, and patterns of recognition. At the moment of first encounter, the immigrant arrives as an image-text whose documents go before him or her at the moment of crossing the

border. This simple gesture of presenting a passport is repeated millions of times every day throughout the world and might be regarded as the "primal scene" of law and immigration in the face-to-face encounter.

Insofar as my topic is "illegalized" immigration, it engages the whole domain of law and the underlying foundations of political philosophy, a highly abstract and general field. In Western jurisprudence, the law is grounded in political philosophies, principally in liberalism, that insist on some form of primacy for the law in its most abstract sense as applying to equally abstract subjects or persons. The "legal subject" must be an abstraction, or the law is not the law, at least in liberalism. Notions of the equality of subjects before the law, the moral equality of persons quite apart from accidents of birth, race, or culture; the individual as a subject of rights and responsibilities, sovereign in its value: All these features of the liberal notions of law and politics remain very difficult to imagine or represent concretely. That is part of the point of liberalism: as a political and legal philosophy, it is deliberately abstract and schematic, employing an ascesis of images, most visibly represented in the image of Blind Justice with her scales.[5] One might even see it as an instance of the aniconism and iconophobia of Judeo-Christian and Muslim religious law and its grounding in an invisible, hidden personification of divine justice. "The principles of justice," as philosopher John Rawls put it, "are chosen behind a veil of ignorance" that eliminates all concrete contingencies and particularities—in other words, all sensuous images.[6]

Of course, there are other notions of the law that are more concretely embodied and visible: the body and buildings associated with sovereignty, notions of cultural custom and communal authority that may clash markedly with liberal notions of individual freedom and equality. When the realm of images and the imaginary collides with the law, in other words, the abstract

tends to become concrete, and liberalism's picture of a rational, legal, politically just framework for immigration begins to expose its contradictions. As Phillip Cole notes, "liberal political philosophy . . . comes to an end at the national border."[7] Rawls's "veil of ignorance" is rent by a revelation of flesh-and-blood human beings who are *not* members of a political community and are outside the contractual protection of a nation-state. The abstract legal subject takes on a human face, and the abstract notion of borders becomes a concrete site. Cole, in fact, opens his book with a meditation on the proper image for the cover of a book about liberal political theory and immigration, and he immediately notes a reversal of expectation. He had been imagining

> something dramatic signifying exclusion—a painting of city walls with massive gates closed against besieging hordes, or a black and white photograph of barbed-wire fences and people with guns keeping out bedraggled travelers. I was searching for something spectacular or stark, which would signify one or other of the poles around which discussions of immigration gather—that liberal democratic states are justified in erecting firm barriers against teeming masses that would drain them dry, or that they are jealously guarding their privileges against the weak and helpless. (ix)

But the image Cole finally adopted was quite at odds with this imaginary scene, a quite banal photograph of a man painting a white line down the middle of a street. This 1947 photograph of a British official marking the boundary between the Soviet and British sectors of Berlin reveals to my eye two quite contradictory readings: on the one hand, it signifies (as Cole notes) the arbitrary, even imaginary and ephemeral character of a border, like a child's drawing a line in the sand to claim a momentary territory; on the other hand, as we now know, it was a premonition of a global dividing line that was central to the Cold War

for half a century. It became the frontier of clashing political philosophies and the site of numerous "legalized" murders and tragic separations that still linger, not only in the consciousness of the German people but also across the world. The banality of this image of "illegalized" migration was matched by its fatefulness for the world order from 1945 to 1989.

Immigration at the level of the image, then, has to be seen as perhaps the most radically *dialectical* image available to us in the present moment. I'm using "dialectical" here in Walter

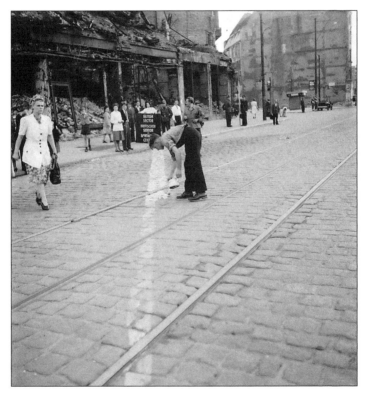

Figure C3.1. Marking the Berlin boundary, 1947. (Reproduced with kind permission of the Hulton Getty Picture Collection.)

Benjamin's sense of the image that captures "history at a stand-still";[8] but I'm also interested in the vernacular sense of the dialectical image as a site of visible, audible, palpable contradiction, where the real and the imaginary suddenly crystallize in a symbolic form, epitomized by the merely imaginal character of the white line and its fateful realization. Migration as a topic engages all the inherent dialectics of the image and exacerbates them: figure and ground (the migrant's body and the physical border); immigration as an affair of bodies and spaces; of living things and environments; the push and pull of movement and stasis, exile and return, expulsion and invasion. We might schematize the dialectics of migration with the diagram shown in Figure C3.2.

In calling this a dialectical diagram I want to insist that its elements do not have the status of binary oppositions that remain in fixed positions. They are, rather, dynamic opposites that are manifested in times and places, events, narratives and

MIGRATION	
EMIGRATION	IMMIGRATION
Exit Departure Exile, Nomad Expulsion Refugee	Entrance Return Settler, Colonist Invasion Detainee
Borders Frontiers Checkpoints Internment camps Ghettoes	

Figure C3.2. The dialectics of migration.

dramatic scenes, and above all, in points of view. Every emigration is at least in principle an immigration somewhere (and to someone) else. Every departure implies an arrival, and perhaps a return. Every exile longs for a home, and even the most radically rootless nomad requires an oasis as a temporary home. Invasions are almost invariably accompanied by expulsions such as ethnic cleansing and the production of masses of refugees. And at every turn, the law is invoked to justify expulsion or confinement, exile or colonization. Every legalization is at the same time an illegalization, as the law of Manifest Destiny showed when it justified driving Native Americans from their ancestral homelands to make room for European settlers.

The dialectical image of "history at a standstill" is most often revealed when the image captures a figure or space of arrested motion or (what may come to the same thing) of endless repetition. The most salient fact about migration in our time is the way it has become, not a transitional passage from one place to another, but a permanent condition in which people may live out their lives in a limbo of illegalized immigration, perpetual confinement in a refugee camp, or a perpetual motion and rootlessness, driven from place to place.[9] We might call this, inverting Heidegger, migration as *dasein*. This paradoxical condition is nicely captured in the Dustbowl ballad "How Can You Keep on Moving," collected and performed by Ry Cooder:

> How can you keep on moving, unless you migrate too?
> They tell you to keep on moving, but migrate you must not do.
> The only reason for moving, and the reason why I roam
> Is to move to a new location, and find myself a home.

The balladeer wants to insist on the logical connection between moving and migrating, only to be told by the law that they are opposites: moving is mandated and migrating is forbidden. And this law was being applied, it should be noted, not to aliens

arriving from another country but to citizens of the U.S., refugees from the Dustbowl in Oklahoma during the Great Depression. America is not only a "nation of immigrants," as is often said, with the Statue of Liberty welcoming "your poor, your tired, your huddled masses" of immigrants from abroad, but a nation of *internal* migration in which whole populations surge across the borders between states and regions, sometimes voluntarily, as in the case of the nineteenth-century pioneers heading westward, or involuntarily, as in the removal and ethnic cleansing of the Cherokee Nation on the notorious Trail of Tears. The Great Migration that brought African Americans from the rural South to the industrial North was, at the level of the imaginary, a utopian reversal of the obscene parody of immigration that had been imposed upon them with their forced migration as slaves. The law showed its teeth at both ends of the African American migration, legalizing slavery as a biblically sanctioned institution, supported further by the laws of property in the notorious Dred Scott decision of the U.S. Supreme Court, and enforced spatially in the long border between the slave-owning states of the South and the free states of the North. The Dred Scott decision (1857) had the effect of rendering African Americans *and their descendants* "resident aliens," ineligible for the rights of U.S. citizenship: "Persons of African descent cannot be, nor were ever intended to be, citizens under the U.S. Constitution. Plaintiff is without standing to file a suit."[10]

Migration in search of freedom or as a compulsion to slavery might be taken, then, as the absolute dialectical poles of the law of human movement. God tells Abraham, "Get thee out of thy country, and from thy kindred, and from thy father's house, unto a land that I will shew thee: And I will make of thee a great nation." He later tells Moses to lead the Israelites out of captivity into their Promised Land. What is not generally noted is that these mandated, "legalized" immigrations are accompanied by

conquest, colonization, and expulsion of the native inhabitants, as well as (not incidentally) their images and idols.

> When you cross the Jordan into Canaan, drive out all the inhabitants of the land before you. Destroy all their carved images and their cast idols, and demolish all their high places. Take possession of the land and settle in it, for I have given you the land to possess. (Numbers 33:52–53)

If our goal is to make visible and to ponder "images of illegalized immigration," then we must focus not only on images of the immigrant body—faces, genders, skin color, clothing, the data gathered on identification documents—but also on images such as "the Jordan" to be crossed over and the "promised lands" to be conquered. Images of immigration crucially involve the places, spaces, and landscapes of immigration: the borders, frontiers, crossings, bridges, demilitarized zones, and occupied territories that constitute the material and visible manifestations of immigration law in both its static and dynamic forms.[11] Above all, we should consider the emergence of the detention camp as a new form of legal limbo where persons may be detained indefinitely in a situation that is de jure "temporary" but de facto "permanent." Illegalization of immigrants and the spaces set aside for them may be regarded as a more moderate version of the most militant form of illegalization in our time, the concept of the "unlawful combatant." What the illegalized immigrant and unlawful combatant share is a peculiar, paradoxical status in relation to the law: they are subject to the law and excluded from it at the same time. Illegalization places them outside legal resources such as due process, habeas corpus, and elementary human rights at the same time that it does so *in the name of the law* or "under the color of legality." The reliance of the Bush administration's extralegal detention camps (Guantanamo being the principal example) on elaborate

legalistic justifications perfectly exemplifies the paradoxical lawful-lawless character of these institutions and their peculiar status as temporary and permanent, visible and invisible.

As a mnemonic device, we might exemplify these two manifestations of the law in the phenomena of the immoveable wall, on the one hand, and the flying checkpoint on the other. These two forms of interdictory legal space have been made famous, of course, by their emergence as fundamental structures of everyday life in the occupied territories of Palestine, but they instantiate a much more general dialectic that governs social space globally, from Tibet to the U.S.-Mexican border, to the boundaries of Russia and Georgia, to the barrier that once divided Catholic and Protestant Belfast along the Falls Road. At one pole of this dialectic is the relatively permanent structure that may divide peoples and prevent *any* movement, much less immigration or emigration—for generations. At the other is the flying checkpoint, a regular feature of military occupations, in which a population is subjected to unpredictable and arbitrary blockages of movements. A routine practice in failed states with insurgencies is the phenomenon of the paramilitary group establishing an ad hoc checkpoint to extract tribute, intimidate populations, and exterminate enemies defined along racial, religious, or tribal lines. In countries like this, everyone is a potential immigrant whenever they try to move anywhere, even within their own homeland. The immigrant is close cousin to the refugee.

And the opposite of the refugee is, of course, the visitor, the guest who comes perhaps with the objective of settling among us or conquering us. It may be helpful, then, to come at the question of immigration from the perspective of the *absolute immigrant*, the arrival of an alien from outer space. Especially useful here are the kinds of science-fiction stories that postulate the viewpoint of the aliens rather than the earthlings, as

is the case in the wonderful novels of Octavia Butler. Butler, an African American novelist who died in 2006, developed an entire series of novels (the *Xenogenesis* series, also known as *Lilith's Brood*)[12] based on the premise of genetic aliens known as the ooloi who travel the universe in search of interesting life-forms with which they can mate.[13] The objective of this travel and cross-pollination is the enhancement of the diversity of life, the acceleration of evolutionary processes of hybridization and mutation. Needless to say, Butler's aliens have to encounter terrestrial human beings in order to get the story moving, and these encounters are invariably filled with ambivalence—fascination, horror, disgust—and thus almost inevitably lead to violence but also (much more interestingly) to sexual encounters and even marriage and reproduction of hybrid offspring. The ooloi in particular are erect bipeds whose bodies are completely enveloped in a "skin" consisting of thousands of tentacles (imagine a full-body Medusa) that are constantly in motion, expressing the mood of the alien, each containing a tiny stinger that is capable of injecting death-dealing and painful poison or intensely pleasurable and ecstatic elixirs of sexual enjoyment into the body of anyone whom they embrace. One never gets over an ooloi hug.

From the standpoint of Butler's aliens, then, the universe is a vast field of life-forms in constant motion, awaiting visitation by other life-forms. Even fixed, static forms such as vegetative life are involved in micro-movements and growth, and they often spring into more dramatic forms of migration aided by animals (such as bees carrying pollen) or simply by the wind carrying their seeds abroad. The ooloi regard all life-forms, from the simplest microorganism to the virus, the fungus, the cactus, all the way up the ladder of creation to higher mammals and intelligent beings capable of complex symbolic behavior, as potential partners in the evolutionary saga.

A salient contrast with Butler's utopia of limitless migration is the recently released science-fiction film *District 9*.[14] Set in Johannesburg, South Africa, against the backdrop of the history of apartheid with its Bantustans and racial pass laws, this film concerns the arrival of an advanced species of bipedal crustaceans who have made a forced landing on Earth and whose only wish is to return to their homeland. The damage to their ship, however, requires an extended stay, and they quickly achieve the status of undesirable and illegalized aliens, referred to contemptuously as "prawns." They are compelled to live in the shantytown of District 9, a place that is ruled by paramilitary gangs and government operatives with a license to kill. District 9 resembles the contemporary shantytown of Kalecha ("beautiful place") outside Capetown and numerous other favelas and slums from Brazil to India. The film centers on a hapless, well-intentioned mid-level bureaucrat who is saddled with the impossible task of removing the aliens to another detention camp, who goes from one shanty to the next with a clipboard and legal documents that the aliens are required to sign in order to certify the legalization of their removal and the illegalization of their continued stay in District 9. But the law quickly breaks down and violence breaks out. The bureaucrat becomes infected with the bodily fluids of the aliens, and his body begins a gradual metamorphosis into the form of the aliens, a transformation reminiscent of Kafka's Gregor Samsa and the mutation of the human body rendered immortal in *The Fly*. Rumors spread that the bureaucrat has been having sex with the aliens, and he becomes the object of a ferocious manhunt with the secondary objective of using him as an experimental animal to analyze the biological character of the aliens.

It is hard to imagine a more vivid dramatization of the collision of liberal notions of legality with the visceral reality of migration. *District 9* is destined, I suspect, to become for this

decade what *The Matrix* was for the 1990s, an allegory of collec-
tive global anxieties about a rising flood of migrations spurred
by the economic displacements of globalization and the literal
disappearance of human habitats caused by climate change. It
also makes explicit the contradiction built into liberal notions
of immigration law, namely, that the law is inherently lawless,
ad hoc, and permeated by ideological prejudices that make it
exactly the opposite of an instrument of justice. It is well known
that American immigration law, from the Chinese Exclusion
Act of 1882 right down to the present day, is a travesty of justice
that is merely a systematic, institutional form of racism. *District
9* helps us to see that, in practice, these forms of racism quickly
devolve into a complete denial of the humanity of the alien, the
treatment of immigrants as cattle to be herded from one pen to
another. Immigrants in the state of Texas, for instance, are con-
fined in remote camps where it is difficult for lawyers to com-
municate with them. They have fewer rights than criminals and
are generally despised by the judges who decide their fate.[15] Add
to this the whole range of sexual anxieties focused on aliens,
that they are reproducing too rapidly and that they are mating
with the "native" population and polluting their racial purity,
and one sees all the ingredients for a form of liberal jurispru-
dence that throws a veil of ignorance over de facto fascism, a veil
that, in this instance, is fundamentally indistinguishable from
the veil of race and racism postulated by W. E. B. Du Bois.[16]

What happens when the space of illegalized migration is
not merely a camp, a detention center, or a shantytown, but an
entire country? The answer is to be found in Israel-Palestine,
a place that concentrates all the contradictory images we have
been contemplating into a small region that, by all accounts,
is at the center of the most important global political con-
flict in our time (as Berlin was throughout the Cold War), the
struggle between the West and the Middle East, European

Judeo-Christian civilization and the Arab and Islamic world.[17] Space forbids a detailed consideration of this complex and deeply fraught region, so a few snapshots will have to suffice. Israel "proper" (which is in itself a deeply contested phrase) contains a sizeable minority of Palestinians who are denied many of the rights of Jewish citizens. In fact, as Saree Makdisi points out, "Israel lacks a written constitution that guarantees the right to equality and prohibits discrimination among citizens"[18] at the same time that it trumpets its status as "the only liberal democracy in the Middle East." Insofar as it is a "Jewish state," a polity defined by religion and ethnicity rather than by a secular or race-neutral concept of citizenship, it "is not the state of its citizens, but rather . . . the state of a people" (144), many of whom do not actually live in Israel but are invited, even encouraged, to immigrate there. The legalized, indeed mandated, migration of Jews to the homeland is enforced by the Law of Return that is exclusively for Jews, no matter where they come from. Palestinians who were forced into exile since 1948, who have titles to land and property inside Israel, have no right of return and no legal means of seeking compensation for their losses. The Palestinian diaspora lives, by definition, in a state of permanent illegalized immigration with respect to its homeland.

The Palestinians who live in Israel proper, then, at least enjoy some of the minimal rights of citizenship while being denied the rights of nationality (although Avigdor Lieberman, the current defense minister, would like to compel all non-Jewish citizens of Israel to sign a loyalty oath declaring allegiance to the Jewish state or be subject to expulsion). Palestinians in the occupied territories of the West Bank and Gaza, by contrast, enjoy none of those rights and are subject to military rather than civil law. It is virtually impossible to describe the complexity of the occupation from a legal standpoint: the multitude of

permits, licenses, passes, and identity papers required of Palestinians surpasses the ingenuity of the South African apartheid regime, to which it is often compared. Gaza has been described as the world's largest open-air detention camp, a densely populated strip of land whose inhabitants are mainly refugees living in appalling conditions, a state of permanent humanitarian crisis, most of them prevented from leaving or threatened with no possibility of return should they manage to escape. This tiny territory is regularly subjected to ferocious military assaults that make only token attempts to discriminate between civilians and noncombatants. In the 2009 Israeli invasion of Gaza, about one-third of the casualties were civilians. Gaza is thus the epitome of the most extreme contemporary condition of the refugee internment camp, and at the same time, it is treated by Israel as if it were a sovereign nation ruled by a rogue terrorist regime with whom no negotiation is possible. The news blackout and general censorship of all images coming out of Gaza constitute a Rawlsian "veil of ignorance" that allows Israel to maintain its own fictional status as a liberal democracy.

But it is in the West Bank that this veil is most dramatically torn away. The notorious "security wall" (known to Palestinians as the "apartheid wall") is the most visible manifestation, a thirty-feet-high wall of concrete slabs that snakes its way through the West Bank, often plunging deep into the occupied territories to protect the illegal Israeli settlements or to surround Palestinian villages such as Qalqilya and cut them off from the agricultural lands on which their economic life depends. I have discussed in Chapter 1 some of the Israeli attempts to mend the veil by painting over the security wall with murals that make it seem to disappear in favor of depopulated Arabian pastoral landscapes (see Figures C1.1 and C1.2), but these efforts seem only to make the veil more egregiously visible, to expose the fantastic contradiction between the imaginary peace the Israelis

talk about and the actual state of permanent war in which they have chosen to live.[19]

Two recent documentary films, one Israeli, the other Palestinian, expose the nature of illegalized immigration when it is concentrated into a relatively tiny space and imposed on an indigenous population. The Israeli film by Yaav Shamir is entitled *Checkpoint* (2003), a "fly on the wall" documentary surveying some of the more than five hundred fixed and flying checkpoints that are sprinkled profusely over the West Bank. The film opens with a scene at a flying checkpoint that introduces the viewer to the petty details of daily life under military occupation. It is set in a scene of what might be called "uglified" landscape: a pond in the foreground that is obviously not natural, a "borrow-pit" created by moving earth to create a roadway, leaving behind marshy, infertile marshland that is marked by human footprints. Perhaps the most obvious is the banality of the ensuing action, the sense that this a boring ritual, one that is repeated so often that it is regarded as a routine performance by the Israelis and a numbing, daily humiliation to be endured with silent resentment by the Palestinians. It has all the signs of a border crossing, with the inspection of belongings and the empting of suitcases. However, it is important to note that this is *not* taking place at any border between Palestine and Israel but is internal to the West Bank, on the road between Nablus (the second oldest city in Palestine) and Jericho (the oldest).

The second thing that may strike us is the attitude of the soldiers, a mixture of cynical detachment, arrogance, and insolence, as they smile and smirk self-consciously for the camera and strut their authority over older people. They issue contradictory commands, one soldier telling the Palestinians to line up by the side of the road, then ordering them to remove their suitcases from the van (which requires them to return to the

van), and then the other impatiently ordering them to line up again by the roadside. The Palestinians register their sense of being caught in a wedge between two arbitrary authorities by pointing out that "he told us to get our bags" and the driver trying to claim an exception for himself, both from the line-up and the removal of his belongings.

This is a scene of "illegalized immigration" in two senses of the phrase. On the one hand, it imposes upon the lawful, native inhabitants of a country a ritual that reduces them to the status of immigrants in their own land, immigrants that are greeted under a cloud of suspicion as potential criminals or terrorists. On the other hand, the soldiers themselves, as representatives of an unlawful military occupation, are performing a kind of arbitrary and capricious authority that amounts to the lawlessness of mere force, embodied in the automatic weapons that they carry so ostentatiously. The real illegal immigrants in this scene are the soldiers themselves, and the more than a quarter-million settlers that Israel has illegally planted in the West Bank. Having traveled in the West Bank with Palestinians myself and been subjected to periodic stops at flying checkpoints, I can testify that this scene is absolutely typical and true to my own experience. At one stop, the teen-aged soldier who inspected my passport expressed surprise to find an American citizen in the West Bank. "What are you doing here?" he asked. My answer was, "I was about to ask you the same question." Of course my Palestinian comrades immediately put their fingers to their lips and urged me to shut up. Later they told me that if it had not been for my presence, they would probably all have been beaten up by the soldiers.

If the soldiers at the flying checkpoint were acting out all the telltale signs of a fascist mentality, this mindset is made verbally explicit at the main permanent checkpoint between Ramallah and Jerusalem. An otherwise nice young soldier who is clearly

bored with his job has completely gone over to the dark side. He refers to the Palestinian town of Ramallah as a "zoo" and calls the Palestinians animals, refers to himself as their "zoo-keeper." And he is defiant and proud to be telling the truth to the filmmakers about an attitude he knows that shares with many of his countrymen. We are human beings; they are not. Racism resolves into a bio-racial picture. Ethnocide, ethnic cleansing, and extermination are the next logical step. Israeli general Rafael Eitan put it in the clearest terms in 1983 when he predicted a time when "all the Arabs will be able to do . . . is to scurry around like drugged cockroaches in a bottle."[20]

The horrific irony of these scenes cannot be lost on anyone who has (as I do) a deep sympathy for and connection with Israel and the Jewish people. These soldiers are only a couple of generations away from the victims of the Holocaust, and the whole fascist resolution of the "Jewish question" in terms that are intelligible in terms of illegalized immigration. Jews were "illegalized" in Nazi Germany; treated as racial foreigners in the midst of the German *Volk*; subject to dispossession, expropriation of their property, deportation; and of course, a "final solution" of industrialized genocide, in which they were treated as animals or, more precisely, as vermin to be exterminated. All this was supported by a process of *legalization* justified by a state of emergency, what Nazi legal philosopher Carl Schmitt called a "state of exception." Small wonder that, right alongside the legalized immigration encouraged by the Law of Return there is a significant tendency toward *emigration* of middle-class Israeli Jews who cannot bear watching their children transformed into fascists by the occupation. As one Israeli father put it in another documentary film about this issue, "I would be willing to send my children to risk their lives in defense of this country. But to see them becoming morally corrupted as agents of this occupation is more than I can bear."[21]

Israelis with a sense of history and justice understand quite clearly that the security wall and the occupation and the checkpoints and the settlements have little to do with security. They are, as Israeli scholar Ilan Pappe has shown, instruments of a long process of ethnic cleansing that began in 1948 and continues to the present day, always hidden under the veil of legality, on the one hand, and the exceptional demands of security, on the other hand.[22] Key to this process is a double system of legalized immigration for Jews and the reduction of Palestinians to the status of illegal immigrants. The aim is finally to encourage all the Palestinians to emigrate not by direct violence but by a war of legal attrition that makes ordinary life and civil society impossible. But Palestinians constitute about 50% of the population of Israel-Palestine (or "Greater Israel," as the Right likes to call it). A disproportionate share of this population is under twenty-five years old, unemployed, and living in a state of constant rage and emotional mobilization. It is a wonder that there is not more violence. If Israeli fanatics manage to set off a bomb in the Dome of the Rock in Jerusalem or Hamas and Hezbollah obtain rockets that can reach Tel Aviv, a fuse will be lit that could set off a holocaust of weapons of mass destruction throughout the Middle East and beyond.

A recent Palestinian film that shows the other perspective on this situation is *Journey 110*, made in the spring of 2009 by Khaled Jarrar. It contrasts strikingly with the Israeli film *Checkpoint* in its strict economy of means (a single camera as opposed to many) and its restriction to one scene, an underpass filled with sewage that passes underneath one of the restricted highways, accessible only to Israelis, that connects Ramallah to Jerusalem. (Most Palestinians are forbidden from going to Jerusalem; the attempt to do so makes them illegal immigrants.) Much of the film, therefore, is shot in darkness, with only the faint outlines of the tunnel and the silhouettes of Palestinians—men,

women, and children—as they slog through the stagnant, boulder-strewn water. Some make the passage with plastic bags tied around their shoes; others attempt the dark passage barefoot. The scenes are generally backlit by the distant "light at the end of the tunnel," which turns out to be obstructed by large boulders and the occasional appearance (off camera) of Israeli soldiers, who send the Palestinians fleeing toward the other end of the tunnel.

This deceptively simple film captures in twelve excruciatingly long minutes one of the most fundamental experiences of everyday life in Palestine. Like Tania Bruguera's checkpoint installation at Documenta 11, *Journey 110* subjects the viewer to the ordeal that it represents as it turns the darkened space of the theater into an analogue of the underpass. Its confinement to this space enacts the sense that Palestinians live in a "no exit" situation, with no outsides to their underground existence. Movement and obstruction, migration and internment have become for them a way of life rather than a temporary passage. In this regard, the film reminds us of the structuralist films of Michael Snow in the 1960s with their obsessive exploration of single, confined spaces (especially corridors). But now the perceptual exploration has been given a specific human and political content. The details of the film—the plastic bags, the bare feet, the voices, including occasional laughter—puncture the darkness and make it clear why the Palestinian people are so difficult for the Israelis to control, why every barrier they erect will be surmounted or undermined.

We could descend endlessly into the vortex of images, law, and immigration that constitutes the political culture of Israel-Palestine. I want to conclude, however, by returning to a more general and global view of this issue, by way of a brief meditation on the work of Cuban artist Tania Bruguera, who has made the question of immigration a central topic of her work.

At Documenta 11 she installed a recreation of an immigration checkpoint that could have been anywhere in the world. The spectator passed through a gauntlet of loud noises, shouting, and dazzling searchlights that induced an intense affect of anxiety, panic, and disorientation that almost invariably accompanies, to some degree, every passage through a border security checkpoint. I have to say that I found the work deeply unpleasant and resented it at the time as overly literal. But I have not forgotten it, and it is perhaps a useful work as a kind of shock treatment that provides some glimpse of the experience of illegalized immigration.

More interesting and successful is Bruguera's current long-term performance-art project in Europe, which aims to create an "immigrant's party," a political organization based not on ethnicity, national origin, or identity but on the shared experience of immigration. Her work has been centered in Paris, which for centuries has been one of the centers of immigration from all corners of the globe and the capital of both secular, enlightened liberalism, on the one hand, and the development of some of the most despicable racial theories in Western pseudoscience, on the other hand.[23] The same culture produces Rousseau and the Comte de Gobineau, Jean-Paul Sartre and Jean-Marie Le Pen. Bruguera's staging of this project as an artistic performance has allowed it to attain funding from the French government; a nonartistic, directly political proposal of this sort would have had nowhere to go for support except the fragmented noncommunity of immigrants who are as suspicious of each other as they are of the government.

It is impossible to predict at this point what will become of Bruguera's project.[24] As a work of conceptual performance art it may simply pass into the archives of contemporary art as an interesting idea whose time is, as Jacques Derrida liked to put it, "to come." Whatever the result, the process will centrally

engage the question of the image, and especially the decon-
struction of the racist and racializing images that are endemic
to the representation of immigrants. The objective will be not
merely to change the way people see immigrants but to change
the way they see themselves, to enable the production of new,
self-generated images and words to articulate the common
interests of immigrants, both legal and illegal. And to do so not
just in order to create new icons but to generate new situations
and performances, from the immediacy of the mass assembly to
the staging of events for the mass media.

As the fastest-growing population on the planet Earth, the
Immigrant's Party will have to create its own slogans and iden-
tity as an emergent public sphere, to build on the blank space or
"place of negativity" that has been such a critical component of
recent critiques of democracy.[25] It may even have to reinvent a
new form of Rawls's "veil of ignorance" in order to suspend the
divisive forces of identity politics, racial, ethnic, and religious
schisms typified by that other veil, the one worn by women that
has been so toxic within French political culture.

I'm aware that this will all sound impossibly utopian and
imaginary, but that is surely another role that the image has to
play in relation to illegalized immigration, namely, to set out
hypotheses, possibilities, and experimental scenarios for a world
of open borders and universal human rights. The road of mili-
tarization and racist schemes of national security is a one-way
street to global fascism and anarchy. And there is one contem-
porary phenomenon at the level of the image that offers some
hope. As you may know, the most powerful man in the world,
the current president of the United States, has been declared
by the "birthers" movement, with the assent of the leadership
of the Republican Party, to be an illegal immigrant. Obama's
image has now gone through the entire cycle of demonization
and idealization; merged with the visages of Jesus, Mao, Lenin,

Bin Laden, and Hitler, he is now revealed at last as an undocumented alien. When an African American man who embodies all the characteristics of a multiracial, multiethnic identity that both fulfills and defies racial categories becomes the leader of the so-called Free World and then is declared to be an illegal immigrant, perhaps an Immigrant's Party is not so very far behind. Obama's image, as distinct from his actual policies, has had the effect of rending the veil of liberalism or, more precisely, of turning it into a screen for the projection of the most extremely antithetical fantasies. We will continue to need the veil of ignorance to secure any notion of legality with respect to migration; we will need to rend that veil and project new images on it to have any hope of justice.

IDOLATRY

NIETZSCHE, BLAKE, POUSSIN

*What is an essay on idolatry, an issue that would seem to belong
properly to religion doing in a book about race? As I have been
arguing, religion (or more precisely, the sacred) often becomes the
dominant parameter of racial difference, especially for the so-called
religions of the book that define the other as a heathen—savage and
bestial, sexually hyperactive, and driven by a pagan obsession with
images and idols. A key part of the icon of race, in other words, is its
tendency to motivate passion and extreme forms of violence. When
race becomes an idol, it demands human sacrifice, murder, and
genocide. Ethnic cleansing, justified by the imputation of idolatry, is
the washing machine of racial purity. I have mentioned in passing
the fetishism of race, its tendency to produce an obsession with the
body and the private parts, the totemism of race and its function
in reinforcing collective solidarity and community, and regulating
reproductive relations with other tribes. But idolatry is clearly the
most virulent form of iconic power and affect. Idols are images to
kill and die for. They provide the objects in which holy war and race
war converge. What precisely is an idol? The following pages attempt
to provide an answer by moving across the disciplinary lines of art
history, religion, media, and visual culture in order to track the
interplay of idolatry and its inevitable counterpart, iconoclasm.*

* * * * * *

Idolatry and its evil twin, iconoclasm, are much in the news these
days. Indeed, it would be no exaggeration to say that the current

Holy War on Terror is just the latest engagement in a religious conflict that dates back beyond the Middle Ages and the Christian Crusades in the Middle East, one that centrally concerned itself with the idols worshipped by one's enemies, and with the imperative to smash those idols once and for all. Although one should be skeptical about reductive ideological scenarios like Samuel Huntington's notorious "clash of civilizations" thesis, it seems undeniable that this theory has manifested itself in the actual foreign policies of great powers such as the United States and its allies, and in the rhetoric of Islamic fundamentalism in its calls to jihad against the West. The fact that an idea is grounded in paranoid fantasy, prejudice, and ignorance has never been a compelling objection to its implementation in practice. The Taliban did not hesitate to carry out the destruction of the harmless Bamiyan Buddhas,[1] and al-Qaeda's attack on the World Trade Center was clearly aimed at an iconic monument that they regarded as a symbol of Western idolatry. The War on Terror, on the other hand, was at first called a "crusade" by the president who declared it, and it has been explained by some of his minions in the military as a war against the idolatrous religion of Islam.[2] Among the most striking features of the hatred of idols, then, is the fact that it is shared as a fundamental doctrine by all three great "religions of the book," Judaism, Christianity, and Islam, where it is encoded in the second commandment, prohibiting the making of all graven images of any living thing. This commandment launches the age-old *paragone* between words and images, the law of the symbolic and the lawless imaginary that persists in numerous cultural forms to this day.

Among those cultural forms is art history, the discipline that would seem by professional necessity to have an account of idols and idolatry and that is centrally concerned with the relation of words and images. Whether regarded as a history of artistic objects or of images more generally, art history is the field that

might be expected to have a powerful account of idolatry. But the topic is generally regarded as more properly the business of religion, theology, anthropology, and perhaps philosophy. By the time idols get to art history, they have become art, which is to say, aestheticized, denatured, deracinated, neutered. Of course, many art historians know this, and I could invoke the work of David Freedberg and Hans Belting on the nature of "images before the era of art,"[3] and the more specific work by scholars such as Michael Camille (*The Gothic Idol*),[4] Tom Cummins (studies of the Inca idol known as the Waca), and many others who have attempted to work backward, as it were, from the history of art toward something more comprehensive: let's call it an iconology. And let's understand iconology as the study of (among other things) the clash between the logos and the icon, the law and the image, which is inscribed in the heart of art history.

We will return to these disciplinary issues presently in a discussion of Poussin's paintings of two scenes of idolatry and the ways that art history has danced around the question of word and image in these paintings. As Richard Neer has noted, these discussions have been paradigmatic for the entire discipline and its ambivalence about the actual material objects that are so central to it.[5] But before we take up these matters, I want to approach the topic through a fundamental reconsideration of the very concept of idolatry. What better place to begin than by reading the second commandment word for word:

> You shall not make for yourself a graven image, or any likeness of anything that is in heaven above, or that is in the earth beneath, or that is in the water under the earth; you shall not bow down to them or serve them; for I The Lord your God am a jealous God, visiting the iniquity of the fathers upon the children to the third and the fourth generation of those who hate Me, but showing steadfast love to the thousandth generation of those

who love Me and keep My Commandments. (Exodus 20:4–5,
King James Version).

The condemnation of idolatry as the ultimate evil is encoded
in this statute with such ferocious militancy that it is fair to
say it is clearly the most important commandment of them all,
as it occupies the central place in defining sins against God as
opposed to sins against other human beings such as murder,
lying, stealing or adultery. It is difficult to overlook the fact that
it supersedes, for instance, the commandment against murder,
which as Walter Benjamin wryly puts it, is merely a "guideline,"
not an absolute prohibition.[6]

Because idolatry is such a central concept for all the adversaries
in the current global conflict, it seems worthwhile to attempt a
critical and historical analysis of its main features. What is an idol?
What is idolatry? And what underlies the iconoclastic practices
that invariably seem to accompany it? The simplest definition of
an idol is "an image of a god." But that definition leaves open
a host of other questions: Is the god represented by the image
a supreme deity who governs the whole world? Or is it a local
"genius of the place" or the tribe or nation? Is the god imma-
nent in the image and its material support? Or is the god merely
represented by the image while the god dwells elsewhere? What
is the relation of this god to other gods? Is it tolerant toward
other gods, or is it jealous and determined to exterminate its
rivals? Above all, what motivates the vehement language of the
second commandment? Why is its condemnation so emphatic,
its judgments so absolute? Does it not seem that there is some
kind of surplus in the very concept of idolatry, a moral panic that
seems completely in excess of legitimate concerns about objects
called "graven images" and their possible abuse? And does not
the passionate intensity of the iconoclastic encounter with idola-
try remind us of Jean-Paul Sartre's diagnosis of anti-Semitism

(and racism more generally) as a *passion* rather than a concept? Could this be why "idolatry" is a word that mainly appears in the discourse of iconoclasm, a militant monotheism obsessed with its own claims to universality and purity?

When we move to investigate the moral questions surrounding idolatry, the concept seems to spin completely out of control. Idolatry is associated with everything from adultery to superstition to metaphysical error. It is linked with materialism, hedonism, fornication, black magic and sorcery, demonology, bestiality, fascist führer cults, Roman emperors, and divination. This bewildering array of evils ultimately resolves itself into two basic varieties that frequently intermix: the first is the condemnation of idolatry as error, as stupidity, as false and deluded belief; the second is the darker judgment that the idolater actually *knows* the idol is a vain, empty thing but continues to cynically exploit it for the purposes of power or pleasure. This is the perverse, sinful crime of idolatry. Thus, there are two kinds of idolaters—knaves and fools—and obviously, considerable overlap and cooperation between the two kinds.

Much of the theological discussion of idolatry focuses on fine points of doctrine and subtle distinctions between idolatry as the worship of the wrong god or of the right god in the wrong way.[7] The difference between heretics or apostates within the nonidolatrous community and unbelievers who live altogether outside that community is obviously a critical distinction. But there is a more straightforward approach to the problem of idolatry, what might be called an "operational" or functional point of view. The key, then, is not to focus on what idolaters believe or on what iconoclasts believe that idolaters believe but on what idolaters *do* and what is done to them by iconoclasts, who by definition must disapprove of the wicked, stupid idolaters. Sometimes the question of belief converges with that of

actions and practices. For instance, iconoclasts tend to believe that, in addition to their wrong-headed beliefs, idolaters commit unspeakable acts such as cannibalism and human sacrifice. This "secondary belief" (i.e., a belief about the beliefs of other people) then justifies equally unspeakable acts of violence against the idolaters.[8] Not only can and must they be killed, but their women and children may be massacred as an expression of the just vengeance of the one true God. There is thus a kind of fearful symmetry between the terrible things idolaters are supposed to do and what may be done to them in the name of divine justice. Idolaters who worship "brutes," for instance, such as the Golden Calf, are thought to have become brutes themselves and therefore may be exterminated without ethical qualms. Intermarriage with idolaters is strictly forbidden as "whoring after strange gods" and the pollution of racial purity. The idolater is thus the racial other and enemy, and iconoclasm becomes a mandate for both racial and religious warfare.

Another key to thinking pragmatically about idolatry is to ask not just *how* they live (which is presumed to be sinful) but *where* they live. Idolatry is deeply connected to the question of place and landscape, territorial imperatives dictated by local deities who declare that certain tracts of land are not only sacred but uniquely promised to them. Indeed, one could write the history of biblical idolatry and iconoclasm as a set of territorial war stories—wars fought over places and possession of land. As Moshe Halbertal and Avishai Margalit put it in their book, *Idolatry*, "the ban on idolatry is an attempt to dictate exclusivity, to map the unique territory of the one God."[9] This becomes clearest when one considers the practical enforcement of the ban on images, which involves destroying the sacred sites of the native inhabitants, "leveling their high places and destroying their graven images and idols."[10] The link between territoriality and idolatry becomes even more explicit when it is invoked as an insuperable objection to any

negotiations or treaties. To make a deal with an idolater, especially about land, is to fall into idolatry oneself. The only politics possible between the iconoclast and the idolater is total war.[11]

Idols, then, might be described as condensations of radical evil in images that must be destroyed, along with those who believe in them, by any means necessary. There is no idolatry without an iconoclasm to label it as such because idolaters almost never call themselves by that name. They may worship Baal or Dagon or Caesar or money, but they do not consider it idolatry to do so; it is rather a normal form of piety within the idolatrous community. On the side of the iconoclasts, the idolater is generally perceived as beyond redemption. Either the idolater is a traitor to the true God (thus the metaphor of adultery and "whoring after strange gods") or he has been brought up in a false, heathen faith from which he will have to be "liberated"—one way or another.

Iconoclasm betrays a kind of fearful symmetry, then, mirroring its own stereotype of idolatry in its emphasis on human sacrifice and terrorism, the latter understood as violence against the innocent, and the staging of spectacular acts of symbolic violence and cruelty. The iconoclastic stereotype of the idolater, of course, is that he is already sacrificing his children and other innocent victims to his idol. This is a crime so deep that the iconoclast feels compelled to exterminate the idolaters—not just to kill their priests and kings, but all their followers and offspring as well.[12] The Amalekites, for instance, are enemies of Israel so vicious and unredeemable that they must be wiped out. And the emphasis on the cursing of idolaters for numerous generations is, implicitly, a program for genocide. It is not enough to kill the idolater; the children must go as well, either as potential idolaters or as "collateral damage."

All these barbaric practices might be thought of as merely the past of idolatry, relics of ancient, primitive times when magic and superstition reigned. A moment's reflection reveals that this

discourse has persisted throughout the modern era, from the Renaissance and from Bacon's "four idols" of the marketplace (the theater, the cave, and the tribe) to the evolution of a Marxist critique of ideology and fetishism that builds on the rhetoric of iconoclasm. This latter critique is focused on commodity fetishism and what I have elsewhere called the "ideolatry" of market capitalism.[13] One of the strangest features of iconoclasm is its gradual sublimation into more subtle strategies of critique, skepticism, and negative dialectics: Clement Greenberg's kitsch and Adorno's culture industry are producers of idols for the new philistines of mass culture. The endpoint of this process is probably Jean Baudrillard's "evil demon of images," where the Marxian rhetoric rejoins with religion and veers off toward nihilism. But Marx had made fun of the "critical critics" who free us from images, phantoms, and false ideas already in his diatribes against the Young Hegelians.

The greatest break and the most profound critique of idolatry and iconoclasm is Nietzsche's late work, *Thus Spake Zarathustra*. Nietzsche turns iconoclasm upside down and against its own roots of authority in the law. The only thing the iconoclastic Zarathustra smashes are the tablets of the law: "Break, break, you lovers of knowledge, the old tablets. . . . Break the old tablets of the never gay," inscribed with prohibitions against sensuous pleasure by the pious killjoys who "slander the world" and tell men "thou must not desire."[14] The only law Nietzsche will tolerate is a positive "thou shalt": he enjoins us "to write anew upon new tablets the word 'noble.'"[15] He criticizes the Manichean moralism of the priestly lawgivers who divide the world into good and evil:

> O my brothers, who represents the greatest danger for all of man's future? Is it not the good and the just? Inasmuch as they say and feel in their hearts, "We already know what is good and

just, and we have it too; woe unto those who still seek here!" And whatever harm the evil may do, the harm done by the good is the most harmful harm. . . . The good *must* be Pharisees—they have no choice. The good *must* crucify him who invents his own virtue. . . . The *creator* they hate most: he breaks tablets and old values. . . . They crucify him who writes new values on new tablets.[16]

Zarathustra also seems to intuit the connection between the old law of good and evil and the imperative to territorial conquest and "promised lands." He equates the breaking of "the tablets of the good" with the renunciation of "fatherlands," urging his followers to be "seafarers" in search of "man's future . . . our *children's land!*"[17]

So far as I know, Nietzsche never explicitly mentions the second commandment, but it becomes the unspoken center of his great text of 1888, *Twilight of the Idols.* This volume can easily be mistaken for a rather conventional iconoclastic critique. Its promise to "philosophise with a hammer" and its opening "declaration of war" against "not just idols of the age, but eternal idols" may sound like a continuation of the traditional iconoclastic treatment of idolatrous "ideas," like Bacon's critique of "idols of the mind" or the Young Hegelians' war against "phantoms of the brain."[18] But Nietzsche turns the tables on *both* the ancient and modern iconoclasts and the second commandment by renouncing the very idea of image destruction at the outset. The eternal idols are not to be smashed but to be "touched with a hammer as with a tuning fork." They are not to be destroyed but "sounded" with a delicate, precise touch that reveals their hollowness (one recalls the biblical phrase "sounding brass") and perhaps even retunes or plays a tune upon them. Nietzsche's war against the eternal idols is a strangely nonviolent practice, a giddy form of "recreation, a spot of sunshine, a leap sideways into the idleness of the psychologist."[19]

The idolatry-iconoclasm complex has always presented a dilemma for visual artists who by professional necessity seem inevitably to be involved in violating the second commandment. Vasari opens his *Lives of the Artists* with an elaborate set of apologias for the visual arts, noting that God himself is a creator of images, architect of the universe and a sculptor who breathes life into his fabricated creatures. He dismisses the inconvenient case of the Golden Calf and the massacre of "thousands of the false Israelites who had committed this idolatry" by arguing that "the sin consisted in adoring idols and not in making them," a rather stark evasion of the plain language of the second commandment, which says "thou shalt not *make*" any graven images of any thing.[20]

The artist who comes closest to carrying out Nietzsche's inversion and transvaluation of the idolatry-iconoclasm complex is William Blake, who anticipates by almost a century the reversal of values contemplated in *Twilight of the Idols*. Blake famously inverts the moral valences of pious, passive Angels and energetic Devils in *The Marriage of Heaven and Hell* (1793), and he consistently links the figure of the Old Testament lawgiver with his rationalist Enlightenment offspring in the figure of Urizen, depicted as a patriarchal figure dividing and measuring the universe or as a reclusive hermit hiding in his cave behind the twin tablets of the law.

Like Nietzsche, however, Blake is not engaged in a simple reversal of a Manichean opposition of good and evil but employs a more subtle strategy, rather like Nietzsche's notion of "touching" the idols with a "hammer" or "tuning fork." Blake's most compelling image of this process is a plate from his illuminated epic poem *Milton*, which shows Los the artist-as-sculptor engaged in a radically ambiguous act of creation *and* destruction. We can, on the one hand, read this as an image of Los molding the figure of Jehovah out of the mud on a riverbank,

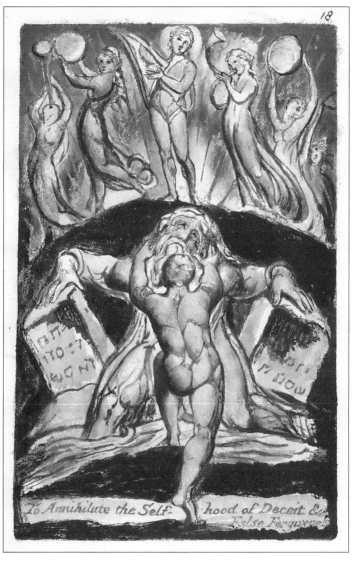

Figure C4.1. William Blake *Milton*, 1804–10: Los creating/destroying Jehovah. (Lessing J. Rosenwald Collection, Library of Congress, Washington, D.C.)

as if we were witnessing Adam creating God out of clay. Or, on the other hand, we can read this as an iconoclastic act, the artist pulling down the idolatrous statue of the father-god. The image condenses the making and breaking of idols into one perfectly equivocal synthesis of creative activity, a visual counterpart to Nietzsche's acoustical tactic of hammering the idols without breaking them. Blake's portrayal of a musical chorus on the horizon above this scene suggests that he too is "sounding" the idol, not with a tuning fork, but with the bare hands of the sculptor. As a child of the Enlightenment, Blake understood very well that all the idols, totems, and fetishes of premodern, primitive polytheistic societies were the alienated product of human hands and human minds:

> The ancient Poets animated all sensible objects with Gods or Geniuses, calling them by the names and adorning them with the properties of woods, rivers, mountains, lakes, cities, and nations, and whatever their enlarg'd and numerous senses could perceive. . . . Till a system was formed, which some took advantage of & enslav'd the vulgar by attempting to realize or abstract the mental deities from their objects; thus began Priesthood.[21]

In light of this genealogy of religion, which could very well have been written by Giambattista Vico, the development of monotheism is not so much a radical break with pagan idolatry as it is a logical development of its tendency to underwrite the consolidation of political power with absolute religious mandates. It is important to remember that Jahweh begins as a mountain god, probably volcanic as he is "hidden in clouds" and speaks "in thunder and in fire." The figure of the invisible, transcendent lawgiver whose most important law is a ban on image making of any kind is the perfect allegory for an imperial colonizing project that aims to eradicate all the images, idols, and material markers of the territorial claims of indigenous inhabitants. The fearsome

figure of Baal, we should remember, is simply a Semitic version of what the Romans called the "genius loci," or genius of the place—the god of the oasis that indicates the proprietary claims of the nomadic tribe that returns to it every year.[22] Dagon, the god of the Philistines, is characteristically portrayed as an agricultural god associated with the harvest of grain. The veiling or hiding of the god in a temple or cave is simply the first step toward rendering him (and he is almost always male) metaphysically invisible and unrepresentable. As Edmund Burke noted in his *Enquiry into . . . the Sublime and the Beautiful,*

> Despotic governments . . . keep their chief as much as may be from the public eye. The policy has been the same in many cases of religion. Almost all heathen temples were dark. Even in the barbarous temples of the Americans at this day, they keep their idol in a dark part of the hut, which is consecrated to his worship.[23]

Kant simply carries Burke's observation to its logical conclusion when he argues that "there is no sublimer passage in the Jewish law than the command, 'Thou shalt not make to thyself any graven image, nor the likeness of anything which is in heaven or in the earth or under the earth.'" For Kant, the secret to the "enthusiasm" of both Judaism and "Mohammedanism" is their "abstraction" and refusal of imagery, together with their claim to absolute moral superiority over heathens and idolaters.[24]

I want to consider two scenes of idolatry and iconoclasm by an artist whose work would seem to be radically antithetical to the antinomian tendencies of Blake and Nietzsche. The work of Nicholas Poussin, as Richard Neer has argued in his recent article on the painter, is deeply concerned with issues of idolatry and iconoclasm. But the depth of this concern would seem to be expressed, if I follow Neer's argument, by Poussin's determination to remain firmly committed to an orthodox moral condemnation of idolatry in all its forms, while at the same time

remaining loyal to the most powerful claims of the visual arts as expressed in classical sculpture. One could put this as a paradox: How does a painter endorse iconoclasm and condemn idolatry at the same time as he deploys all the visual, graphic resources of a thoroughly pagan, idolatrous culture?

Neer takes Poussin's problem not merely as the case of an individual artist but as the central problem of art history as a discipline. As he notes, Poussin scholarship has made him "the most literary of painters," assuming that "to know a picture's literary source is to know the essential thing about it. . . . One gets the impression that he is studied more in the library than the museum."[25] When scholars have broken away from this textually dominated mode of interpretation to identify "visual sources," the usual conclusion is that Poussin's numerous citations of classical imagery are "strictly meaningless." This "bifurcation" of Poussin into the camps of word and image "is in fact exemplary." According to Neer, "it is, in germ, what separates 'the two art histories,' the museum and the academy; the study of Poussin is the grain of sand in which to see a whole disciplinary world."[26] It is as if the *paragone* of word and image that was launched by the second commandment has penetrated into the very heart of the discipline that is supposed to devote itself to the visual arts, confronting it with a version of Poussin's own dilemma: How does one attend to the meaning of an image without reducing it to the mere shadow of a textual source? How does one remain faithful to the claim of the image without becoming an idolater and descending into the abyss of meaninglessness?

Ultimately, I want to propose a third alternative to Neer's division of the resources of art history into the "library" and the "museum." The alternative, unsurprisingly, is the *world* and the larger sphere of verbal and visual culture within which paintings, like all other works of art, inevitably function, and perhaps

not merely as what Neer calls "useful evidence in . . . a cultural history" but as *events and interventions* in that history.[27] But this is to get slightly ahead of myself. Let's turn to the paintings.

Two of Poussin's most famous treatments of the theme of idolatry are *The Adoration of the Golden Calf* (1633–36), now in the National Gallery in London, and *The Plague at Ashdod* (1630–1), now in the Louvre. Together, the paintings provide a panorama of the fundamental themes of idolatry and iconoclasm. The *Calf* shows the moment of idolatrous ritual and celebration as the Israelites dance around the Calf with the artist, Aaron, who gestures toward it to urge his countrymen (and beholders of the painting) to contemplate his creation. In the darkness of the background on the left, we see Moses descending from Mount Sinai, preparing to smash the stone tablets of the law in fury over the terrible sin of the Israelites. In *Ashdod*, by contrast, we see the terrible punishment for idolatry as the panicked Philistines realize they have been stricken by the plague. In the darkness of the left background (see Figure C4.3) we see the fallen idol of Dagon with its severed head and hands and behind it, the Ark of the Covenant (which the Philistines have seized as a trophy after defeating the Israelites in battle). In the story of the plague (1 Samuel 5:1–7), the Philistines bring the Ark into the Temple of Dagon, and during the night it magically overturns the statue of the Philistine's god and mutilates it.

Neer makes a convincing argument that from Poussin's point of view, and thus from the dominant disciplinary perspective of art history, the principle subject matter of *Ashdod* is *not* the foreground tableau of the plague but the background vignette of the Ark destroying the idol.

The evidence: the contemporary testimony of Joachim Sandrart and Poussin's own title for the painting, *The Miracle of the Ark in the Temple of Dagon*. This argument, depending

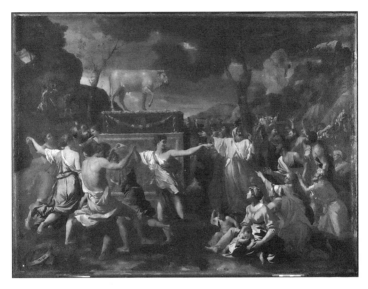

Figure C4.2. Nicholas Poussin, *The Adoration of the Golden Calf*, 1633–36. (Copyright National Gallery, London/Art Resource, New York.)

on verbal evidence, goes directly against what Neer calls the "visual prominence" of the plague narrative, which would seem to undermine his insistence elsewhere in the essay that visual and pictorial elements should be primary.[28] But for Neer, Poussin is a painter whose work is governed by signs and citations that point toward an invisible and unrepresentable foundation. Like the motif of the Ark itself that hides the tablets of the law, like the hidden God on Mount Sinai, Poussin's painting encrypts a meaning that is not evident to the eye but only to the connoisseur who is able to reverse the significance of "visual prominence" and see that the primary subject of the painting is "the hiddenness of the divine." "The miracle in the temple is the Second Commandment in action: a battle between statue and sign, ending in the literal destruction of the former" with

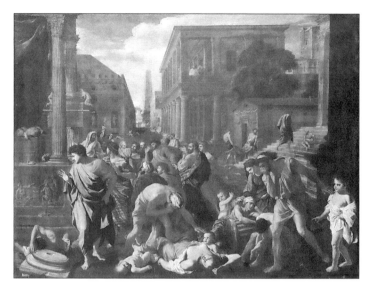

Figure C4.3. Nicholas Poussin, *The Plague at Ashdod*, 1630–1. (Erich Lessing/Art Resource, New York.)

the plague as merely its outward manifestation.[29] The failure of a beholder to see the plague as a merely secondary consequence or allegorical shadow of the real event in the painting is thus made equivalent to the error of the idolatrous Philistines who also mistake the outward image for the true meaning: "The failure of the literal-minded Philistines to 'read' the plague correctly . . . thus amounts to seeing only the Aspect of the plague" rather than the true "Perspective" in which the events and their depiction are to be understood.[30]

Neer convincingly shows that Poussin intended his painting to be an allegorical "machine" that generates a series of "rigidly antithetical" oppositions (which turn out to be reversible as well): Ark versus the "brutish" idol, imitation versus copy; signification over depiction; Poussin versus the "bestial" Caravaggio.

Poussin is doing everything possible to avoid falling into mere copying, mere naturalism or realism. He had an "abhorrence of reproduction, verging on mimetophobia."[31] He must constantly remind us that his scenes are staged and are based in a kind of citational parade of classical figures. The dead mother with her babies starving at her breast is probably a citation of Saint Matthew that ironically undercuts the realism of its source in Caravaggio. The hidden truth of the painting, however, is *literal*. It is a straightforward *istoria* that shows a mutilated idol and an impassive Ark. Like most of Poussin's painting, it is dominated by textualizing practices if not by textual sources, planting subtle clues and citations of previous pictures that will be recognized by the learned viewer. To take the "foreground group" literally, then, and not see it as a "citational structure" but for "the story it happens to tell" is to miss the point of the painting.[32] This foreground group is "the *allegory of the symbol of the narrative*," a phrasing, as Neer concedes, that is "otiose in a way the picture is not."[33]

I think Neer has given us the most comprehensive professional reading of this painting we could ask for. As art history his interpretation is unimpeachable, and as iconology it is incredibly subtle and deft. My trouble begins with his moving of Poussin's theory into the sphere of ethics, where a certain way of reading the painting is reinforced as the morally responsible, and even the "pious" way of relating to the picture as a sign or symptom of Poussin's intentions. There is something subtly coercive about this move, and I want to resist it in the name of the painting itself and perhaps in the name of that "meaninglessness" that scholars like Louis Marin have proposed. In other words, I want to ask "The Plague" (or is it "The Miracle") of Ashdod what *it* wants from the beholder, rather than what Poussin wants.[34] Because the painting outlives Poussin and participates in what Neer calls a kind of "natural history" (as

opposed to its iconological meaning), this means an unleashing of the painting from its own historical "horizon" of possible meanings and allowing it to become anachronistic.

And this might be the place to admit that my entire response to this painting is radically anachronistic. I cannot take my eyes off the foreground group. I cannot help sharing in the Philistine gaze that believes this scene is portraying a human reality, an appalling catastrophe that is being reproduced in a kind of stately, static tableau, which is the only thing that makes it bearable to behold. Like William Kentridge's drawings of the atrocities of apartheid or Art Spiegelman's translation of the Holocaust into an animal fable, Poussin shows us a highly mediated scene of disaster, of a wrathful judgment that is striking down a city and a people in an act of terror that does not discriminate between the guilty and the innocent. The center of this perception is, of course, the most prominent image in the painting, the dead mother with her starving infants at her breast. Neer sees her as a citation to the martyred Saint Matthew; I cannot see her without being reminded of a contemporary image that dawned on the world at the same moment of the writing of this text. This is the image that emerged from Gaza during the Israeli invasion of January 2009 of "four small children huddling next to their dead mothers, too weak to stand up."[35]

The image of the dead mother with her infants, living or dead, has been an icon of total war, genocide, and ethnic cleansing at least since Pliny the Elder's *Natural History*, in which he describes a painting by Aristide of Thebes, the first Greek painter to show *ethe*, or soul and the emotions. Pliny describes a painting representing "the capture of a town, showing an infant creeping to the breast of its mother who is dying of a wound."[36] This motif, also employed by Raphael in the *Morbetto*, where Poussin doubtless saw it, is echoed today in scenes such as the massacre of Italian villagers by the Nazis in Spike Lee's film

Miracle at St. Anna and in news photographs such as the one by Palestinian photographer Mahmud Hams, taken in the Gaza City morgue during an Israeli incursion.[37] These scenes of the slaughter of innocents by military force or divine intervention have a deep history, then, as an emblem of terror and its Aristotelian companion, pity. The racist subtext of the second commandment, the threat to "visit the iniquity of the fathers upon the children to the third or fourth generation" is shown with unmistakable clarity.

The unbearable pathos of this kind of scene is rendered visible by Poussin in the reaction of the prominent figure at the left of the picture's center, who recoils in horror and refuses to look. In some sense we may see this figure as an allegory of the art historian who refuses to see this central tableau as the primary subject

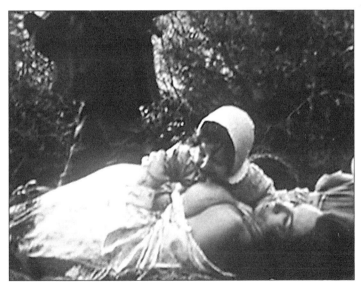

Figure C4.4. Film still from *Miracle at St. Anna*, directed by Spike Lee, 2008.

and insists on turning away, his attention directed first toward the rat (the immediate material cause of the plague) at the base of the Temple of Dagon and ultimately toward the Ark of the Covenant (the "final cause," as it were) in the background. It is as if the sight of the image, like the plague itself, might have an infectious character, a point that is reinforced by the gesture of the man reaching down to touch the still-living infant while he covers his face to block the smell of the dead mother.[38]

Of course, there is a point of view from which this scene is, like Poussin's, merely an allegory of divine justice in action. The Palestinians, as we have recently learned from a leading Israeli rabbi, are "Amalekites" who deserve the disasters that are being visited on them by an overwhelmingly superior military power that has God on its side.[39] The Hamas movement in Gaza is a terrorist organization that seeks the destruction of Israel. If terrible things such as civilian casualties occur, then it is the fault of Hamas, which unscrupulously uses civilians as

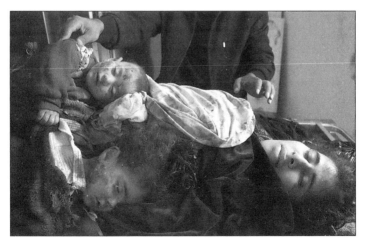

Figure C4.5. Dead Palestinian mother and children, Gaza City morgue. (Photo by Mahmud Hams.)

"human shields." (The fact that the fighters of Hamas actually live among and are related by blood and marriage to many of the people of Gaza does not excuse them from the responsibility to stand up and fight courageously in the open where they can be mowed down by the vastly superior firepower of the Israeli army. Instead, they are understood to be hiding away like cowards in their homes, schools, mosques, government buildings, and community centers while their women and children are massacred around them.) And if there have been injustices on the Israeli side, they will be "investigated properly, once such a complaint is received formally, within the constraints of current military operations."[40] Justice and the law are being and will be served, if only we have the ability to put this shocking picture in perspective.

Nothing I have said invalidates Neer's interpretation of Poussin's painting. I think that it probably reflects, for better or worse, what Poussin thought about his subject, what he thought was expected of him, and what his audience would have understood.[41] My argument is that there is another, quite contrary perspective on the painting, one in which an "aspect" is not merely an appearance but, as Wittgenstein would have put it, the "dawning" of a new way of thinking about its subject matter and its handling.[42] This is the anachronism that disrupts the doctrine or *doxa* of the painting and calls into question the ethical discipline and piety that it encourages. I would argue further that this sort of anachronistic seeing is inevitable with images, which are open to the world and to history in a way that deconstructs their legibility and certainty. In short, I am on the side of Derrida's abyss and Louis Marin's "meaninglessness" in Neer's argument, not Montaigne's well-grounded faith in the invisible lawgiver. I am also on the side of Foucault's insistence, in his famous reading of *Las Meninas*, that we must "pretend not to know" who the figures are in the painting; we

must forego the comfort of the "proper name" and the learned citation, and confine ourselves to the "visible fact," described with "a gray, anonymous language" that will help the painting "little by little" to "release its illuminations."[43]

What happens if we follow this procedure with the Golden Calf? What would it mean to see this painting through the eyes of Blake and Nietzsche? Does the painting not threaten to be a transvaluation of the idol it is supposed to be condemning? Could Poussin's painting, without his quite knowing it, be *sounding* the idol not with a hammer or tuning fork but a paintbrush? The Calf is gloriously painted and sculpted; it is a wonder, and the festive dance around it is a celebration of pagan pleasure.[44] But up in the dark clouds is the angry patriarch, breaking the tablets of the law. Nietzsche's pious killjoy and Blake's Nobodaddy converge in Poussin's Moses.

Of course, this is all wrong as art history. As iconology or anthropology, however, it may have some traction. The great French sociologist Émile Durkheim would have instantly recognized the Calf as a totem animal and would have rejected the category of the idol for the ideological (and racist) fiction that it is.[45] It is important to note that totemism and fetishism play a distinguished role in disciplines such as anthropology and psychoanalysis; idolatry, as a still-potent polemical notion, has rarely been put to technical use by a human science. The difference between totemism and idolatry is not merely a matter of perception but of an entire field of social relations surrounding the object in question. It is the difference between, on the one hand, a sense of tribal or racial belonging (often coupled with a mandate for intermarriage with members of another totemic clan in the practice known as exogamy) and on the other a passionate hatred of the other, a prohibition on intermarriage and a mandate to conquest and the destruction of sacred images.[46] Totemism is to idolatry, in short, as race is to racism.

So let's consider Poussin's calf as a totemic image (totems are generally plant or animal images), a figure of the self-conscious projection of a community's self-love on a common symbol. Let's look at it through the eyes of Durkheim, Nietzsche, and Blake, as Poussin's attempt to "sound" the idol with his paintbrush rather than destroy it. It is important that in the story, the Israelites have *asked* for this Calf. They have demanded that Aaron, the artist in residence, make an idol "to go before them" as a symbol of their tribal identity. "God is Society" is Durkheim's famous formulation of the concept.[47] One could actually think of this as a kind of democratic emblem, at least partly because it seems to have been a random, chance image, flung out from the fire. As Aaron tells Moses: "I cast the gold into the fire and this Calf came out" (Exodus 32:24).

What if that was Zarathustra up on the mountain, smashing the law and joining in the fun? What if the dark clouds are Blake's Nobodaddy "farting and belching and coughing" in his cave on the mountaintop? Could it be that Poussin was (like Blake's Milton) a true poet-painter, and of the devil's party without knowing it?

CONCLUSION:
MONEY AND MASQUERADE

For Poussin, the pious and learned seventeenth-century Christian, the Golden Calf was no doubt an orthodox symbol of idolatry, a combination of religious backsliding ("whoring after strange gods"); a return to Egyptian captivity (the Calf is related to the cult of the fertility god Apis); and a degeneration into the "worship of brutes" that reduces its followers to animals, slaves of sensuality and materialism. This view was probably charged with a degree of anti-Semitism directed not only at "Egyptian" idolatry but also at the supposed Jewish tendency to fall away from the purity of an ascetic monotheism into their role in Christian Europe as moneylenders.[1] Like most conventional anti-Semites of his era (including Shakespeare), Poussin no doubt overlooked the legal structures that prevented Jews from owning property and confined them to the sphere of commerce and usury. We must not overlook the most obvious and literal symbolism of the Golden Calf: it stands for money, the "gold standard" that is supposed to endure all fluctuations of the market.

For Poussin the artist, on the other hand, the Calf was a work of art, exemplary of ancient classical culture, and thus a paradigm for modern art. The Jews celebrating the Calf, like the Philistines of *The Plague at Ashdod*, are therefore portrayed as Greeks, and the Calf is worth more than its weight in gold. As an idol, it is beyond price. So what role does race play in these paintings? Does the idol, along with the classical dress of the

Israelites (and their Bacchanalian performance) indicate racial degeneration and miscegenation, the tendency of the Jews to intermarry with the indigenous tribes inhabiting the Promised Land? Are the Semites (whether Jews or Philistines) turning into Greeks? Or are the Greeks turning into Semites? Poussin depicts both the Philistines of Ashdod and the Israelites around the Calf as Greeks. Insofar as race functions as a medium of transmission, communication, and representation, the question is unanswerable. Poussin's words (and the texts supporting his images) tell us one thing; his images show us something quite different. Racial identity is not fixed (except perhaps in the eye of the racist) but is imitable and performable. White folks can "act Black" and Black folks can "act White" (although exactly which variety of Blackness or Whiteness is always up for grabs). Race does not exist, but we know it when we see it or hear it just the same.

Another way to put this is to ask: Does Poussin, the stage-manager of this tableau, identify with Moses or Aaron? Is he on the side of the angry iconoclastic messenger of the law (who, according to Freud, was probably an Egyptian)[2] raging in the darkness on the mountainside? Or with the white-cloaked high priest, gesturing in triumph toward his golden artifice? I have confessed my own suspicion that, in his heart, Poussin sides with Aaron, the artist, but the unanswerable nature of these questions is what makes him something more than a typical artist of the seventeenth century, more than a mere illustrator of a biblical text. Poussin is our contemporary. His paintings persist as teachable objects long after the moment of their creation precisely because they defy the ready-made pedagogy that knows the answers in advance.

What of the Golden Calf in our times? One answer was provided by the British artist, Damien Hirst, in 2008 when he fabricated a quite literal golden calf and put it up for auction at

Sotheby's. The calf, an actual bull carcass immersed in a vitrine filled with formaldehyde, features gold-plated hooves and horns, a solid gold disc on its back, and stands on a marble base inside a gold-plated glass box. The scandal of this object was not merely its violation of religious taboos about idolatry (it was, after all, reviving and literalizing the paradigmatic biblical example). Even more provocative was Hirst's way of bringing the calf to market. Instead of the usual procedure of going through the gallery and the dealer-collector system that normally vets the aesthetic value of works of art, Hirst took his work directly to auction, as if it were already a certified old master, a rival to Poussin.[3] Aside from the obvious chutzpah of this move, it also amounted to a frank reflection on the character of the art market in an era of neoliberal market fundamentalism and unbridled capital speculation—a "bull market" fueled by derivatives and junk mortgages. (Hirst's calf, by the way, is actually a bull). Hirst acknowledged that it was risky venture, but one which he felt represented "a natural evolution for contemporary art."[4]

Hirst's teachable object coincided with one of the most dramatic teachable moments in contemporary history, namely, the banking crisis of September 2008 and the subsequent "Great Recession" that followed. The Golden Calf sold for a record-breaking eighteen million dollars on September 15, 2008, the same day that Lehman Brothers Holdings Inc., the fourth largest investment bank in the United States, declared bankruptcy. Would it have sold for this much on September 16, when the world banking system seemed on the verge of collapse? We will never know. But the uncanny coincidence of this auction in a wildly inflated and cynical art market and a similarly inflated (and cynical) stock market will be forever associated with this object and this moment.

Hirst's Golden Calf, unlike Poussin's, seems to have little to do with race. The invisible god whose place it usurps is not

the tribal God of the Jews but the ruler of the contemporary universe of capitalism with his invisible hand. Clement Greenberg would surely have called Hirst a Philistine, but only as a metaphor for kitsch and mass culture. The racial component of Hirst's calf had to await the further development of the scandal and crisis that followed. The collapse of the global financial system was a key element, as I have already noted, in the election to the American presidency of a man whose name and appearance identified him with the historic enemies of White America. How could a man named Barack Hussein Obama, visibly African American, audibly Arab and Muslim, with a proper name that resounds with echoes of Saddam Hussein and Osama bin Laden, be elected to the highest office in what some people still like to regard as a White Christian nation? The most plausible answer, aside from Obama's intelligence, good looks, and oratorical gifts, is that a massive popular revulsion against Bush-era policies, already signaled by a disgust with his endless wars, was pushed to the tipping point by a realization that Bush had led the nation over a financial cliff as well. Again, we will never know what would have happened if the collapse had occurred two months later, after the election, just as we will never know what Hirst's calf would have fetched a few weeks after September 15. What we do know is that John McCain (boosted by Sarah Palin) was leading in some polls in early September of 2008, and as the financial crisis unfolded, Obama began to rise in the polls. Among the key elements of a teachable moment in history is the understanding that timing is crucial. Things could have happened quite differently.

But they didn't. Hirst made a bundle on his calf just before the crash, and Obama won the election just after. The resurgence of race comes in the aftermath, first in the outburst of racist reactions to Obama's election, with everything from the usual vicious caricatures to thinly veiled calls for assassination

in the form of "watering the tree of liberty" with a "Second Amendment solution."[5] The second resurgence takes the form of a new class consciousness accompanied by new forms of racialization. As the Great Recession progressed, it became obvious that, although Blacks would be disproportionately affected, White working-class people were also in the crosshairs. The usual right-wing strategy of dividing the working classes along racial lines quickly swung into action. In a remarkable pivoting move, the most extreme element of the Republican Party (the notorious Tea Party) launched a campaign to blame the rise in unemployment on "excessive government spending" and higher taxes imposed by the Black socialist-fascist-Muslim tyrant who had usurped the White House. The fact that tax rates had never been lower and that the excess spending and massive deficits had mainly occurred during the Bush era was quietly forgotten. The race card once again trumped the class card.

But the real resurgence of racialization had to wait almost three years, as the continued weakness of U.S.-dominated neoliberalism began to become more evident. In rapid succession two revolutionary events—call them the Arab Spring and the English Summer—erupted in 2011. The first was an authentic political event, one that dealt a decisive blow to the longstanding U.S. policy of supporting authoritarian Arab regimes on the theory that they would restrain Islamic fundamentalism. An effort was quickly mounted to deploy Islamophobia in order to prop up the Mubarak regime in Egypt, but it could gain little traction in the face of massive evidence that the Egyptian revolution was secular, middle class, nonviolent, and driven by fairly straightforward demands for economic and political justice.

The second event, the English Summer, was a debased parody of the first. Marx claimed that every historical event happens twice, the first time as tragedy, the second as farce—but usually not this fast. Rarely has history produced such a rapid

moment of repetition. Indeed, it was followed hard by the September 17 launching of Occupy Wall Street, a movement that promises a new coalition of resistance to racial and economic inequality, and to the oligarchy that benefits from it.

The English riots had no clear political objective, and they steered clear of attacking government buildings and political symbols. But the thing that shocked the British was not just the hooliganism, the self-destructive and nihilistic attacking of small businesses and residences, or even the naked consumerism. It was the racial masquerade performed by the rioters, a substantial number of whom were White and gainfully employed. Marxists like David Harvey labeled the riots "feral capitalism," a kind of violent street theater imitating the rapacious practices of the British Establishment, especially the moneyed classes.[6] We might call this "violent consumerism." But the clothing (hoodies) and language (Jamaican patois) were at the same time imitating the Black underclasses of Britain, and the spectacularization of "gangsta" violence in rap videos. "The whites have become black," was the provocative conclusion of British historian David Starkey, who of course was roundly attacked as a racist for having noticed and named the masquerade.[7]

Where Starkey went wrong, in my view, was not in *naming* the racial masquerade but in *blaming* it for the moral degradation of stupid, pointless looting. Causality and blame will no doubt be generously distributed among the usual suspects: a neoliberal Tory government that is engaged in drastic cutting of social services and education; oppressive policing that vacillates between overaggressive presence and a notable absence when rioting breaks out; a decline in morale and morality among working-class youth. Gangsta rap, a highly publicized subgenre of hip-hop culture, would be very far down my list of causes. David Harvey comes much closer to the mark in his inventory of multiple determinations:

Bad policing; continuing racism and unjustified persecution of youths and minorities; mass unemployment of the young; burgeoning social deprivation; and a mindless politics of austerity that has nothing to do with economics and everything to do with the perpetuation and consolidation of personal wealth and power. Some may even get around to condemning the meaningless and alienating qualities of so many jobs and so much of daily life in the midst of immense but unevenly distributed potentiality for human flourishing.[8]

Note that Harvey does not blame the racial masquerade but the racist structures, rooted in Britain's very long history of colonialism, for the demoralization and violence of the Black community. As we have seen repeatedly, race is not the cause but the symptom and therefore the diagnostic tool for analyzing racism. If White, British working-class youth are walking, talking, and dressing like Jamaican gangsters, what does that mean? Could it be the dim awareness that they are beginning to experience the world in a way that is not so different from their Black brothers and sisters? Norman Mailer glimpsed this syndrome long ago in his classic essay "The White Negro," which examined the phenomenon of the hipsters in the period of 1920 through the 1940s who adopted jazz and Black culture as their own. Comedian George Carlin described the racial masquerade in a more comic vein as a kind of envious imitation of the physical and emotional freedom that White youth ascribe to their Black peers. "Have three white boys hang around with three black boys for a few weeks," Carlin noted, "and you will *not* find the black boys saying things like 'Gee, whiz, guys. Shall we play some ball?' But you *will* find the white boys saying things like 'shee-it, muthahfuckah. Wuzzup?'"[9]

What the racial masquerade tells us about the English Summer of 2011 is not that rap caused the riots but that White

British youth are beginning to experience the receiving end of racism: racialization and negritude. They are finding out what the Irish have known for several centuries: a White skin is no guarantee against being treated like a Black slave. When Irish immigrants "Blackened up" in nineteenth century minstrel shows, they were performing a recognition of this fact, as did the Jews in the twentieth century.[10]

So is this all a question of race or class? Would that it were as simple as a base/superstructure problem. As Foucault pointed out, Marx based his critique of class on an earlier discourse of race.[11] Wage slavery and unemployment were the two sides of the economic coin for the working classes. Systemic racism— the American prison system, for instance—can achieve the same effect, admittedly at a much greater cost. It is of course now all the rage to disavow race and racism, to insist on a totally economic and class account of inequality. Walter Michaels goes so far as to suggest that "antiracism activates a certain nostalgia for Jim Crow" and a longing for the good old days when the antiracists held the moral high ground. This is especially true, he argues, "on the humanities faculties of our universities" where "we might plausibly say not that racism is rare but that it is extinct."[12]

But the supposed extinction of racist attitudes among college professors is hardly an argument for the disappearance of racism in the society as a whole. Michaels is right, however, in claiming that the overt expression of racism is no longer socially acceptable in academic circles or in public conversations; what is said in private is another matter. Contemporary racism is invariably accompanied by denial and disavowal, expressed in coded language, and concealed by a masquerade of White, liberal tolerance for "diversity." If there is any nostalgia, it is perhaps for a time when racism showed its face openly. Racism today hides in systems and structures of inequality that are subtly interwoven with class.

If racism has gone underground or has hidden behind a mask of color-blind neutrality, race has become, curiously enough, overtly theatrical in the post-racial era. The other thing that "humanities faculties at our universities" now agree on is that race—whether based in a genealogical claim or a desire to claim an identity—to "act Black" or "act White," is mainly masquerade and performance. The question, then, is what are the specific models for imitation? What is their history, and how are they transmitted? How are they acquired by individuals and groups and transformed in performance? Is the masquerade consistent and coherent, a lifelong commitment or a moment's playacting? Is it freely chosen or imposed, and what is its relation to concrete circumstances (historic moments and events, class, profession, nationality, gender, social status)? How does it manifest itself in objects and events?

Seeing through race—seeing it as a medium—does not provide easy answers to these questions; it merely aims to raise the questions in a way that opens us to teachable moments and teachable objects whose meaning we cannot predict in advance. It also offers a diagnostic tool, and perhaps a form of therapy, for the insidious, elusive disease known as racism. Naming it as such is the first, essential step toward knowing it for what it is. Desedimenting that name and all that it stands for requires us to reverse the terms of race and racism, to see the concept as a result, not a cause, of the passionate hatred and ambivalence of racism. That is why I have tried throughout these papers to separate race from racism, to allow the concept to rise above the passion and become, as Du Bois dreamed, "an instrument of progress."

NOTES

PREFACE

1. See William Julius Wilson, *The Declining Significance of Race* (Chicago: University of Chicago Press, 1978).

PART I. TEACHABLE MOMENTS

1. His worst speeches (and policies) tend to concern questions of economics and justice, where he has notoriously disappointed those who expected strong leadership in these areas.

LECTURE 1. THE MOMENT OF THEORY

Epigraph sources: Appiah, *Critical Inquiry* 12:1 (Autumn 1985), 35; Derrida, *New Literary History* 6:1 (Autumn 1974), 11.

1. "The Violence of Public Art: *Do the Right Thing*," Chap. 12 in *Picture Theory* (Chicago: University of Chicago Press, 1994); and "Living Color: Race, Stereotype, and Animation in Spike Lee's *Bamboozled*," Chap. 14 in *What Do Pictures Want?* (Chicago: University of Chicago Press, 2005). "Narrative Memory and Slavery," Chap. 6 in *Picture Theory*; "Holy Landscape" and "Imperial Landscape" in *Landscape and Power*, 2nd ed., (Chicago: University of Chicago Press, 2002).

2. Fanon, *Black Skin, White Masks*, trans. Richard Philcox (New York: Grove Press, 2008), 101. There is a vast amount of work already done on this front by scholars such as Kobena Mercer, bell hooks,

David Theo Goldberg, Paul Gilroy, Hortense Spillers; by artists such as Adrian Piper, Kara Walker, and William Pope L; and by activists such as Bill Ayers and Bernardine Dohrn, to name only a few. But there is no general theory of race as itself a medium, so far as I am aware.

3. An interesting topic for further research would be Obama's adoption of the role of "presidential teacher" (or preacher) at various moments during his presidency: his reinvocation of the phrase during the episode of the firing of Shirley Sherrod from the Agriculture Department after a fraudulent right-wing attack on her; also Obama's speeches on race during the election campaign and at the memorial service for the murders and attempted political assassination of congresswoman Gabrielle Giffords in Tucson, Arizona, in January 2011. The firing of Sherrod was said by the *New York Times* to have "sparked a national conversation about politics and race" (July 21, 2010) and drew an apology from Tom Vilsack, the Secretary of Agriculture.

4. I have been inspired to pursue this more complex and critical notion of the "teachable moment" by conversations with William Ayers, as well as by his numerous books on the philosophy of education, including *To Teach: The Journey of a Teacher*, 3rd ed. (New York: Teachers College Press, 2010), which has also been issued in as a wonderful comic book, drawn by Ryan Alexander-Tanner.

5. See for instance, Yvonne Chireau and Nathaniel Deutch, eds., *Black Zion: African American Religious Encounters with Judaism* (New York: Oxford University Press, 2000).

6. *Race: A Philosophical Introduction* (Cambridge: Polity Press, 2004), x. Taylor could have added numerous others to this list, of course. Among those I would add immediately would be Henry Louis Gates Jr. and Cornel West, whose prophetic pragmatism is one of the main inspirations for my approach.

7. Jameson's distinction between theory and philosophy was expressed in the public colloquium "The Future of Criticism and Theory," convened by *Critical Inquiry* at the University of Chicago in April of 2003. My reflections on "medium theory" appear in *Critical Inquiry*'s special issue, "The Future of Criticism and Theory," 30:2 (Winter 2005).

8. Mills, *The Racial Contract* (Ithaca, New York: Cornell University Press, 1997).

9. "On the Concept of Race" (1940), in *W. E. B. Du Bois Reader*, ed. Eric Sundquist (Oxford: Oxford Unive3rsity Press, 1996), 95.

10. Raymond Williams, *Marxism and Literature* (New York: Oxford University Press, 1977).

11. I also would not pretend that this is a terribly original insight. My sense is that the whole positive account of race, from Gates's discussion of it in relation to the linguistic sign down through the rich literature on performance, masquerade, and acting out, not to mention the screen and projective critiques of race offered by scholars such as Kaja Silverman, has in a sense been saying all along that race is best understood as a medium, whether it is a medium in the usual, vernacular sense of an intervening substance (wall, screen, veil); a middle term in an argument; or a compromise formation forged out of a binary opposition between, for instance, scientific and sociohistorical explanation, or (more simply) nature and culture.

12. Appiah's classic essay, "The Uncompleted Argument: Du Bois and the Illusion of Race," appeared in *Critical Inquiry* 12:1 (Autumn 1985), 21–37. An interesting follow-up to Appiah's argument is provided by Joshua Glasgow in his book *A Theory of Race* (New York: Routledge, 2009), 1. Glasgow focuses on the question of the reality of race throughout his book, ultimately recommending a change of name from "race" to "race*," the addition of an asterisk indicating a "racial reconstructivism" that simply shifts the meaning of race from biology to culture and social construction. This solution has two disadvantages in my view: (1) the substitution of an asterisked term has little chance of gaining a grip in the ordinary language of race; (2) in eliminating biological discourse completely, Glasgow's reconstructivism rejects the key element of genealogy and reproduction, the notion of race as constituted by "bloodlines" as well as by body types. As we will see, this move eliminates one of the key features of race-talk as a practice.

13. *Racism after "Race Relations,"* (London: Routledge, 1993), 21.

14. *Of Grammatology*, trans. Gayatri Spivak (Baltimore: Johns Hopkins University Press), 10–11.

15. Appiah consistently maintains that he is after the "truth" about race, not just what he calls "meaning," and he sees this as Du Bois's project as well: "Throughout his life, Du Bois was concerned not just with the meaning of race but with the truth about it." Op. cit. p. 22. But suppose the truth is that race is a medium, a mechanism for making meaning and communicating information—some of it true, some of it false.

16. *Tarrying with the Negative: Kant, Hegel, and the Critique of Ideology* (Durham, NC: Duke University Press, 1993), 89. Zizek also provides an excellent guide to the terminology of the Symbolic, Imaginary, and Real.

17. Bhabha, *The Location of Culture* (New York: Routledge, 1994). "Fixity . . . in the discourse of colonialism is a paradoxical mode of representation: it connotes rigidity and unchanging order as well as disorder, degeneracy and daemonic repetition. . . . [It] vacillates between what is always 'in place', already known, and something that must be anxiously repeated" (66).

18. Wheeler, *The Complexion of Race: Categories of Difference in Eighteenth Century British Culture* (Philadelphia: University of Pennsylvania Press, 2000), 2.

19. See Hortense Spillers, "Psychoanalysis and Race," in *Black, White, and in Color* (Chicago: University of Chicago Press, 2003), 407, on the inflection of race "through the Lacanian dimensions."

20. Sartre, *Anti-Semite and Jew: An Exploration of the Etiology of Hate*, trans. George J. Becker (New York: Shocken Books, 1948), 10.

21. The notion of being "misled" or "led astray" by grammar into false ascriptions of causality or temporal priority is a frequent motif in Wittgenstein's critique of philosophical language. See especially *Philosophical Investigations* (London: Blackwell, 1958), 43: "Our investigation is therefore a grammatical one. . . . Misunderstanding concerning the use of words, caused, among other things, by certain analogies between the forms of expression in different regions of language." The analogy of race/racism to matter/materialism and ideas/idealism is of precisely this variety.

22. And Piper herself has a performance that literalizes the idea of "playing the race card," in which she hands a person a card (rather

like the sort used by Deaf people to identify themselves) which informs the recipient that she, Piper, is Black, and that the remarks the recipient has been making are offensive to Black people. See Piper's essay, "Passing for White, Passing for Black (1991), originally commissioned by *Harper's Magazine.* First published in *Transitions* (1992) and reprinted in *Adrian Piper, Out of Order, Out of Sight*, vol. 1, *Selected Essays in Meta-Art 1968–1992* (Cambridge, MA: MIT Press, 1996).

23. "Racism's Last Word," Critical Inquiry, Vol. 12, No. 1, "Race," Writing, and Difference (Autumn, 1985), pp. 290–99.

24. Preface to *The Birth of the Clinic: An Archaeology of Medical Perception*, trans A. M. Sheridan Smith (New York: Vintage Books, 1975), xii.

25. Deleuze, "Strata, or Historical Formations," in *Foucault* (Minneapolis, MN: 1988), 51. It is important to add here that "visibilities" are not merely phenomenological or empirical perceptions of "qualities, things, objects . . . but rather forms of luminosity . . . that allow a thing or object to exist only as a flash, sparkle, or shimmer," what Wittgenstein would have called "seeing as" or "the dawning of an aspect" (53). Artists like Adrian Piper are especially attuned to this aspect of racial perception, inviting us to see things under the aspect of race even when they are not "self-evident." Note Deleuze's canny observation that Foucault's "theory of visibilities" has a great deal in common with Wittgenstein (50).

26. To be more precise, Freud never completely accepted the notion of scotomization, which was proposed to him by the French psychoanalyst René Laforgue. Nevertheless, the notion of hysterical blindness and the whole metaphor of the "blind spot" retains an important role in the Freudian vocabulary, naming (in this context) the repressive character of racist disavowal, the refusal to *see* the racial other and to see oneself as complicit in racist attitudes. See the *International Dictionary of Pyschoanalysis*, s.v. "scotomization," http://www.enotes.com/psychoanalysis-encyclopedia/scotomization.

27. *Racial Paranoia* (New York: Basic Civitas, 2008), 205. See also David Theo Goldberg's analysis of the "color bar," a phrase that, like

the "color line," merges the seeable and sayable, perception and a law or prohibition. *Racist Culture* (Malden, MA: Blackwell, 1993), 137.

28. Walter Benn Michaels, *The Trouble with Diversity: How We Learned to Love Identity and Ignore Inequality* (New York: Metropolitan Books, 2006), 28. It is not that I disagree with Michaels' argument that economic inequality is an important issue. I merely want to question the claim that we must *choose* to ignore "the phantasm of race" in order to give proper attention to class. In what follows, I will argue that this choice is a kind of illusory decisionism that will not make race go away, especially in its linkage to class.

29. "White Mythology: Metaphor in the Text of Philosophy," *New Literary History* 6:1 (Autumn 1974), 11.

30. See, among many others, Richard Dyer, *White* (New York: Routledge, 1997). But one could look back to many earlier precedents for the identification of Whiteness as a race in the writing of White supremacists. See, for instance, Madison Grant, *The Passing of the Great Race: The Racial Basis of European History* (New York: Scribner's, 1916). Whiteness is the "great" race—or it is the non-race.

31. Fanon's concepts of the "corporeal schema" and the "historico-racial schema" comprise a kind of spatial-temporal division of race as medium.

32. See Gates's PBS special, *African American Lives,* for an account of the sharp difference between the racial significance of genetics and genealogy, summarized aptly in the *New York Times* review by Ron Nixon, "DNA Tests Find Branches but Few Roots," November 25, 2007.

33. I would contrast "race-thinking" here with what Cornel West calls "racial reasoning," which he regards a form of rationalization that "discourages moral reasoning." *Race Matters* (New York: Basic Books), 26.

34. I am referencing here a key concept in media theory, the notion of "remediation," or the "nesting" of one medium inside another medium. Marshall McLuhan made this point when he insisted that "the content of a medium is always another medium." *Understanding Media* (Cambridge, MA: MIT Press, 1994), 18.

This point has been more systematically elaborated in Jay Bolter and Richard Grusin's book *Remediation* (Cambridge, MA: MIT

Press, 2000). See also my discussion of media "nesting" in *What Do Pictures Want?* (Chicago: University of Chicago Press, 2005), especially "Addressing Media."

35. In some ways, this whole linguistic approach to race was anticipated years ago by Henry Louis Gates Jr. in his insight that race was a semiotic phenomenon, a play of signs, rather than a positive object in the world. But Gates felt the need at that time to put "race" in scare quotes in his classic special issue of *Critical Inquiry*, "'Race,' Writing, and Difference." I would now shift the quotation marks and put them around "writing" as a synecdoche for "media" as a term that covers the full range of nonverbal ways of making meaning.

36. Du Bois's first published essay was entitled "The Conservation of Races," *American Negro Academy*, Occasional Papers, no. 2 (1897).

37. This, I take it, is the goal of Joshua Glasgow's "reconstructionism." See Glasgow's chapter, "Reconstructionism," in *A Theory of Race*. (New York: Routledge, 2009).

38. "The Work of Art in the Age of Biocybernetic Reproduction," in *What Do Pictures Want?*

39. *Digitizing Race: Visual Cultures of the Internet* (Minneapolis: University of Minnesota Press, 2008), 2. See also Mark B. N. Hansen, 'Digitizing the Racialized Body or the Politics of Universal Address," *SubStance* 104, 33:2 (2004), 107–33.

40. Michael Omi and Howard Winant, *Racial Formation in the United States*, 2nd ed. (New York: Routledge, 1994), 151.

41. Nakamura, 4. Nakamura, *Digitizing Race*, op cit., above.

42. As Kelly Oliver notes, "color blindness is a symptom of racism. Rather than see and acknowledge racial difference, we would rather not see at all. . . . Thus remaining blind to the effects of the sight of race in a racist culture is a symptom of racism." Quoted in Nakamura, *Digitizing Race* 3.

43. I quote here the final sentence of Thomas Borstelmann, *The Cold War and the Color Line* (Cambridge, MA: Harvard University Press, 2001), 271. The phrase "identity tourism" is Lisa Nakamura's in *Digitizing Race*, 13.

44. See Michelle Alexander, *The New Jim Crow: Mass Incarceration in the Age of Colorblindness* (New York: New Press, 2010).

45. See Christopher Caldwell, *Immigration, Islam, and the West* (New York: Doubleday, 2009) for one of the more hysterical arguments that the arrival of Middle Eastern immigrants in Europe is not traceable to a search for gainful employment but a new Moorish conquest.

46. *How the United States Racializes Latinos*, ed. Jose Cobas, Jorge Duany, and Joe R. Feagin (New York: Paradigm Publishers, 2008).

47. It's hardly surprising, then, that as the recession affected a generation of White youth, British historian David Starkey would say of the rioters in the "British summer" of 2011, that "the whites have become black." See the BBC debate with Owen Jones and Dreda Say Mitchell, August 12, 2011, http://www.bbc.co.uk/news/uk-14513517.

48. For a full discussion of the convergence of the language of cloning and terrorism, see my book, *Cloning Terror: The War of Images, 9-11 to the Present* (Chicago: University of Chicago Press, 2011).

49. I realize that it will sound strange to characterize homophobia in relation to the more radical fear of "sameness" found in clonophobia. For a fuller development of this idea, see my discussion in "Clonophobia," Chap. 4 in *Cloning Terror: The War of Images, 9/11 to the Present* (Chicago: University of Chicago Press, 2011).

50. *The Concept of the Political*, trans. George Schwab (Chicago: University of Chicago Press, 1996), 26.

51. Dyer, *White* (New York: Routledge, 1997); Painter, *The History of White People* (New York: W. W. Norton, 2010); Michaels, "The Souls of White Folk," in *Literature and the Body: Essays on Populations and Persons*, ed. Elaine Scarry (Baltimore: Johns Hopkins University Press, 1988), 185–209.

52. Sundquist, "The Concept of Race," 96.

53. See Ian Hacking, "Why Race Still Matters," *Daedalus* (Winter 2005), 102–16. Some examples include the West African susceptibility to sickle-cell anemia and higher immunity to malaria, and the frequency of Tay-Sachs disease among Ashkenazi Jews. Hacking makes

crucial distinctions between statistical *significance*, *meaningfulness*, and *usefulness* that should be kept in mind.

54. The paradigm case, of course, is Africa, which as Achille Mbembe points out "is almost always deployed in the framework of a meta-text about the *animal*—to be exact, about the *beast*." *On the Postcolony* (Berkeley: University of California Press, 2001), 1. Mbembe's brilliant diagnosis goes on to point out that as a specific case of racial mediation, Africa has always played the role of "the mediation that enables the West to accede to its own subconscious" (3).

55. See Hacking, "Why Race Still Matters," for a demolition of Richard Herrnstein and Charles Murray's logic in claiming that "the Gaussian distributions of IQ scores establish a natural distinction of some importance between different races" (106).

56. Hacking, "Why Race Still Matters," 114. The idea of racial purity is invariably centered on questions of sexuality and reproduction.

57. See West's discussion in *Race Matters* (Boston: Beacon Press, 1993), 30.

58. See Foucault, *"Society Must Be Defended": Lectures at the College de France, 1975–76* (New York: Picador, 2004), 79.

59. "Du Bois and the Illusion of Race," op. cit. 22.

60. Jackson, *Racial Paranoia: The Unintended Consequences of Political Correctness* (New York: Basic Books, 2008).

61. *Wikipedia*, "Race." http://en.wikipedia.org/wiki/Race, accessed October 30, 2011.

62. Most notoriously, the "curse of Ham" was invoked by slave owners in the American South to justify slavery. See Sylvester A. Johnson, *The Myth of Ham in Nineteenth Century American Christianity* (New York: Macmillan, 2004).

63. Said, *Beginnings: Intention and Method* (1975).

64. I am echoing here Hacking's discussion of John Stuart Mill's account of classification systems. See "Why Race Still Matters," op. cit.

65. Claude Levi-Strauss, *Totemism*, trans Rodney Needham (Boston: Beacon Press, 1963), 13.

66. *Against Race*, 14.

67. See my discussion of totemism, fetishism, and idolatry in *What Do Pictures Want?*

68. See my essay, "Idolatry: Nietzsche, Blake, Poussin," Part 2. Chapter 4.

LECTURE 2. THE MOMENT OF BLACKNESS

Epigraph sources: Du Bois, "The Conservation of Races," in *The Oxford W. E. B. Du Bois Reader*, ed. Eric J. Sundquist (New York: Oxford University Press, 1996), 40.

1. See Wilson, *The Declining Significance of Race* (1978); Moynihan's 1970 memo to President Richard Nixon (discussed in his *New York Times* obituary by Adam Clymer, March 26, 2003); Patrick Martin, "The Republican Party and Racism: From the 'Southern Strategy' to Bush," *World Socialist Web Site*, December 24, 2002, http://www.wsws.org/articles/2002/dec2002/race-d24.shtml.

2. Wittgenstein, *Philosophical Investigations*, tr. G. E. M. Anscombe (New York: Macmillan, 1953), 213–14.

3. Reid's remarks were of course made in private and were made public by one of the innumerable "tell-all" books based in Washington gossip. See John Heilemann and Mark Halperin, *Game Change: Obama and the Clintons, McCain and Palin, and the Race of a Lifetime* (New York: Harper, 2010).

4. See Latour, *We Have Never Been Modern* (Cambridge, MA: Harvard University Press, 1993). I use the word "preposterous" here not simply as a put-down but with the sly intention of introducing a new temporal and historical category that might someday find an application, namely, the "pre-post-erous."

5. *A Voyage on the North Sea: Art in the Age of the Post-Medium Condition* (New York: Thames and Hudson, 2000), 5.

6. Williams, *Marxism and Literature* (New York: Oxford University Press, 1977, 158–64.

7. See John Heilemann and Mark Halperin, *Game Change*, which quotes Joe Biden's remark that Obama was "the first mainstream African-american who is articulate and bright and clean. . . ." (336).

And then there is Bill Clinton's notorious remark to Ted Kennedy that "this guy would have been serving us coffee a few years back." ABC News: Politics Message Board: http://forums.abcnews.go.com/n/ pfx/forum.aspx?tsn=1&nav=messages&webtag=ABCPolitics&tid= 358456. Accessed October 31, 2011.

8. For the full text of Obama's "A More Perfect Union" speech, see the *Huffington Post*: http://www.huffingtonpost.com/2008/03/18/ obama-race-speech-read-th_n_92077.html.

9. See my book, *Cloning Terror* (Chicago: University of Chicago Press, 2010), for a discussion of role of religion in framing the contemporary conflict with Islam and the Arab world.

10. See *Media Matters*, June 8, 2008: http://mediamatters.org/ mmtv/200806060007. Accessed November 26, 2011.

11. Conservative pundits such as Charles Krauthammer made this point almost immediately after the election.

12. 'Cultural Criticism and Society,' *Prisms*, trans. Samuel and Shierry Weber (Cambridge, Mass.: MIT Press, 1967), p.19.

13. The confusion of Obama with Osama reached peak intensity around May 1, 2011, when the news of the killing of Bin Laden was announced. Fox News put up a graphic announcing the "Obama bin Laden" had been killed, and the anchorwoman of Canadian World News repeatedly substituted Obama's name for Osama.

14. See Obama's press conference on July 24, 2009 on YouTube: http://www.youtube.com/watch?v=-4RQmBlQvEQ. Accessed November 26, 2011.

15. There is a fifth possibility that has occurred to me: that the whole episode was about class and not race, a version of the traditional "town-gown" conflict. The Cambridge police officer, having recognized a wealthy, successful Harvard professor when he saw one, may have been determined to teach the professor a lesson in good manners toward a cop. It may have been only a secondary issue for Officer Crowley that this particular professor was playing the role of an "uppity" Black man.

16. William Butler Yeats, "The Second Coming." *The Collected Poems of W. B. Yeats* (New York: Macmillan, 1933), 184–85).

17. See Robert Gooding-Williams, *Reading Rodney King/Reading Urban Uprising* (New York: Routledge, 1993), 1, on the fading of this brutal incident into "old news."

18. Rogin, *Blackface, White Noise* (Berkeley: University of California Press, 1996), 46. For detailed reading of *Bamboozled*, see my essay "Living Color: Race, Stereotype, and Animation in Spike Lee's *Bamboozled*," Chap. 14 of *What Do Pictures Want?*

19. See Kara Walker, *Narratives of a Negress* (Cambridge, MA: MIT Press, 2003) for a compendium of Walker's work and authoritative commentary by a wide range of critics and art historians.

20. Now published by Harvard University Press, 2011.

21. See my essay "The Violence of Public Art: *Do the Right Thing*," originally published in *Critical Inquiry*'s special issue "Art and the Public Sphere" 16:4 (Summer 1990) and the subsequent book of the same title.

22. See my discussion of this legend in "Drawing Desire," Chap. 3 of *What Do Pictures Want?*

23. For an extended discussion of *Bamboozled*, see my essay "Living Color," 294–308 of *What Do Pictures Want?*

24. Governor Bob McDonnell announced a program for Confederate History Month in the state of Virginia that failed to mention the *s* word: slavery. On national fantasy, see Lauren Berlant, *Anatomy of National Fantasy* (Chicago: University of Chicago Press, 1991).

25. This is the title of English's book (Cambridge, MA: MIT Press, 2010).

26. Michel Foucault, *"Society Must Be Defended": Lectures at the College de France, 1975–1976* (New York: Picador Press, 2003), 83.

LECTURE 3. THE SEMITIC MOMENT

Epigraph sources: Fanon, trans. Richard Wilcox (New York: Grove Press, 2008), 165. Meier, quoted by Gerald Butt, BBC News Profiles, Tuesday, April 21, 1998, http://news.bbc.co.uk/2/hi/events/israel_at_50/profiles/81288.stm. Accessed November 4, 2011. Said, private correspondence with the author. Foucault, trans. David Macey (Picador: New York, 2003), 77.

1. Fanon, "The Lived Experience of the Black Man," in *Black Skin, White Masks* (New York: Grove Press, 2008), 95. Fanon contrasts Blacks and Jews in terms of visibility and savagery: "The Jewishness of the Jew . . . can go unnoticed. . . . He is a white man, and apart from some debatable features, he can pass undetected"; "He belongs to a race that has never practiced cannibalism."

2. *We Are All Moors* (Minneapolis: University of Minnesota Press, 2009), 58.

3. See Roxann Wheeler, *The Complexion of Race* (Philadelphia: University of Pennsylvania Press, 2000), and the discussion in Lecture 1 in this volume.

4. "I Have a Dream," delivered August 28, 1963, at the Lincoln Memorial, Washington, D.C.

5. Sartre's analysis of racist passion in *Anti-Semite and Jew* is especially acute about the language of intuition and preconscious aversion that was typical of anti-Semitism as he experienced it.

6. On this last "primal crime," see Part II, Chap. 4 on "Idolatry."

7. Paul C. Taylor, *Race: A Philosophical Introduction* (Malden, MA: Polity Press, 2004).

8. See Susan Mettler, *The Submerged State: How Invisible Government Policies Undermine American Democracy* (Chicago: University of Chicago Press, 2011).

9. See David Theo Goldberg, *The Racial State* (Malden, MA: Blackwell, 2002), for a comprehensive critique of liberal state-formation and social contract theory. See also Michelle Alexander, *The New Jim Crow: Mass Incarceration in the Age of Colorblindness* (New York: New Press, 2010); and Saree Makdisi, *Palestine Inside Out* (New York: W. W. Norton, 2007), especially his discussion of "segregation by the numbers" and the appalling statistics of "ethnic" discrimination in Israel, 150–51.

10. George Frederickson puts this most emphatically in *Racism: A Short History* (Princeton, NJ: Princeton University Press, 2003), 17. Clearly we need a *longer* history of race.

11. Frederickson, *Racism: A Short History*, 17. Frederickson attempts to rescue his exclusively modern and Western account of racism, and his

exemption of Greek xenophobia and legitimation of slavery, by invent-
ing a new term—"culturalism"—that will stand in for nonracial forms
of racism. But he then admits that "there is a substantial gray area
between racism and 'culturalism'" (7) that is bridged when "culture is
reified and essentialized to the point where it becomes the functional
equivalent of race."(7).

12. E-mail correspondence, January 20, 2010. See Jonathan Hall,
Ethnic Identity in Greek Antiquity (Cambridge: Cambridge University
Press, 1997), which argues that "the ethnic groups of ancient Greece
. . . were not ultimately racial" but also concedes that the replacement
of the term "race" by "ethnic group" was "in many cases . . . purely
cosmetic" (19). See also Benjamin Isaac, *The Invention of Racism in
Classical Antiquity* (Princeton, NJ: Princeton University Press, 2004),
which uses the concept of "proto-racism" to wipe off the cosmetics.

13. Note that Arthur de Gobineau's foundational screed of biological
racism is still classified by the Library of Congress as "ethnology." See
The Inequality of the Human Races (New York: Howard Fertig, 1999).

14. See Latour, *We Have Never Been Modern.*

15. See Jonathan Hall, *Ethnic Identity in Classical Antiquity* (Cam-
bridge: Cambridge University Press, 1997): Although "the Holocaust
discredited the racial philosophies that had spawned it, and . . . the
term 'race' was replaced by another—most often, 'ethnic group'. . . .
in many cases it was also quite clear that this new use was purely cos-
metic, and the basic conceptual apparatus of 'race' had remained,
despite a change in terminology" (19).

16. In this sense, ethnicity is the relic of an anthropological discourse
that employs it as a "scientific" category for sorting out a variety of col-
onized peoples. See Mahmood Mamdani, *When Victims Become Killers:
Colonialism, Nativism, and the Genocide in Rwanda* (Princeton, NJ:
Princeton University Press, 2001); and the discussion by Gil Anidjar in
The Jew, the Arab (Stanford: Stanford University Press, 2003). On the
commodification of ethnicity, see Jean and John Comaroff, *Ethnicity,
Inc.* (Chicago: University of Chicago Press, 2009).

17. Oregon State University, http://oregonstate.edu/instruct/
phl302/distance_arc/las_casas/Aristotle-slavery.html. Quotations are

from Aristotle's *Politics.* Note that Aristotle's political theory presumes that whereas a king may be superior in nature to his subjects, "in race he should be the same." (Cambridge, MA: Harvard University Press, Loeb Classical Library, 1932), 59: 1259b). The Greek word *gens* (the etymological origin of "genetics") can be translated as "kin," "tribe," or "ethnicity" as well as "race," but the debate is not settled by philology alone; it must take into account the operational force of a term and the conceptual, discursive, and political field in which it functions. John and Jean Comaroff, for instance, do not flinch from naming the commodification of ethnicity as "racial capitalism." *Ethnicity, Inc.*, 108. See footnote 19.

18. See Page du Bois, *Slaves and Other Objects* (Chicago: University of Chicago Press, 2003), especially her discussion of Basil Gildersleeve, one of the founders of classical studies in the United States and a fervent proponent of the "States Rights" defense of slavery.

19. Claude Berard, in Beth Cohen, ed., *Not the Classical Ideal*; (Boston: Brill, 2000). and Jean Pierre Vernant, "Food in the Countries of the Sun," in *The Cuisine of Sacrifice among the Greeks.* (Chicago: University of Chicago Press, 1989).

20. Eric Lott, *Love and Theft: Blackface Minstrelsy and the American Working Class* (New York: Oxford University Press, 1993).

21. Bhabha, "Signs Taken for Wonders: Questions of Authority and Ambivalence under a Tree outside Delhi," in *The Location of Culture* (New York: Routledge, 1994).

22. Anidjar, *Semites: Race, Religion, and Literature* (Stanford: Stanford University Press, 2008), 9.

23. Renan thought that the Semites were "an incomplete race," lacking in the arts of civilization in their single-minded and dogmatic devotion to the "desert" religion of monotheism. See Kelman Bland's critique of this prejudice in *The Artless Jew: Medieval and Modern Affirmations and Denials of the Visual* (Princeton, NJ: Princeton University Press, 2001).

24. In 1799 Napoleon issued a proclamation in the Palestinian city of Acre that called upon Jews as the "rightful heirs of Palestine" to return to Zion. "Napoleon Bonaparte's Letter to the Jews," April

20, 1799. Middle East News, http://www.mideastweb.org/napoleon1799.htm, accessed November 4, 2011.

25. Orson Hyde, a Mormon missionary, visited Jerusalem from April 1841 to December 1842 and "dedicated Jerusalem and Palestine for the ingathering of the Jews." Hyde erected a small altar with stones on the Mount of Olives, a site that would later be purchased by Brigham Young University. See *Wikipedia*, "Orson Hyde," http://en.wikipedia.org/wiki/Orson_Hyde. For a more comprehensive discussion of the relation between Christian and Jewish Zionism, and the resonance between Palestine and the American West, see my essay "Holy Landscape: Israel, Palestine, and the American West," in *Landscape and Power*, 2nd ed. (Chicago: University of Chicago Press, 2002).

26. Quoted in Jacqueline Rose, *The Last Resistance* (London: Verso, 2007), 194.

27. See Chomsky, "U.S. Savage Imperialism, Excerpt from 2010 ZMI Talk," Z Media Institute, http://www.hotkashmir.com/hotkashmir-news/hk-international/2022-us-savage-imperialism-excerpt-from-2010-zmi-talk-by-noam-chomsky. Accessed November 4, 2011. Chomsky mounts a critique of the notion that Israel-Palestine has become and should be acknowledged as a *single state* that exists in an intolerable condition of apartheid. His cold-blooded "realist" prediction is that Israel will simply continue what it is doing until the United States becomes fed up and imposes a two-state solution. Z Communications, *ZNet*, http://www.zcommunications.org/aboutzcom.htm.

28. See Ariella Azoulay, "Declaring the State of Israel—Declaring a Warring State," *Critical Inquiry*, 37:2 (Winter 2011), 265–85.

29. See Weizman, *Hollow Land: Israel's Architecture of Occupation* (New York: Verso, 2007).

30. Makdisi, e-mail correspondence, January 27, 2011.

31. *Haaretz*, November 2007. Quoted in Makdisi, *Palestine Inside Out*, 292.

32. The equating of the state of Israel with the "Jewish state" is of course a deliberate blurring of a quite sensible and essential distinction, and it contributes to the rhetoric of "existential threats" that

make any democratic vision of Israel-Palestine into a threat to the existence of the Jewish state.

33. See Pappe, *The Ethnic Cleansing of Palestine*, (Oxford: Oneworld, 2006).

34. See Weizman, *Hollow Land*, 10–11.

35. Quoted in Philip Weiss, "Is Zionism Racist? Foxman: 'You Bet It Is. Every Nationalism Is,'" in *Mondoweiss: The War of Ideas in the Middle East*, March 25, 2009, http://mondoweiss.net/2009/03/foxman-is-zionism-racism-you-bet-it-is-all-nationalism-is.html.

36. I call it futile, but there is powerful evidence that suicide bombing can under some circumstances be an effective tool for influencing political change. That does not make it any less morally reprehensible. See Robert A. Pape and James K. Feldman, *Cutting the Fuse: The Explosion of Global Suicide Terrorism and How to Stop It* (Chicago: University of Chicago Press, 2010). See also Talal Asad, *On Suicide Bombing* (New York: Columbia University Press, 2007).

37. The apocalyptic and messianic overtones of the Zionist enterprise are carefully disentangled by Amnon Raz-Kratkotzkin: "The intention of the nuclear weapon is to protect 'the utopian return'; nevertheless, it consciously carries the notion of apocalyptic destruction: the strategy associated to it is officially called the 'Samson option' and therefore carries the self-destruction of the 'Utopian Return'. Israel exists between these two markers of exceptionality: the absent Temple and the nuclear Temple." *Exile et Souverainete* (Paris: La fabrique, 2007), 27. Translation by the author. See also Seymour Hersh, *The Samson Option: Israel's Nuclear Arsenal and American Foreign Policy* (New York: Random House, 1991).

38. If Obama had been capable of candor about "perverse and hateful" religious ideologies, he could have taken on the Evangelical Christians who sowed homophobic prejudice in Africa, which has provoked murderous official and unofficial actions against gays and lesbians, most recently the assassination of the leading gay activist in Uganda.

39. An ally, it must be said, whose behavior is increasingly at odds with the interests of the United States. As Saree Makdisi notes: "Israel is a massive strategic liability for American power; not only Walt and

Mearsheimer [see *The Israel Lobby*] but a whole host of people in the Pentagon and other corridors of power have been saying this for some time. Look at the crisis over the Gaza flotilla: forced to choose between Turkey and Israel, which does the United States back? Turkey, the major staging ground and airbase for ongoing wars in Iraq and Afghanistan, a strategic partner without which U.S. Middle East and Central Asia policy would not function; or Israel, the utterly useless little state that the United States has to beg (as in 1991) not to get involved in its own regional interventions and that brings no value-added to the American projection of power in the region?" E-mail correspondence, January 25, 2011. See also, of course, Makdisi's magisterial analysis of the current state of the Israeli-Palestinian impasse, *Palestine Inside Out.*

40. I put "interests" in quotation marks because it is not all that certain that the current U.S policy toward Israel and the Middle East is in the U.S.'s interests. See the discussion in the Retort Collective's book, *Afflicted Powers: Capital and Spectacle in a New Age of Art* (New York: Verso, 2005).

41. Petraeus testified to the Senate Armed Services Committee on March 17, 2010, that "the Israeli-Palestinian conflict was fomenting anti-American sentiment in the region," as if our alliances with authoritarian, undemocratic regimes in Egypt, Tunisia, Saudi Arabia, and Yemen were not already enough to sow resentment. See *Haaretz*, March 17, 2010, http://www.haaretz.com/news/u-s-general-israel-palestinian-conflict-foments-anti-u-s-sentiment-1.264910.

42. Hever, "The Post-Zionist Condition," *Critical Inquiry*, forthcoming.

43. See *For My Children*, film directed by Michal Ariad, 2007.

44. See the amazing documentary *What I Saw in Hebron*, dir. Don and Noit Geva, 2007.

45. Raja Shehadeh, *Palestinian Walks: Forays into a Vanishing Landscape* (New York: Scribner, 2007), 198.

46. Dir. Yaav Shamir, 2007. Again, Eyal Weizman's *Hollow Land* is the most comprehensive account of the innumerable ways in which space is racialized in Israel-Palestine.

47. See Jay Boulter and Richard Grusin, *Remediation: Understanding New Media* (Cambridge, MA: MIT Press, 2000).

1. I am indebted throughout this discussion to the work of my colleague Bill Brown, whose explorations of "thing theory" have been a constant source of inspiration.

2. For further discussion of the triad image/object/medium, see *What Do Pictures Want?*

1. Jay Appleton, *The Experience of Landscape*, rev. ed. (London: John Wiley & Sons, 1996).

2. For simplicity's sake I refer throughout this chapter to *The Gates* as having been created by the artist Christo, but his collaborator Jeanne-Claude should be mentioned as well.

3. I am grateful to Israeli artist Larry Abramson for introducing me to this remarkable piece of landscape art and for his advice on this chapter. I have also benefited greatly from Ruth Malul Zadka's M.A. thesis, "The 'Transparent' Wall in Jerusalem's Gilo Neighborhood" (Bretton College, University of Leeds, Israel Extension, Tel Aviv, 2003). My thanks also go to Elizabeth Helsinger and Bill Brown, who read an earlier draft of this chapter and made very helpful comments on it.

4. Zadka, "'Transparent' Wall," 14.

5. Larry Abramson, e-mail correspondence, March 18, 2006.

6. Zadka, "'Transparent' Wall," 14.

7. I regard the Warsaw Ghetto wall as more sinister than the Berlin Wall because the latter was "merely political." The walls currently being erected in Israel are racial, a symptom of a strategy of ethnic cleansing.

8. "OCHA Weekly Briefing Notes Update for oPt (28 January–10 February 2004)," *HumanitarianInfo.org*, http://www.humanitarian info.org/opt/docs/UN/OCHA/WBN39.pdf.

9. See Blake Gopnick, "Christo's Gates: A Little Creaky," *Washington Post*, February 12, 2005, D01. Gopnick, like many other reviewers, dismissed *The Gates* as merely ornamental, utterly lacking in "the kind of puzzling, complex, probing experience we're supposed to get from significant art."

10. Lines 11–14, *Selected Poems of Alexander Pope*, ed. William K. Wimsatt Jr. (New York: Holt, Rinehart, and Winston, 1964), 42. See "Frederick Law Olmsted and the Dialectical Landscape," in *Robert Smithson: The Collected Writings*, ed. Jack Flam (Berkeley: University of California Press, 1996).

11. See Roy Rosenzweig and Elizabeth Blackmar, *The Park and the People: A History of Central Park* (Ithaca, NY: Cornell University Press, 1992), 196–97.

12. In fact the rooftop of the Metropolitan Museum was wrapped in orange construction sheets during the Christo installation, and thus seemed to become an unintended extension of the work.

13. See Carol Fabricant, "Binding and Dressing Nature's Loose Tresses: The Ideology of Augustan Landscape Design," *Studies in 18th Century Culture* 8 (1979), 109–35.

14. Wordsworth, "Tintern Abbey," ll. 4–8.

15. According to the photographer Maria Nadotti, the mural was painted by a group of Mexican visitors to Qalqilya.

16. See Berger's essay, "Undefeated Despair," about his visit to the West Bank, which appeared next to my reflections on the Gilo Wall and Christo's *Gates* in *Critical Inquiry* 32:4 (Summer, 2006), 602–9.

17. Thanks to Daniel Monk for helping me recognize the image of the olive trees.

CHAPTER 2. BINATIONAL ALLEGORY

1. I have learned, however, that this blemish is a Duchampian accident, perhaps a flaw in the photographic reproduction in the catalogue in which I reviewed this painting. However, Abramson tells me that Malevich's original is now developing cracks, just like the old masters,

and that his current returns to the black square are consequently exploring the issue of cracks and flaws. Sometimes chance leads the way to design.

2. On the "dawning of an aspect," see Ludwig Wittgenstein, *Philosophical Investigations*, trans. G. E. M. Anscombe (New York: Macmillans, 1958) 194. See also my discussion of this concept in "Metapictures," Chap. 2 of *Picture Theory* (Chicago: University of Chicago Press).

3. See my essay "Metapictures" for extended discussion of the phenomenon of multistable images.

4. The artist, as quoted in Daniella Talmor, "Eventus Nocturnus," in *Larry Abramson: Eventus Nocturnus*, trans. Hanita Rosenbluth (Haifa: Haifa Museum of Art, 2001), 110.

5. Elyakim Chalakim is a name invented by the Israeli licensees of the Garbage Pail Kids, an American series of trading cards released in 1985 by the Topps Company, that depict grossly deformed kids designed to parody the Cabbage Patch Kids dolls. In the English original the character dubbed Elyakim Chalakim was called Second Hand Rose, or Trashed Tracy. As chance had it, the name Elyakim (in Hebrew, literally meaning "God will raise up, resurrect") Chalakim (in Hebrew, "parts, pieces") could be read: God will resurrect the pieces. Even though the Israeli translator was probably only looking for a first name to rhyme with Chalakim, the resultant Elyakim Chalakim brings to mind the Kabbalist notion of *tikkun*, the mending of the shattered vessels that contained the divine light. In 1990 Abramson allegorically proclaimed Elyakim Chalakim "the great artist of the future" by virtue of his will to "raise himself out of the surrounding wilderness of refuse and rehabilitate himself as a new axis of vertical meaning." Quoted in Gideon Ofrat, "The Death of Elyakim," in *Larry Abramson: Eventus Nocturnus*, trans. Peretz Kidron (Haifa: Haifa Museum of Art, 2001), 102.

6. E-mail correspondence with the artist, February 22, 2010.

7. I have many reasons for using the phrase Israel-Palestine (or Palestine-Israel) to designate a hyphenated country that, from one point of view, only exists in the utopian image of a binational state,

but from another point of view, *actually exists* and has existed for more than half a century as a single administrative, governmental entity in which a population resides in a condition of radical inequality. But this would require an essay in itself. See Ariella Azoulay's brilliant analysis of Israel-Palestine as one nation, state, and country in "Declaring the State of Israel—Declaring a Warring State," *Critical Inquiry* 37:2 (Winter 2011), 265–85.

8. See Mark Twain, *Innocents Abroad: or The New Pilgrim's Progress,* (Hartford, Conn.: American Publishing Company,1869).

9. Despite the large body of commentary on Abramson's work by Israeli critics and art historians, there has been little attention to centrality of the political in his "abstract" and symbolic works. The political meaning of the crescent, which has been part of his work for the last twenty-five years, has "never been seriously regarded," according to the artist. E-mail correspondence, February 6, 2010.

10. Fredric Jameson, "Third World Literature in the Era of Multinational Capitalism," *Social Text*, no. 15 (Autumn 1986), 65–88.

11. Abramson's work *tsooba*, made between 1993 and 1994 and exhibited in 1995 at the Kibbutz Art Gallery in Tel Aviv, was a groundbreaking critical dialogue with the role of abstract painting in the erasure of Palestinian memory from the landscape and its representations. *tsooba* included thirty-eight 25′25 cm oil on canvas landscape paintings after a photograph of the site of a deserted Palestinian village, thirty-eight impressions of the wet landscape paintings on newspaper, and thirteen still-life paintings after samples of flora taken from the site.

12. Jameson, "Third World Literature," 69n6.

13. When Golda Meir notoriously claimed that "there is no such thing as a Palestinian people," she meant that the native inhabitants of pre-1948 Palestine did not amount to a national entity, but rather to a loosely linked network of tribal communities. Of course a half century of suppression and occupation has had the predictable effect of turning the Palestinians into a people with nationalistic aspirations of self-determination and emancipation, something that the Ottoman and British empires were never quite able to accomplish. Palestinian

nationalism may thus be seen as one of the most notably ironic achievements of Zionism.

14. This figure of the sovereign with raised arms was famously discussed by Meyer Schapiro in "Themes of Action and Themes of State," Lecture IV in *Romanesque Architectural Sculpture: The Charles Eliot Norton Lectures* (Chicago: University of Chicago Press, 2006), 97–122. See also my essay, "State of the Union: Jesus Comes to Abu Ghraib," in *Cloning Terror: The War of Images, 9/11 to the Present* (Chicago: University of Chicago Press, 2010).

15. See Saree Makdisi, *Palestine Inside Out*, for a sober assessment of the convergence between the utopian notion of a binational state and the right wing Zionist determination to control all of Eretz Israel. Of course the latter fantasy generally involves a tacit understanding that the Palestinians must leave the country.

16. Jameson, "Third World Literature," 73n6.

17. This piece was first shown in *The Political Imaginary*, a retrospective of Bruguera's work held at the Neuberger Museum, Purchase College, State University of New York, January 28–April 11, 2010, curated by Helaine Posner.

18. Tamar Manor-Friedman, "The Rose of Jericho: A Dormant Parable," in *Larry Abramson: The Rose of Jericho*, trans. Peretz Kidron (Jerusalem: Jerusalem Print Workshop, 2004), xiii

19. Discussed at a symposium, "Art of the Brain," that brought together artists and brain researchers from the Hebrew University's Interdisciplinary Center for Neural Computation, held in Kibbutz Cabri in 2004, where "the scientists find great resemblance between his images of the 'Rose of Jericho' and the form of brain cells." Abramson, *Chronology*, 46.

20. I must mention here the work of a gifted young Palestinian artist, Khaled Jarrar, who has produced a series of glossy brochures with suburban bungalows urging people to immigrate to Palestine where they will find it easy to obtain the Palestinian equivalent of an American "green card." Jarrar is also a principal subject of my essay "Migration, Law, and the Image: Beyond the Veil of Ignorance" (See Chap. 3) which takes up his video work on the sewer underpasses that

Palestinians must traverse in order to bypass the Jews-only "security roads" that crisscross the West Bank linking up with the settlements.

21. Quoted in Galia Bar Or, "'We Are All Felix Nussbaum': On Larry Abramson's Pile," in *Trummerhaufen/The Pile*, trans. Richard Flantz (Osnabrueck: Felix Nussbaum Haus, 2005), 21.

22. Larry Abramson, "A Letter from the Underground," *Studio* 53, May–June 1994: 34 [Hebrew].

23. See Talmor, "Eventus Nocturnus," 110n2.

CHAPTER 3. MIGRATION, LAW, AND THE IMAGE

1. This chapter was first written as the keynote address for "Images of Illegalized Immigration," an international conference at the University of Basel, Switzerland, August 30, 2009. I am grateful to Francesca Falk, Christine Bischoff, and Sylvia Kafehsy for their kind invitation to address this topic.

2. See my book *What Do Pictures Want?* for an extended discussion of this point.

3. See my essay "Migrating Images: Totemism, Fetishism, Idolatry" in *Migrating Images*, ed. Petra Stegmann and Peter Seel (Berlin: Haus der Kulturen der Welt, 2004), 14–24.

4. For further discussion of the law against images, see Chap. 4, "Idolatry."

5. See Martin Jay's "Must Justice Be Blind? The Challenge of Images to the Law," which appeared, among other places, in his collection *Refractions of Violence* (New York: Routledge, 2003), 87–102.

6. John Rawls, *A Theory of Justice* (Cambridge, MA: Harvard University Press, 1971). It is important to note that from another standpoint, the veil of ignorance is an *invitation* to imagination because it encourages the speculative possibility that when the veil is lifted, one might be poor, powerless, ill, enslaved, or otherwise abject. Rawls's veil is a device for preventing abstract notions of justice from being grounded in a comfortable, bourgeois position of autonomy and freedom. I am grateful to Rob Kaufmann, professor of English at University of California, Berkeley, for extensive correspondence on this point.

7. Cole, *Philosophies of Exclusion: Liberal Political Theory and Immigration* (Edinburgh: Edinburgh University Press, 2000), ix. .

8. See my discussion of Benjamin's dialectical images in *Iconology: Image, Text, Ideology* (Chicago: University of Chicago Press, 1986), 202–3. See also Benjamin's "Baudelaire, or the Streets of Paris," in *Reflections*, ed. Peter Demetz (New York: Harcourt, Brace, Jovanovich, 1978), 157.

9. One of the enduring scandals of the U.S. immigrant detention system is the number of detainees who die in custody, often without being counted and without any account of the manner of their deaths. See Nina Bernstein, "Officials Say Fatalities of Detainees Were Missed," *New York Times*, August 18, 2009.

10. Compare the notorious Article 1, Section 9 of the U.S. Constitution: "The migration or importation of such persons as any of the states now existing shall think proper to admit, shall not be prohibited by the Congress prior to the year one thousand eight hundred and eight, but a tax or duty may be imposed on such importation, not exceeding ten dollars for each person." Congress prohibited the international slave trade in 1808 but treated it as taxable immigration prior to that.

11. See Jacques Derrida, *Of Hospitality*, trans. Rachel Bowlby (Stanford: Stanford University Press, 2000), 51: "The frontier turns out to be caught in a juridico-political turbulence, in the process of destructuration-restructuration, challenging existing law and established norms." All this as a result of the "mutation" (as deconstruction) brought on by new technologies of communication and "social media" such as e-mail.

12. (New York: Grand Central Publishing, 2000).

13. More precisely, the ooloi are the "third gender" of a race of extraterrestrials known as the Oankali. It is the ooloi who conduct genetic experimentation.

14. Directed by Neil Blonkamp who also wrote the screenplay. Ranked number 2 on movie meter out of ten thousand slots in the final week of August 2009.

15. I am grateful to Anne Pinchak, former immigration lawyer, for sharing with me her practical experience on these matters.

16. On the notion of the racial veil, and the more general status of race as medium or "intervening substance," see the three lectures in Part I of this book.

17. For a familiar argument that immigration from the Middle East to Europe is threatening a "Moorish return" that will destroy Western civilization, see Christopher Caldwell, *Reflections on the Revolution in Europe: Immigration, Islam, and the West* (New York: Doubleday, 2009).

18. Makdisi, *Palestine Inside Out*, 146.

19. For further discussion, see "Gilo's Wall and Christo's Gates," Chap. 1.

20. See the obituary of the "earthy" General Eitan in the *Independent*, November 26, 2004, http://www.independent.co.uk/news/obituaries/rafael-eitan-534569.html.

21. *For My Children*, dir. Michal Ariad (2006).

22. Ilan Pappe, *The Ethnic Cleansing of Palestine* (Oxford: Oxford University Press, 2006).

23. At this writing, the project has relocated to Corona, Queens, New York, where it is focusing on Latin American immigrants. See Sam Dolnick, "An Artist's Performance: A Year as a Poor Immigrant," *New York Times*, May 18, 2011.

24. The project has now moved to New York City, where Bruguera has created a storefront drop-in center for immigrants, mainly Hispanic, who are looking for ways to address their condition in symbols and performances.

25. I'm thinking particularly here of Ernesto Laclau and Slavoj Zizek's debate over the role of negativity in contemporary democratic politics. Certainly immigrants in the United States occupy precisely the position of the negative in contemporary political polemics. Among the many lies that were circulated about Obama's health plan was the claim that it would provide insurance for illegal immigrants.

CHAPTER 4. IDOLATRY: NIETZSCHE, BLAKE, POUSSIN

1. Denounced, of course, as idols by the Taliban. It is important to note, however, that a Taliban spokesman who toured the United States

prior to the destruction of the Buddhas claimed that the statues would be destroyed, not because there was any danger of their being used as religious idols, but (on the contrary) because they had become secular idols for the West, which was expressing interest in pouring millions of dollars into Afghanistan for their preservation. The Taliban blew up the "idols," in other words, precisely because the West cared so much about them.

2. See the remarks by Lieutenant General William Boykin, Undersecretary of Defense during Donald Rumsfeld's tenure as Secretary of Defense. For a discussion of the response to Bush's declaration of a "crusade" of "good against evil," see (among numerous commentaries) Peter Ford's piece, "Europe Cringes at Bush 'Crusade' against Terrorists," in the *Christian Science Monitor*, September 19, 2001.

3. The phrase is from the subtitle of Hans Belting, *Likeness and Presence: A History of the Image before the Era of Art* (Chicago: University of Chicago Press, 1994).

4. (New York: Cambridge University Press, 1989).

5. Neer, "Poussin and the Ethics of Imitation," *Magazine of the American Academy in Rome (MAAR)*, 51/52 (2006/7), 297–344.

6. "Critique of Violence," in *Reflections*, ed. Peter Demetz (New York: Harcourt Brace, 1978), 298.

7. The best study of this sort is Avishai Margalit and Moshe Halbertal, *Idolatry* (Cambridge: Harvard University Press, 1992), which surveys the major themes of idolatry and iconoclasm from the rabbinical commentators through the history of Western philosophy.

8. For a fuller discussion of the concept of "secondary belief," see "The Surplus Value of Images," Chap. 4 of my book *What Do Pictures Want?*

9. Halbertal and Margalit, *Idolatry*, 5.

10. See my chapter "Holy Landscape," in *Landscape and Power*, 2nd ed. (Chicago: University of Chicago Press, 2002).

11. As Halbertal and Margalit note, "the prophets speak of protective treaties with Egypt and Assyria as the worship of other gods." *Idolatry*, 5.

12. The second commandment makes the mandate of collective punishment explicit: "You shall not bow down to them or serve them;

for I The Lord your God am a jealous God, visiting the iniquity of the fathers upon the children to the third and the fourth generation . . ." Exodus 20:5, King James Version.

13. See my "The Rhetoric of Iconoclasm: Marxism, Ideology, and Fetishism," in *Iconology* (Chicago: University of Chicago Press, 1986), Chap. 6. For a survey of the sublimated, immaterialist concepts of idolatry, see Halbertal and Margalit, *Idolatry*.

14. *The Portable Nietzsche*, ed. Walter Kaufmann (New York: Penguin, 1954), 317.

15. Ibid., 315.

16. Ibid., 324–25.

17. Ibid., 325.

18. Karl Marx, *The German Ideology*, ed. C. J. Arthur (New York: International Publishers, 1970). 28. For further discussion, see my essay, "The Rhetoric of Iconoclasm," in *Iconology: Image, Text, Ideology* (Chicago: University of Chicago Press, 1986).

19. Ibid., 466.

20. Introduction to *The Lives of the Artists*. Trans. George Bull (London: Penguin Books, 1987), 11.]

21. *The Marriage of Heaven and Hell*, plate 11, in *The Poetry and Prose of William Blake*, ed. David V. Erdman (Garden City, NY: Doubleday), 37.

22. See W. Robertson Smith, *The Religion of the Semites: The Fundamental Institutions* (1889; New York: Shocken Books, 1972): "In semitic religion the relation of the gods to particular places . . . is usually expressed by the title Baal" (93).

23. Burke is of course speaking here of the idols of *Native* Americans in this passage. *A Philosophical Enquiry into the Origin of Our Ideas of the Sublime and Beautiful*, ed. James T. Boulton (1757; South Bend, IN: Notre Dame University Press, 1968), 59. See my discussion in "Eye and Ear: Edmund Burke and the Politics of Sensibility," *Iconology*, Chap. 5, 130.

24. *Critique of Judgment*, trans. J. H. Bernard (New York: Macmillan, 1951), 115.

25. Neer, "Poussin and the Ethics of Imitation," 297.

26. Ibid., 298.

27. Ibid., 299.

28. Ibid., 312.

29. Ibid.

30. Ibid.

31. Ibid., 309.

32. Ibid., 313.

33. Ibid., 318.

34. This shift of the question from the meaning of the painting to "what it wants" is of course the procedure I have advocated in *What Do Pictures Want?*

35. It is hard to ignore the fact that Ashdod is located in the short space of land (about twenty miles) between Tel Aviv and Gaza. During the invasion of Gaza in January 2009, it suffered rocket attacks from the Palestinians in Gaza.

36. *Natural History*, Vol. 9, Book 35: 98, trans. H. Rackham (Cambridge, MA: Harvard University Press, 1984), 335.

37. See Meir Wigoder, "The Acrobatic Gaze and the Pensive Image in Palestinian Morgue Photography," *Critical Inquiry* 38:2 (Winter 2012), for further discussion. The Hams photograph is viewable in the Getty Image Archive, #72469093, http://www.gettyimages.com.

38. See Sheila Barker, "Poussin, Plague, and Early Modern Medicine," *Art Bulletin* 86:4 (December 2004), 659–89.

39. See Nadav Shragal, "An Amalek in Our Times?," *Haaretz*, January 21, 2009. http://www.haaretz.com/print-edition/features/an-amalek-in-our-times-1.242717.

40. Alan Cowell, "Gaza Children Found with Mothers' Corpses," *New York Times*, January 8, 2009, http://www.nytimes.com/2009/01/09/world/middleeast/09redcross.html?partner=rss&emc=rss.

41. In a fuller exposition, I would explore the relation between the dogmatic historicism of art history, its assumption of a proper "horizon of meaning," and the closely related problems of anachronism and intentionalism. Richard Wollheim is among the most prominent supporters of a strict historical psychologizing of pictorial meaning, which in his view "always rests upon a state of mind of the artist, and the

way this leads him to work, and the experience that the product of this work brings about in the mind of a suitably informed and sensitive spectator." *Painting as an Art* (Princeton, NJ: Princeton University Press, 1987), 188. See my essay, "The Future of the Image: Ranciere's Road Not Taken," for a discussion of the inevitability of anachronism and unintentional meaning in pictures in *The Pictorial Turn*, ed. Neal Curtis (New York: Routledge, 2009); also Georges Didi-Huberman, "The History of Art within the Limits of Its Simple Practice," in *Confronting Images* (University Park: Penn State University Press, 2005), 12–52: "Anachronism is not, in history, something that must be absolutely banished—in the end, this is no more than a fantasy or an ideal of equivalence—but rather something that must be negotiated, debated, and perhaps even turned to advantage" (41). We should note as well that when Wollheim asks himself "Where have I seen this face before?" in Poussin's *Rinaldo and Armida*, his answer is—of all things—Courbet! See *Painting as an Art*, 195.

42. *Philosophical Investigations*, trans G. E. M. Anscombe (New York: Macmillan, 1958), 194.

43. See *The Order of Things*, (New York: Vintage Books, 1970), 10; and my discussion in "Metapictures," Chap. 2 of *Picture Theory*. (Chicago: University of Chicago Press, 1994).

44. The Israelites dancing around the Golden Calf, like the Philistines in terror at the plague, are both depicted as classical figures—as Greeks, in other words. As it happens, contemporary archaeology research suggests that the Philistines were in fact Mycenaeans who migrated from Greece down to Palestine. This fact gives the historical dimension of Poussin's painting an uncanny accuracy in relation to modern historical knowledge that he could not have known. Thanks to Richard Neer for this factoid.

45. See my discussion of Durkheim and the relations of totemism, fetishism, and idolatry in *What Do Pictures Want?*

46. Sir James Frazer's *Totemism and Exogamy* (1910) is the classic discussion of this dimension of the sacred object and a major source for Freud's linkage of totemism to the incest taboo. See also *What Do Pictures Want?*, Chaps. 7–9.

47. Emile Durkheim, *The Elementary Forms of Religious Life*, trans. Karen Fields (New York: Free Press, 1995): The totem "expresses and symbolizes two different kinds of things. From one point of view, it is the outward and visible form of what I have called the totemic principle or god; and from another, it is also the symbol of a particular society that is called the clan. . . . God and society are one and the same" (208).

<h3 style="text-align:center">CONCLUSION</h3>

1. The obverse charge was that the Jews' hatred of images and dogmatic allegiance to the second commandment condemned them to the status of a "people without art." See Kelman Bland, *The Artless Jew,* (Princeton: Princeton University Press, 2000).

2. See *Moses and Monotheism*, Trans. Katherine Jones (New York: Knopf, 1939).

3. See Arifa Akbar, "Hirst Hopes to Revolutionise Art Market with 'Golden Calf,'" *Independent*, June 20, 2008, http://www.independent.co.uk/arts-entertainment/art/news/hirst-hopes-to-revolutionise-art-market-with-golden-calf-851034.html.

4. See Arifa Akbar, note 3.

5. "The tree of liberty must be refreshed from time to time with the blood of patriots and tyrants, It is its natural manure." Thomas Jefferson, letter to William Stephens Smith, November 13, 1787, in *The Papers of Thomas Jefferson*, ed. Julian P. Boyd, vol. 12, (Princeton: Princeton University Press, 1950), 356. The Second Amendment to the Constitution guarantees the right to bear arms. Sharron Angle, the Republican candidate for the U.S. Senate in 2010, was notorious for her use of this kind of language.

6. David Harvey, *The Global Sociology Blog*, August 11, 2011, http://globalsociology.com/2011/08/11/david-harvey-on-feral-capitalism/.

7. See the video of the debate between Starkey, Dreda Say Mitchell, and Owen Jones (the author of *Chavs*) on BBC News, August 12, 2011, http://www.bbc.co.uk/news/uk-14513517. On the concept of racial masquerade, see Phillip Brian Harpter, "Passing for What?

Racial Masquerade and the Demands of Upward Mobility," *Callaloo* 21:2 (1998), 381–97.

8. Harvey, *Global Sociology Blog*, op. cit.

9. See Carlin's album, *Operation: Foole*, "White Harlem" (1990).

10. See Rogin, *Blackface, White Noise*.

11. *"Society Must Be Defended": Lectures at the College de France, 1975–76* (New York: Picador, 2003):, 28: "Marx told Engels in a letter written in 1882 that 'You know very well where we found our idea of class struggle; we cound it in the work of the French historians who talked about the race struggle.'"

12. Walter Benn Michaels, *The Trouble with Diversity* (New York: Metropolitan Books, 2006), 73.

ACKNOWLEDGMENTS

The chapters in Part II, "Teachable Objects," have been previously published. "Gilo's Wall and Christo's Gates" first appeared in *Critical Inquiry* 32:4 (Summer 2006); "Binational Allegory" first appeared in *Larry Abramson: Paintings 1975–2010*, Tel Aviv Museum of Art (exhibition catalogue, curator: Ellen Ginton, Tel Aviv, 2010) and subsequently in *Studies in Romanticism* 49:4 (Winter 2010); "Migration, Law, and the Image" first appeared in *Images of Illegalized Immigration*, ed. Christine Bischoff, Francesca Falk, and Sylvia Kafehsy (Bielefeld: transcript Verlag, 2010) and subsequently in *The Migrant's Time*, ed. Salone Mathur (Williamstown, MA: Clark Institute Publications); "Idolatry: Nietzsche, Blake, Poussin" first appeared in *Idol Anxiety*, ed. Joshua Ellenbogen and Aaron Tugendhaft (Palo Alto, CA: Stanford University Press, 2011). I am grateful to the various editors and publishers for allowing me to reprint these essays, slightly modified, in the present volume.

INDEX